Podkewanos
09·12·01

Stephen

With thanks for tonight's recital with Sarah — you gave the nice old crowd here — in Somerset an evening to cherish.

Jeremy

P.S. We'd love you to do a solo piano recital here — of the contemporary music you most like to play? — I'd be happy to talk through ideas for any kind of 'event'!

no FuN
without U

to K

no FuN without U

the art of
Factual Nonsense

jeremy cooper

●●●ellipsis

First published 2000 by
●●● ellipsis
2 Rufus Street
London
N1 6PE
EMAIL ...@ellipsis.co.uk

Jeremy Cooper has asserted his right to be identified as the author of this book

ISBN 1 899858 80 6

British Library Cataloguing in Publication Data: a CIP record for this publication is available from the British Library

Designed by Jonathan Moberly
Edited by Rosa Ainley
Index by Diana LeCore
Printed and bound in Hong Kong

●●● ellipsis is a trademark of Ellipsis London Limited

contents

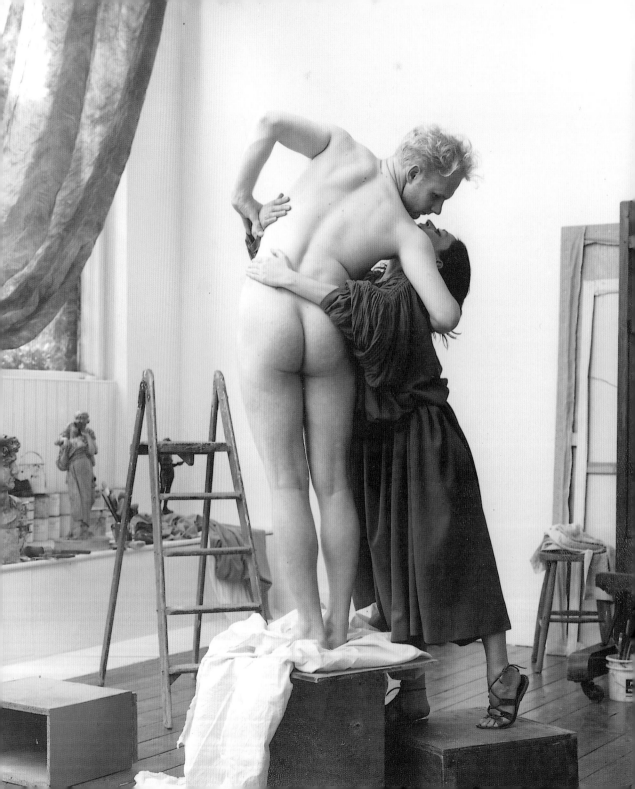

one

Joshua Compston feared there was something odd about him which he himself could never hold in view long enough to apprehend, something that made him different. At other times he feared not being different enough. Mostly though, he got on with the business of living, at an exceptional pace, with quite extraordinary energy.

'I have an inclination to overbe,'[1] he wrote to a friend in February 1989, half way through his first undergraduate year, reading History of Art at the Courtauld Institute in London. 'Because of my tiresome ardour of spirit I find it difficult to rest. I always have to search.'[2]

In pursuit of this hidden path he walked almost at a run, chewing his lower lip, short curly blond hair bouncing on broad forehead – always in the lead, never side-by-side with anybody. Compston sought, for sure, to make a difference.

'I'm worried that I shall perish to this world. Before this happens I must try and leave something worthy of that great bloody mother – Art,'[3] he had stated in a letter written to the same friend on 20 July 1988, a couple of weeks after his eighteenth birthday.

Did it have to be 'Art' which fired his spirit? Might he not have declared, just as dramatically, a passion for politics or the desire for money and women?

Compston photographed at the Atlantis Gallery in Brick Lane, Spitalfields, in the winter of 1993.

OPPOSITE Joshua Compston (born 1 June 1970, died 6 March 1996) in Pygmalion pose.

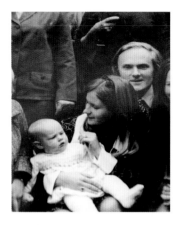

September 1970, baby Joshua's christening,
held in the arms of his mother, Bronwen
Lenton; his father, Christopher Compston,
seated behind.

In fact, Joshua Compston wanted it all: to be rich,
to be loved and to recreate the world. Then as now
as always, art was a weapon, the most accessible
weapon of weight available to a young man dissatis-
fied with the ways of conventional life from which
he feels by nature excluded. He and others like him
are forced to remould the world to make for them-
selves a home.

Art is the start, work a way of life, death their end
like the rest of us. What matters is not the form itself
but the force of will with which the individual builds
a place to be. Change, for such people, is a radical
necessity rather than rational choice. Anything goes:
rather, everything goes. It all has to be different –
though not necessarily new. In Joshua Compston's
case, aspects of the old – in particular the art and
ideals of the early modern movement – appealed as
strongly as contemporary experiment with the new
technologies of video and electronics. Even though
Compston's personal taste tended towards the his-
torical avant-garde, at Factual Nonsense, the art
premises he opened in Shoreditch in October 1992,
he never minded what his artist friends did, provid-
ing it was done to the utmost, unconditionally, and
with abandon.

GLORY OR DEATH – STRAIGHT UP OR DOWN
Don't you just hate all those theories, critics, books on

post-this and ism-that? We need those who can not only call a spade a spade but take that spade and ram it down on the neck that supports: popular entertainment, art-culture, Americanisation, kitsch, fascism, until the tendrils that hold them to the betrayed people collapse and their polluted blood flows back into the motherland.[4]

Born into a family interested in the visual arts, with a mother who painted and a barrister father who dealt part-time in second-hand books, Compston's initial ambition was to be an artist. His room in his mother's house on the banks of the Thames at Chiswick became, during his teenage years, a private museum, tightly packed with favourite objects, both found and created, impregnated with the nicotine-and-birds'-nest tang of an apothecary's cell, his own death mask on prominent display, cast from life in lead smelted on the kitchen stove. From early childhood he had kept and categorised all sorts of personal and public ephemera. In 1983, at the age of thirteen, after meeting Peter Blake, he marched round to the Pop-artist's nearby studio to present him with a collection of printed paper containers, similar to those he had noticed in work exhibited at Blake's retrospective at the Tate earlier in the year. With brazen belief in his right to contribute personally to the creative process, he talked to Blake of the kind of use the artist might

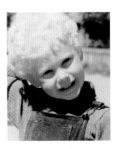

Compston aged three.

At the age of eighteen Compston became a member of the Colony Room, the Soho drinking club used by Francis Bacon, Lucien Freud and numerous other artists and writers. Compston signed and dated this Polaroid snap, 22 April 1991, a characteristic act of self-documentation.

Pen and wash drawing by Peter Blake, taken from a theatre poster in the artist's possession. Signed and inscribed 'For Joshua', a present from Blake in 1984, when they were neighbours in Chiswick, west London.

like to make of this treasured ephemera, secretly hoping to receive it all back in a piece dedicated to him, on the lines of *A Little Museum for Tom Phillips* (1977). Typical of the man he was to become, Compston had already begun the search for ways to make art happen around him. In 1988, while on a Foundation Course at Camberwell School of Art, he staged a performance piece at the Tate Gallery, arriving tied head to toe in a sack, rolling down the front steps, then lying there till officialdom took notice and gave him assistance. Maybe he was just too impatient for results, too greedy for experience to devote his days to producing art himself; his response to the frustrating year at Camberwell was to switch to the Courtauld and a degree in Art History.

One way or another, he never stopped creating. Indeed in the eyes of many who delighted in the dynamism of his later life in Shoreditch, Joshua Compston was the object and subject of every show and of all the events which burst forth from Factual Nonsense. As his friend Gilbert – of Gilbert and George – insisted: 'The thing about Joshua is that he is the artist.'⁵ Or as another close artist friend, Tracey Emin, put it: 'His dream was the coming together of all, a greater understanding: of life and art, with no boundaries, no hierarchies ... Joshua created a place where it was possible for us all to live out our fantasies, our dreams. He was art, and his

Damien Hirst, *The Three Strange Partners* (1983–5), one of a series of collages the artist made from material found in the house abandoned by his neighbour in Manor House, London, Mr Barnes. The title is taken from the opened page of the book on which Mr Barnes had underlined in green the sentence: 'They simply don't know how to be independent'. The title subsequently refers to the curatorial partnership of Billee Sellman, Damien Hirst and Carl Freedman, in whose home in Greenwich the work used to hang. Hirst has said: 'I think if I hadn't found Mr Barnes' house I wouldn't be where I am today … I just see it all like collage. In an artwork you are not doing a lot different and it is a bit like arranging a group show. It is organising already organised elements and that is what collage is.'

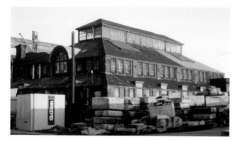

The Port of London Authority's abandoned gym in Surrey Docks that Hirst, then in the second year of his BA course at Goldsmiths' College, borrowed in 1988 to mount the group exhibition 'Freeze' of work by fellow students, marking the public birth of 'young British art'.

Sponsored by the London Docklands Development Corporation, 'Freeze' was presented in two instalments, this view of Part 2 including *Grey Unit*, in acrylic and pencil on hardboard, by Angus Fairhurst, three door paintings by Gary Hume and, on the floor, Anya Gallaccio's *Waterloo*, in poured lead.

ability was to make a place where everybody could be art.'[6]

Moulded by his Brit-standard upper middle-class education, Compston initially accepted the Establishment view that the modern artists who mattered were, by definition, those exhibiting in key West End galleries. Had not family friend and neighbour Peter Blake been offered his first solo show at Leslie Waddington's in Cork Street in 1969, and remained a gallery artist ever since? Even Gilbert and George, he learnt, had exchanged their youthful antagonism to the West End – 'We wouldn't even go to galleries any more because we hated the idea of the art object, like sculpture on the floor or a painting on the wall. We thought it was totally finished.'[7] – for representation by the other dominant dealer of the London scene, Anthony D'Offay. With his rabid appetite for power, Compston was naturally drawn towards D'Offay and Waddington when setting out in 1990 to infiltrate the art market. He soon discovered that much the most interesting developments were taking place in a different part of town, at exhibitions and events arranged by artists themselves.

Compston was introduced to the work of the amorphous gang of young artists with and through whom he was destined to make a life of his own at a show called 'Modern Medicine'. This was mounted in Building One, part of Peak Freen's disused biscuit

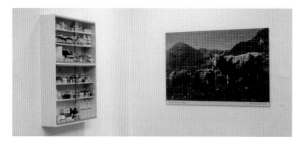

At Goldsmiths' in the summer of 1989 Hirst and Fairhurst presented their degree show together: on the left Hirst's *Bodies,* one of his earliest pharmaceutical pieces; on the right, Fairhurst's *Attachment*. Hirst and Fairhurst were later to play a memorable part, dressed as clowns, in Compston's first Fête Worse Than Death, a day-and-night street event in Shoreditch in the summer of 1993.

factory in Drummond Road, Bermondsey, inland from the dockside development south-east of Tower Bridge. Two years earlier, in August and September of 1988, Damien Hirst had persuaded fellow BA students at Goldsmiths' College, the progressive south London art school, to self-present their work in the Port of London Authority's gym in Surrey Docks. Hirst was now joined by a childhood friend from Leeds, Carl Freedman, also a recent undergraduate, in anthropology at University College London, and by Billee Sellman, a friend of Freedman's from university, to co-curate and organise a professional exhibition freed from the conventional boundaries of commercial galleries and their small white cubes of take-away art, sold and bought with silent shrugs and the occasional arch of an elegant eyebrow.

On all counts, physical, intellectual and aesthetic, the essential distinction of 'Modern Medicine' lay in the quality of its participants' commitment to collaboration. So rapidly did 'the Freeze generation'[8] – an epithet derived from the title[9] of their Surrey Docks show – establish a sensational public profile, that the actual experience of together staging this first fully-public group exhibition in Building One is by now enfolded within layers of media myth. What matters in the memory of the artists involved, many of whom have continued the creative patterns established at this time, is not the critical success of

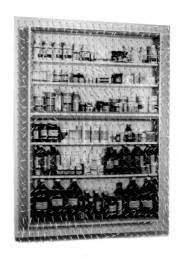

For the exhibition 'Modern Medicine' in 1990 at Peak Freen's disused biscuit factory, Building One in Bermondsey, Hirst and Fairhurst combined their signature devices of the time, chemist cabinets for Hirst and clothing tags for Fairhurst, in a collaborative series of works, this piece titled *Gimme No Colour Shit. Gimme Red.*

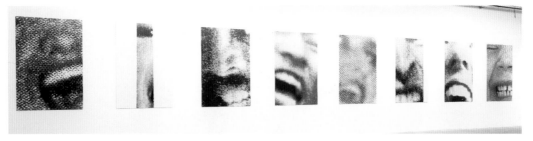

Hirst curated 'Modern Medicine' jointly with a friend from Leeds, Carl Freedman, and with Freedman's undergraduate colleague from University College, Billee Sellman. Fairhurst was invited to display a wall of photographs, all eight titled *Mostly Smiling*.

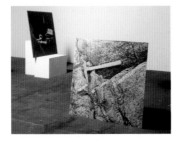

Another Goldsmiths' graduate and 'Freeze' exhibitor, Abigail Lane, also chose to exhibit photographic work in 'Modern Medicine', mounted on aluminium, titled *Prop One* and *Prop Two*. 'For me it's much more powerful to leave things unsaid, or quiet, or empty, than to really go and try and make something shocking or spooky.'

'Modern Medicine', nor its significance in establishing the whole warehouse ethos, but the fact that they took control and enjoyed the feeling of working for themselves. In a vital sense, they still are. The excitement of being an artist, for most of them, remains with the process. It is concerned primarily with creative life: their own, their friends', and the life of the work itself out there in the market place and beyond, even the lives of the collectors and museum curators who by buying the stuff they produce make artistic existence a valid reality.

The Freeze generation has too easily made a name for itself yet to be understood. Commentators' ideological assumptions invariably either miss the point or manufacture one which does not exist. Angus Fairhurst, a veteran freelance maker and performer, convincingly maintains that the attraction of Building One was simply its size, the opportunity to experiment on a scale no commercial gallery could offer. He did not think of his contribution to 'Modern Medicine' as antagonistic to the West End gallery system, but as a pleasurable alternative, as a way of practical exploration of issues then active in his mind and imagination. Sarah Lucas, Fairhurst's Goldsmiths' contemporary, with whom a decade later he shares a studio in Clerkenwell, expresses a similar refusal to be restricted in her creative interest by the financial limitations of established commercial structures: 'Art has

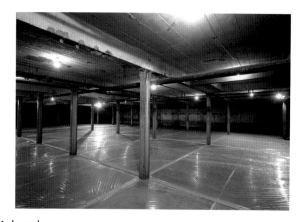

Untitled, Craig Wood's dramatic basement installation, exploring the contrasting and yet collaborative properties of polythene and water

to be something that is totally mine, it can't be taken away from me by lack of money or materials. It is important to me that you can make art out of anything at all.'[10] Or make it anywhere at all, as Lucas has since many times demonstrated. Bruce Nauman, a hero of Hirst's as well as of Lucas', agrees: 'I've always felt I've worked with whatever money's been available and whatever equipment's been available. You just do the work. Using those things as an excuse, like 'I haven't got the money or the equipment or the room', are a bad excuse for not doing work.'[11] Anya Gallaccio, an artist from Hirst's graduate year at Goldsmiths', remembers the spirit of their original endeavour: 'It's about going out there and saying you want something and taking it, not waiting for it to be given you on a plate.'[12] Not Joshua Compston's vocabulary, but his sentiments precisely.

In another part of Building One's basement Fairhurst showed his video of 1990, with no title.

The physical effort of preparing a biscuit factory for the professional display of art, the majority of exhibits conventionally wall-based, was considerable. With Building One, empty for years, and colonised by London's pigeons, Hirst and Freedman set themselves a challenge few possess the combined energy and imagination to carry beyond a daydream. Beneath anarchic exteriors perfectionists at heart, this pair from Leeds took personal responsibility for every aspect of the organisation: raising funds to finance the project; cleaning, restoring and decorat-

Man Abandoned by Colour (1992), by
Angus Fairhurst, photographed in the
studio he at that time shared with Damien
Hirst, whose work stands in the
background.

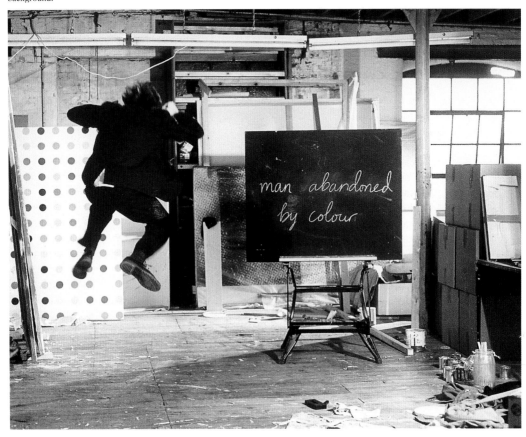

no FuN without U

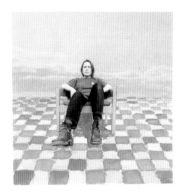

Untitled (1993), a self-portrait collage by Sarah Lucas, one of the key 'Freeze' exhibitors. 'I'm only interested in what I need to know in any given instance, which might be a lot or it might not be very much. When that's achieved, I'll move on. The whole idea of mastery is sort of antithetical to what I do.'

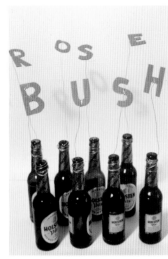

Lucas' *Rose Bush*, which the artist sold from The Shop in Bethnal Green Road, opened by her and Tracey Emin in January 1993.

ing the space; selecting and helping the artists; installing the exhibition; handling the promotion and publicity; printing a catalogue. The headquarters of the operation was Freedman's rented terraced cottage in the wastelands of Greenwich, beside the gasworks subsequently demolished to make way for the Millennium Dome. Far from competing with the galleries, 'Modern Medicine' – and, before Compston's time, 'Freeze' too – received their enthusiastic support, with most of the money to mount the show coming from the Establishment, Lisson and D'Offay, with additional donations from Karsten Schubert, Maureen Paley, Alexander Roussos and Laure Genillard. The artists themselves – Mat Collishaw, Grainne Cullen, Dominic Denis, Angus Fairhurst, Damien Hirst, Abigail Lane, Miriam Lloyd, and Craig Wood – were inevitably the prime contributors, actively engaged in the curators' uncompromising assertion that life and art are indivisible. Together they took the risk of producing work that interested them personally, and of presenting it in a manner with which they, not their elders, felt comfortable. They issued no manifesto, no bloated appeal to posterity, their youthful self-confidence balanced by a mature sense of the conflict and contradiction inseparable from intelligent ambition for change. The introductory text to the catalogue of 'Modern Medicine', unattributed in the spirit of collaboration, exemplifies the wis-

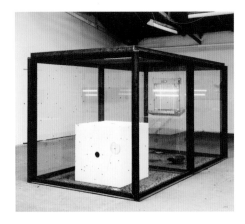

Freedman and Sellman curated a second group show at Building One in 1990, 'Gambler', in which they included Hirst's *A Thousand Years*, the first of his monumental steel and glass cage pieces, modelled on aspects of Bruce Nauman's work in New York.

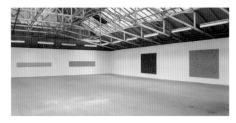

The painters Tim Head (wall on left) and Mike Scott joined the Goldsmiths' regulars in 'Gambler'. Head said in an interview with fellow artist Liam Gillick, published in the catalogue: 'There is a feeling of no more territory to cover. But taking a surface or detail and blowing it up maybe creates some more space. It's a pessimistic view in one sense.'

dom culled from lived experience that underpins the best work of this intriguing bunch of British artists: 'There is a gamble that takes place every day in your contact with other people, that your own logic (the way in which you think or do things) will not contrast too greatly with theirs, otherwise you might not have too smooth a ride. Pitching in your wits against theirs or alternatively bypassing your own conviction in order to placate, in many ways you are involved daily in bartering your actions and thoughts.'[13]

'Gambler' was the title given to the next show at Building One, mounted later the same year. Curated by Freedman and Sellman alone, 'Gambler' included the first of Damien Hirst's monumental statements, much admired by Compston: *A Thousand Years*, a seven- by seven- by fourteen-foot steel and glass case, in one half of which maggots hatch into flies and are drawn, by nature, through a small circular hole in the dividing glass panel to feast on the severed head of a cow, subsequently to die on the electrified bars of an industrial fly killer. 'Being sensational isn't sensational anymore. People do it all the time,' Hirst explained in an interview given to fellow-artist Liam Gillick, printed in the 'Gambler' catalogue. 'The piece will look quite plain.'[14] Aside from his amused irony and the determination to have fun, Hirst's disrespect for the hype surrounding his work seems genuine. Instead of letting the attention distract him he

no FuN without U

Fairhurst's *Choir No 9*, the photograph of a microscopic section of an image in a popular magazine, mounted behind a wall of gel in a wooden box. Fairhurst told Gillick, for the 'Gambler' catalogue: 'The things that affect people's lives are the subject matter of art. Television has ensured that people's experiences are mediated by a feeling that they have something close to a real experience. They have had an element of the horror of Vietnam, for example, just be watching movies or reading a magazine.'

makes use of it, milks the market for the money required to move on to bigger, wilder projects. The important point is to live, to do the work and leave others to write about it. Gillick, an artist whose favoured medium is the spoken word, reveals how he and his friends have thought themselves a step ahead of critical dialogue on the post-post-modern present. 'Why be alternative when the alternative has already become the mainstream, and when everything's turned on its head, and it doesn't make any sense? There's no motivation to act in that way. It doesn't mean anything anymore. None of those terms mean anything anymore, so you might as well go ahead and just do it for real. We were just a group of people thinking 'Well, I'll make the art instead, seeing as nobody else seems to be doing it'.'[15]

Of the art shown in Building One during the trail-blazing year of 1990, Michael Landy's *Market* made the strongest impression on Compston. Set out on a street-like grid across the entire ground floor of the factory, as if in city blocks, Landy created almost a hundred works from steel market stalls, brown plastic bread-trays and an assortment of greengrocer's display shelves, partially covered in artificial grass. Richard Shone, associate editor of *The Burlington Magazine* and ex-Turner Prize juror, wrote in admiration of *Market*: 'The quotidian materials, restricted forms and colours, and the packed, recti-

Freedman's third show of 1990 at Building
One was of Michael Landy's *Market*. 'It was
just a one-off thing, it will never be seen
again. I kind of like that about my work,
that people just don't see it again.'

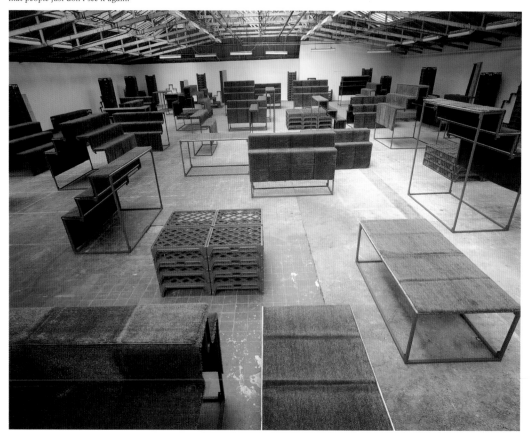

no FuN without U

Landy's *Stack III* (1990) an element of *Market*. Kate Bush wrote in the exhibition catalogue: 'By refusing to idealise or embellish, Landy refamiliarises us with the familiar. he preserves the ordinary indifference of his objects, and presents a situation which is, at the level of appearance, value-free.'

linear layout produced, almost against the odds, an effect of intense fascination, a mood that, curiously, was both bitter and exhilarating.'[16] Landy articulates the political nature of his work, a facet often denied by his Goldsmiths' colleagues. 'Most of my work comes from anger,' he says. 'People don't seem to have ideas, and there's no real ideology anymore. There's just a kind of middle ground where everyone seems to be huddling.'[17] Landy is relentless in his gathering both of information and of material over a long period of time for works in the end often executed on a wondrously large scale. Richard Flood, curator of the influential 1995 show at the Walker Art Centre in Minneapolis, 'BRILLIANT! New Art from London', noted the necessarily obsessive qualities hidden behind the public reputation for hard-partying camaraderie of the Freeze generation: 'In his art, Landy is as daunting and enthralling as the Ancient Mariner, unable to disengage until his dreadful story has been told in its entirety.'[18]

The impact on Joshua Compston of these off-centre events cannot be overrated. Five or six years younger than most of the artists involved – Hirst was born in 1965, Fairhurst in 1966, Landy in 1963, Compston not until 1970 – and beginning to emerge from his more constrained social background, he embraced this new-to-him art culture with arms and heart and mind all open. 'More pages of my crum-

pled soul,' he began – on 23 July 1990 – a new journal. 'Yet I bear it, and make repairs ... Weakness bedevils me. I am never tired and yet always seek to sleep since I do not wish to exist. Guilt plagues me. I potter, dash off some inadequate letter in the hope that I may disturb someone's complacency to unroll and heartily, dangerously *communicate*.'

Inspired by the transformation of Building One, Compston typically first set his sights on the physical improvement of the environment in which he spent most of his days: Somerset House, on the Strand, home of the Courtauld Institute of Art. Thus in the course of 1990 he hatched a magniloquent plan to fill the sombre Georgian rooms, halls, stairwells and passageways of Sir William Chambers' much-altered masterpiece with a loan collection of contemporary art. He set about this task with near-desperate commitment, as revealed in another diary entry, for 28 November 1990: 'It is vitally important for my health: it will be my only creative act of significance in the past two years. Once completed, even if only temporarily for a year, it may help me to believe again in the power of the individual.'

'I thought it immoral not to work among art while studying its history; frightening to contemplate the near future when Courtauld graduates were to be given curatorial responsibilities when many of them would have had no direct experience of contemporary

no FuN without U

art,'[19] Compston wrote in a memorandum of January 1991. By then he had already persuaded the collector Jeremy Fry, together with one of Fry's protégés, Natalia, Duchess of Westminster, to pledge £40,000 towards the purchase of works by young British artists of his choice, which, together with loans promised from the art-world luminaries Howard Hodgkin, Peter Blake, Albert Irvin and Gilbert and George, were to form the basis of a permanently developing collection for display in the student rooms of the Courtauld. With his established passion for printed records and with the Sellman, Hirst and Freedman example to follow, Compston planned to raise further funds to publish a catalogue of the inaugural exhibition scheduled, in his mind, for the opening of his final undergraduate year in September 1991: 'In keeping with the spirit of the exhibition, it may be possible to commission a young designer and a young photographer to work on the catalogue. Such an item, if successful, could constitute an 'art object' in its own right.'[20] As was soon to become his usual practice, Compston also declared ideological warfare on the art Establishment: 'Through this exhibition I hope to question the unfortunate timidity of most public galleries ... [It] will demonstrate the multifaceted attractiveness of a vigorous acquisition policy, the necessity of private patronage and the sheer improvement works of art make to a building.'[21] In

these public statements a language began to evolve to match the intuitive idealism of a young man, who had been unable to read or write a word before his tenth birthday, at this stage of his meteoric flight still only twenty years old:

BUSINESS DESCRIPTION

The intentions and ultimate aims of Factual Nonsense are manifold since they aim towards a complete commercial, intellectual, moral and political dominion. To summarise the intention of its initiator and main operator, Joshua Compston, is to create a trans-world corporation, with holding and controlling interests in property development, media communications, retailing and industrial production, that differs from existing concerns in two vital areas:

1 All that it sells, promotes, manufactures or manages must observe the dictates of Modernist idioms; particularly as revealed and manifested between the years circa 1890 and 1940. This will apply as much as to the design of staff uniforms as to the typography employed in the annual company reports, as to the design of its factories.

2 It will be a model organisation in that it is ethically conscious towards not only its employees, involving to a large degree shop floor participation at boardroom level, but moreover the effects of its products (and waste) on society, its role as an arbiter, originator and

upholder of value judgements and its position
as an educational font. It will therefore extensively
sponsor and encourage the role of enlightened
education as the fundamental lynchpin for the
formation of the future.
It should be noted that it wishes to achieve all these
objectives while making a financial profit. A suitable
motto might be capitalism of the moral avant-garde.[22]

This was for the future. For the present Compston
operated within the confines of institutional life, and
a letter from Dr Dennis Farr, Director of the Cour-
tauld Institute Galleries, soon made clear to him the
limitations this imposed on his spirit of enterprise.

University of London
Courtauld Institute Galleries
Somerset House
London WC2R ORN
Telephone: 071-873 2526/2538
DF/EC
15 March 1991

From the Director: Dr Dennis Farr CBE

Dear Joshua Compston
Your Courtauld Loan Institute Collection paper and its
accompanying Projections dossier, of February and

March 1991 respectively, has been brought to my attention. I have discussed the matter with Professor Kauffmann and we are agreed on the following points:

1 You will cease your fund raising efforts forthwith, please;

2 You will be kind enough to furnish Mrs Jane Benson of the Sponsorship Office with a list of people/institutions to whom you have sent letters requesting support.

Let me say, at once, that in principle we approve of your idea of trying to encourage young artists, and to show their work in the Committee Rooms and on the back stairs of the Institute, subject to certain precautions.

However, you are using the Courtauld Institute's name in an improper way, and you also make some very questionable assertions in your letter. I am particularly saddened to read your allegation that students are now 'disabled' since the removal of all the art to the Galleries, as the whole point of putting the Institute and the Galleries under one roof at Somerset house was to return to a situation where the two halves, so to speak, were in much closer proximity. The Bonnards were removed to Woburn Square in 1958, along with the rest of the Courtauld paintings. If you were of my ancient generation of Courtauld undergraduates, you would have enjoyed studying among Cézannes, Renoirs etc. at 20 Portman Square, but the situation could not continue

no FuN without U

Gilbert and George's postcard piece *Niche World* (1989), borrowed by Compston from the artists for his Courtauld Loan Exhibition in 1991, organised during his second undergraduate year, reading History of Art. 'Incredibly, historically it is believed that this will be the first exhibition of contemporary art to be held in Somerset House since the Royal Academy of 1836,' Compston wrote in his press release.

because a) public access was practically nil, and b) security would have been a nightmare.

I think you will find Alan Bowness would take exception to your remarks about the Tate's Patrons of New Art.

Finally, by sending out letters soliciting for financial support under the Courtauld banner, you are cutting across the work of the Sponsorship Office, and you have already caused acute embarrassment with people who are otherwise well-disposed towards us. Hence this rather stern letter; but you must understand the wider consequences of your actions.

If you have persuaded some artists to lend a few paintings then this could perhaps serve as a pilot scheme; but your more ambitious project must be shelved for the time being.

Yours sincerely
Dennis Farr

Despite realistic self-doubt – 'My madness is not irresponsible though it does strike me as highly irregular. What am I doing? Sometimes I struggle not to drown under the overwhelmingly ambitious position that I have placed myself in,' he noted in his diary on 26 March 1991 – Compston could not easily be dislodged from his crusade. On 23 April he wrote to an ex-Sotheby's ally, enclosing a copy of the Farr letter: 'I

Damien Hirst *ATT Media Supplement*
(1991), gloss household paint on canvas,
sold through Compston to the Cologne
dealer Aurel Scheibler. A work from the
same series was included by Compston in
his Courtauld show. 'I come from Leeds,'
Hirst said, 'where people have the idea that
you paint how you feel. If you're depressed,
you do a big brown and purple painting. If
you're happy you do a red and orange and
pink painting. So I just created a structure
which doesn't allow that to work. No
matter what you do, if you're working
within that structure – which is quite
scientific, a grid with evenly spaced dots –
you always get a happy-looking result. It
was the idea of art without the angst.'

only received this letter last week as they sloppily sent
it to the wrong address. I actually found it rather con-
fused and totally indefensible ... Thus I am currently
gathering my considerable defences together.'[23]

By this time Compston had added Gilbert and
George to his growing band of supporters. A part-
time lodger at the house of decorator Jocasta Innes in
Heneage Street, the other side of Brick Lane from
Gilbert and George's Spitalfields home, with his cus-
tomary directness, he had knocked on their door to
offer himself and his mother's disobedient bull terrier
as photographic models. Rejecting the dog, Gilbert
and George were drawn to Compston's intellectual
intensity and to its taut exposition on his face and
body. The photograph they took of him, naked, bal-
anced upside down on his back on a bench, legs in the
air, head hanging down to the ground, featured larger
than life at the apex of *Naked Dream*, a work first
exhibited in 'New Democratic Pictures' at Aarhus
Kunstmuseum in September 1992. In an essay for the
catalogue of this show, Andrew Wilson wrote of
Gilbert and George: 'They believe that the role of the
artist should not be just a matter of reproducing what
is visible but rather to render visible a vision ... The
will to power and change that Gilbert and George
make visible in the 'New Democratic Pictures' is one
that is founded on a spiritual intoxication and the
capacity to dream, an overabundance of force, energy

Fiona Rae *Untitled (blue and yellow)* (1991), which Compston persuaded the Duchess of Westminster to buy, for long-term loan to the Courtauld Institute.

and life.'[24] The same was true of Joshua Compston, to whose request for weaponry with which to counterattack Dr Farr they responded: 'We write to confirm our intention to lend you an Art-Work for the Courtauld Institute Loan Collection. We really think your idea to bring the art of living breathing Artists to this necrophillic and backward looking establishment is brilliant and culturally important.'[25]

Gilbert and George were right: this was an extraordinary young man who had entered their lives, like themselves not easy company, and never at rest from the struggle. But as George had pronounced in an interview given for the Gilbert and George extravaganza in Moscow the year before: 'Civilisation is not 'advanced' by lying on a beach with a gin and tonic. Everything is subservient to the art, in fact, and everything has to fit around it.'[26] In the mouth of Gilbert and George Compston thus heard the language in which, until then, he had conversed solely with himself. It was the beginning of the end of his debilitating sense of isolation; from that moment onwards he was usually able to focus his inner gifts on positive action, on polemic with a purpose; the violence of his fear of remaining forever misunderstood shifted targets.

The feeling of danger enveloping Joshua Compston, however, never lifted. Those who came to care about him, who persevered in their efforts to comprehend the wild complexity of his convictions, always

Compston made close friends with Ben Langlands and Nikki Bell, who have worked in partnership since graduating from Middlesex Polytechnic in 1980. Compston exhibited their relief *The Council of Europe* (1990) at the Courtauld.

Ian Davenport *Untitled* (1988), borrowed
from Waddington Galleries for the
Courtauld show.

Magnolia VI, *Magnolia VII* and *Magnolia
IX* at Gary Hume's one man show at
Karsten Schubert's gallery in Charlotte
Street, Fitzrovia, in June 1989. Compston
chose a similar Hume work for the
Courtauld Loan Exhibition in November
1991. Hume was to participate in all the
performance events later organised by
Compston in the streets around the artist's
Shoreditch studio-home.

feared for him. Tracey Emin's 'main fear for Joshua
was that he seemed the perfect candidate for sponta-
neous combustion ... Idealism was his main fault, or
more to the point, his lack of reality.'[27] On the other
hand, Emin was among the first of her generation of
young London artists to recognise the congruity of
Compston's presence, the genuineness of his beliefs
beneath the bombast. Unlike Gilbert and George,
whose response to feeling alienated when students at
St Martin's Art School was to invent a single artist
being for their two separate personas to inhabit joint-
ly, Compston materialised in the art world fully and
singularly formed. Implausibly ambitious and vision-
ary though many considered his Courtauld plans to
be, they were, by his account, based on utter reality,
on the plain truths of his lived and felt experiences.
He was, in his own eyes, not an artist but an aircraft
carrier steaming through the ocean storms, a stage for
artistic endeavour from which to take to the skies,
and return to as a safe place.[28] Compston seemed to
be one of those people whom the novelist and art his-
torian Anita Brookner describes as 'the happy few
who remain emotionally alive, who never compro-
mise, who never succumb to cynicism or the routine
of the second hand. The happy few are not necessari-
ly happy. But they are never corrupted and seldom
bored. The happy few possess what Baudelaire calls
'impeccable naïveté', the ability to see the world al-

Guy Moberly's portrait of Joshua Compston in the Committee Room at the Courtauld Institute; Rae's *Untitled* hanging on the wall behind.

Compston talking to Lord Palumbo, then Chairman of the Arts Council, at the private view of the Courtauld Loan Exhibition on 27 November 1991.

ways afresh, either in its tragedy or in its hope. For the happy few, art and life are indistinguishable.'[29]

Predictably, the Courtauld Loan Exhibition went ahead on a reduced scale – 'a distilled concentration'[30] – later than intended and without a catalogue, its well attended private view taking place on 27 November 1991. Among the younger artists whose work Compston borrowed for the show were four of the original Goldsmiths' exhibitors at 'Freeze' in 1988: Ian Davenport, Damien Hirst, Gary Hume and Fiona Rae. (This was not as inspired a choice as it might appear, for all four had by then been discovered by others, Rae and Davenport seen at Waddington, Hirst taken up by Jay Jopling, and Hume lauded for his two solo shows earlier in the year at Karsten Schubert's prominent gallery). 'This evening's private viewing of the first Courtauld Loan Collection is primarily the result of a horror vacua experienced more than a year ago when faced with seminar rooms of such bareness, that the eye and mind revolted,' Compston wrote in the information sheet handed out by a bevy of helpers to his guests. 'I therefore decided, by hook or by crook, to find some contemporary art to destroy all vestiges of such nudity, and by this act restore to its rightful position art in everyday surroundings.'[31]

In truth, as he knew it, a mere marker for the future had been laid. 'A witty will to power, I hope!'[32] he

Guests at the Courtauld show, including the dealer Kasmin.

Compston cleaning up after the Courtauld opening party, beside Langlands & Bell's *The Council of Europe*.

Damien Hirst's 1991 solo show 'In and Out of Love' incorporated the birth and first flight of exotic butterflies. 'I am interested in realism. I want art to be life but it never can be.'

privately proposed to a friend. To himself he continued his visionary rant: 'Occasionally I am terrified of the part I want to play and the scale I think on … Every day I try very hard to save my colleagues at the Courtauld. As bait I use the words Love, Belief, Freedom, Fearlessness … I am absolutely convinced I must continue my efforts towards some intelligent cultural anarchy. Aim to prune and to decorate at the same time. Though I think I will soon be wealthy, influential and famous I will not change one dot or iota.'[33]

Meanwhile, young artists continued to make their mark on the art world. Damien Hirst held his first solo West End show, in a vacant building in Woodstock Street, organised by Tamara Chodzko, wife of the artist Adam Chodzko, and Thomas Dane, the private dealer later behind the first corporate collection to focus exclusively on the Freeze generation, formed since 1993 by London solicitors Simmons & Simmons. *In and Out of Love* Hirst titled his installation: in cloying heat a host of Malaysian butterflies hatched from pupae stuck on to white canvases hung on the walls, and flew about feeding on the exotic flowers growing in pots ranged on ledges beneath each living picture. The critic Stuart Morgan remembers this work as 'a visual miracle: creatures which might have been taken for dead suddenly stirred, fluttered, sailed through the air, and, as they alighted, changed the existing pattern on whatever surface

no FuN without U

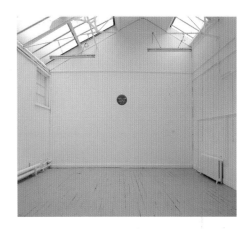

For his degree show at the Royal College of Art in 1991, Gavin Turk presented *Cave*, clearing the studio of the year's other work and mounting on the wall a ceramic heritage plaque. Turk and Compston met soon after this, and formed a close friendship.

they chose.'[34] This was the effect as designed by Hirst: 'I wanted these paintings to be more than a De Kooning painting, where the colour leaps off the canvas and flies around the room.'[35] On another floor he hung canvases thickly painted with single primary colours, embedded in which were dead butterflies, wings spread in halted flight. 'No questions and no answers just instability. I'm perfectly happy with contradictions. I try to say something and deny it at the same time,'[36] the artist argued with a crowd of Animal Rights protestors in the street outside.

In the summer of this same year, 1991, an artist who was soon to become a close friend of Joshua Compston's and a regular collaborator at Factual Nonsense, Gavin Turk, was due to graduate with an MA from the Royal College of Art, Kensington Gore. For his degree show Turk produced *Cave*, a single work of iconic significance. High on the tongue-and-groove boards at the centre of the pitched roof of an otherwise empty, immaculately clean studio he placed a blue and white ceramic pseudo-heritage plaque inlaid with the legend:

<div align="center">

BOROUGH OF KENSINGTON

GAVIN TURK
Sculptor
worked here
1989 – 1991

</div>

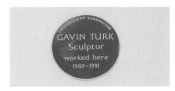

1.37 Detail from *Cave* (1991), which exists only in photographic memory. The plaque itself was exhibited in 'Gavin Turk. Collected Works 1989–1993' in a glass cabinet, titled *Relic (Cave)*, later reproduced as an edition of three and exhibited in 'SENSATION' in 1997, described in the catalogue: 'By beginning his career with its metaphoric completion – in effect memorialising it – Turk announced his artistic programme: a critique on authorship and the myth of "the artist" within the history of the European avant-garde.'

Despite the visual power of Turk's statement, immediately recognised by fellow artists for its subversive brilliance, the Royal College of Art's Academic Board for Concessions and Discipline along with its Final Examination Board decided Turk had 'displayed insufficient work of the standard required for Final Examination'[37] and after interviewing him a second time, refused to award an MA certificate. The then-Principal of the Royal College, Jocelyn Stevens, left soon afterwards to run English Heritage. Turk secured representation by Jay Jopling and the patronage of the decade's dominant collector, Charles Saatchi.

As Compston was quick to appreciate, the point of *Cave* was very different from its subsequent perception. For instance: the building in which Turk and his fellow students worked was due to be demolished at the end of that term. Internal and external reality was, in fact, about to cease to exist, making the realistic blue plaque a knowing statement about Englishness, about the disguise of emotion, blatantly formed in the by-then Establishment language of Surrealism. Turk, Compston intuitively realized, had no intention at all of failing his degree, his purpose serious and, in the same moment, amused. Becoming a vaunted Saatchi-artist was part of the fun.

During the month of August, nearby in Kensington Gardens, the Freeze generation was enjoying its first

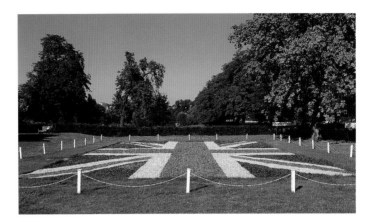

exhibition in a major public space, 'Broken English', selected and catalogued by Andrew Graham-Dixon for the Serpentine Gallery. On this occasion the ex-Goldsmiths' graduates Angela Bulloch (subsequently short-listed for the 1997 Turner Prize), Ian Davenport (short-listed for the 1994 Turner Prize), Anya Gallaccio, Damien Hirst (winner of the 1995 Turner Prize), Gary Hume (short-listed for the 1996 Turner Prize) and Michael Landy were joined by Sarah Staton, a graduate of St Martin's, and Rachel Whiteread (winner of the 1993 Turner Prize), who had studied at Brighton Polytechnic and the Slade School of Art in London. Graham-Dixon felt that the work he chose demonstrated a generational desire to break free from the parochial concerns of earlier modern British painters, architects and composers, most of whom were over-influenced by classical images of the Arcadian landscape. 'These artists have found, in the wreckage of the modern art tradition, not a dispiriting ruin, but a source of stimulation,' Graham-Dixon wrote. 'They have not been discouraged, but provoked, by the multitude of languages available to them. They recognise the fragmented nature of their inheritance and find an alibi in it for their own freedoms.'[38] He was aware, however, that although they spent social time together as well as helping out in each other's studios, these were highly individualistic producers of art work, united in

In 'Broken English' at the Serpentine Gallery in August 1990, the soon-to-be-notorious young British artists received their first museum show. On the lawn outside, Sarah Staton made a vast Union Jack with crushed glass delivered to Kensington Gardens from a west London bottle bank in skips. 'Laying it out in the rain felt like some kind of agricultural activity, like planting,' Staton said. 'Sober but pleasant.'

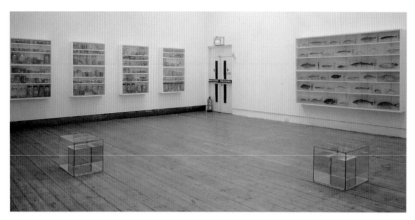

Hirst's contribution to 'Broken English' was *Isolated Elements Swimming in the Same Direction for the Purpose of Understanding (left)* (1990), here seen the month before, in 'Louder Than Words' at the Cornerhouse in Manchester, together with works from his 'Internal Affairs' series.

friendship not aesthetics. Comparison between the exhibits of Gary Hume and Damien Hirst illustrates their generic differences. At this stage in his career Hume was still engaged on a potentially limitless series of paintings, executed in household gloss on board, modelled on measurements taken of doors in St Bartholomew's Hospital. 'It wasn't about illness, it was about a democratic use of the symbol of the door. I had to use a totally democratic door. That's a hospital door … the institution of the hospital won't care whether I'm Gary Hume the artist or Gary Hume the dustman. At the point of crisis I will be passing through those doors, so I wanted to make them democratic. I'm not naming the political but the human.'[39] By physical contrast, Hirst exhibited *Isolated Elements Swimming in the Same Direction for the Purpose of Understanding*, thirty-seven different species of fish bought one morning from Billingsgate Market, suspended in individual tanks of formaldehyde and ranked nose to tail on shelves behind sliding glass doors. The artist again signalled his delight in confusion and controversy: 'I really like these long, clumsy titles which try to explain something but end up making things worse, leaving huge holes for interpretation.'[40]

Compston's next public venture was the organisation of a West End exhibition for an older artist friend, David Taborn, at the Grob Gallery in Dering

no FuN without U

Street, from 28 February to 4 April 1992. A family contact, Taborn had introduced Compston to many of his most virulent modernist principles. Among the large abstract canvases exhibited at Grob were two particularly impressive pictures, *Factual Nonsense* and *A Guide for the Perplexed*, titles which Compston requisitioned later in the year for, respectively, the art premises he opened in Charlotte Road, Shoreditch and his inaugural show. Taken from Taborn's extensive readings of Wittgenstein, the title Factual Nonsense – or FN as Compston desired his corporation to be known throughout the universe – was perfect for his purposes: 'a mixture of exclusion and inclusion, it's a deliberately annoying name.'[41]

Compston was no philosopher, his thought processes too desperate, too immediate for ordered exposition, and any alignment with Wittgenstein is arbitrary. Along with many other young men of every generation Ludwig Wittgenstein had volunteered to place himself in mortal danger in his search for meaning. 'Now I have a chance of being a decent human being, for I am standing eye to eye with death,' he wrote from the trenches of the First World War. 'Perhaps the nearness to death will bring light into life.'[42] On leaving school Compston had similarly gestured to the devil, by journeying to San Salvador to make himself into a revolutionary: 'I wanted to join the guerrillas. I wanted to die.'[43] The

shallow romanticism of this gesture was unmasked when he took up with, not the gun, but a dusty heiress and spent his summer night-clubbing – useful training for keeping pace with young British artists in his London life to come.

The term Young British Artists – shortened by the art tabloids to YBAS – gained currency through the first exhibition so-named at the Saatchi Gallery, which ran from March to October 1992, featuring the work of John Greenwood, Damien Hirst, Langlands & Bell and Rachel Whiteread. This was the show in which Hirst unveiled *The Physical Impossibility of Death in the Mind of Someone Living* (1991), a fourteen-foot tiger shark lolling in a sea-green tank of formaldehyde. No less impressive in the wide white spaces of this renovated factory was Whiteread's *Ghost* (1990), the plaster cast of a room in a house on the Archway Road, mounted inside out, in texture, shape and sensibility like a tomb transplanted to the advertising magnate's collection from some forgotten cemetery. 'I wanted to mummify the sense of silence in a room,' Whiteread has said, 'to create a mausoleum to my past and also something to which others could relate – like the room in the Victorian house where I was born.'44 Langlands and Bell were already friends of Compston's, invited to join him not only professionally, by exhibiting their work at the Courtauld, but also for

row-boat picnics on the Thames. Whiteread, Hirst and Langlands & Bell were all included in Paragon Press' concurrent publication of a group portfolio of prints entitled *London*, notable for *Gavin Turk Right Hand and Forearm*, the artist's first screenprint, and for the appearance of a significant new name, Marc Quinn, who missed the peer-influences of art school by reading History and History of Art at Cambridge University. In Quinn's *Template for my Future Plastic Surgery* a photographic portrait of the artist was improved upon by the superimposition of plaster casts of body parts from envied sources: the ear of a violinist; the nose of an impresario; the tongue of a chef; the hand of Quinn's lover over his heart; and, in place of his brain, a piece of coral.

In spite of his fierce childhood resistance to learning to read, Compston grew up to be a high academic achiever (handwriting remained torturedly child-like all his life), that summer effortlessly adding a BA (Hons) degree in History of Art to his ten 'O' Levels and four 'A' Levels. Before the ink was dry on his final examination papers, he had already moved full-time into the art world. Hearing of the vacancy of the ground floor of a Victorian furniture factory in Shoreditch, Compston returned to his main benefactor, Jeremy Fry, for finance; this time to seed-fund a permanent 'gallery and project centre, … a forum for all elements disenchanted with the laxity and ennui

(overleaf) The Paragon Press published in the spring of 1992 a group portfolio of eleven screenprints, in a numbered edition of 40, under the title 'London'. Fifteen young artists were originally chosen, all of whom at that time lived and worked in London. Ian Davenport and Fiona Rae were unable to contribute due to gallery commitments, while Angela Bulloch and Gary Hume declined the invitation, leaving a final line-up of Dominic Denis, Angus Fairhurst, Damien Hirst, Michael Landy, Langlands & Bell, Nicholas May, Marc Quinn, Marcus Taylor, Gavin Turk, Rachel Whiteread and Craig Wood. Two years later Compston curated for The Paragon Press an equally significant portfolio, 'Other Men's Flowers'.

Langlands & Bell, *UNO City*.

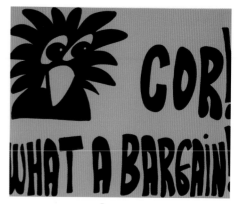

Michael Landy, *Cor! What a Bargain!*

Damien Hirst, *Untitled*.

no FuN without U

Rachel Whiteread, *Mausoleum under Construction.*

Gavin Turk, *Gavin Turk Right Hand and Forearm.*

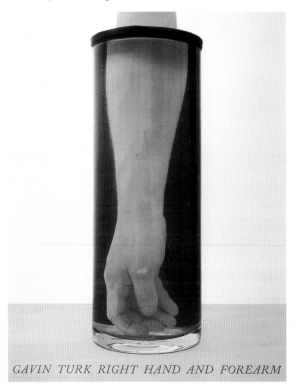

GAVIN TURK RIGHT HAND AND FOREARM

Angus Fairhurst, *When I woke up in the morning, the feeling was still there.*

Marc Quinn, *Template for my future Plastic Surgery.*

Joshua Compston moved to Shoreditch in the summer of 1992, taking a lease on the ground floor of 44a Charlotte Road, a furniture factory, little altered from this 1929 photograph.

At the rear of 44a Charlotte Road in 1929 was a timber yard.

of current thinking.'[45] With the lease on 44a Charlotte Road agreed to run for three years from 1 October 1992, on Saturday 18 July he obtained in advance the keys to his future, and immediately set about the physical creation of Factual Nonsense.

Impatient for a continual public presence, while the artist David Taborn laboured over the construction of a new gallery space, Compston occupied himself curating a bizarre summer show at the Benjamin Rhodes Gallery in New Burlington Place. A letter to a friend, dated 17 July, communicates his exuberance of the moment:

> Veni, Vidi, Vici: such is the logo/motto on the Marlborough packet which I noticed the other day and I am sure it carries a sinister portent. My skin is in a dreadful state and I could be so aged as I have not stopped or stalled for many months now; so much battling against the common real, and the gut splitting desire to keep up mercilessly a total and pure fearlessness of thought and Aktion. More, to make this into a creed so that others may withdraw any remnants of their rusty swords; being 'claro' pure thought and brave jocular humanism!
>
> I had thought of writing you a sensible, more sedate but still a loving (agape?) letter but since I look now over the rising dawn and not too much commercial noise, the first flor de cana and my ears scream with the combined

no FuN without U

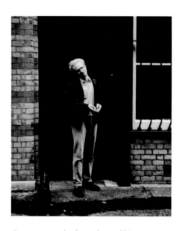

Compston at the front door of his new home, preparing for its transformation into the art business Factual Nonsense, 'purveyors of the ND(SFM) Notorious Dream (Struggle for Modernism)'.

horror banality of a radio chat show and stories of grand suspension and Bunuel film set 'real-time' of Auschwitz; I recall that not since my last intense affair (I spilled blood over this one!) have I attempted to write such an epistle that aims to work in a manner similar to that desperate emotional ambition as practiced by Kandinsky and all those I deal in today(!).

I had not forgotten you but you caught me disarmed and shattered after my Kitsch tour. The chosen areas were so demeaning and limited to a mere – but deeply dangerous – mythology of cliches, the house a bastardized mixture of low class capitalist Romanticism – 1930s Tudor and in the Indian areas Saree style – that I lost some faith and was angered more since though I have known such areas and deliberately cultivated a strong relationship with the streets since I was 13; however my mind being so occupied with abstract matters of art and my own quest for power in the last few years that I had completely forgotten the extent of the disease. It is nothing less than a disease and a stunning foist that has deep and cunning roots. 'All reality being Kitsch' – not my latest fad or speculation but an absolute conviction. A SURETY as sure as Miro knew that two and two do not equal four …

I am essentially so utterly prepared to be a martyr. It is this 'greater inner freedom' which cares not for anything but itself and it must therefore be at least fun

While the exhibition space was being constructed at Factual Nonsense, Compston curated a show at the Benjamin Rhodes Gallery in New Burlington Street, titled 'Abstractions from Domestic Suburb Scene (Sin)', running from 13 August to 4 September 1992.

Compston in active research for this show, at a discount carpet store.

and enervating for those I would like to display it to. Better than Damien's butterflies in any case. It'd better be! So achtung – you have kicked open an ant's nest, a real person who cries in an amused power craze in a wilderness but thank God knows exactly what he is doing. What it would be to be profoundly ignorant!! Ridiculous denominations like curator, dealer, lover, critic, dustman fall away, there is only the Real. Except of course that this is so rare that most live according to known coinage.

A dose of Wild Reason/Factual Nonsense must now be ushered in … I desire nothing less than a vicious volte face of firstly 'the art world' and then later the time when people awake and start to destroy all the form compromises that surround them. Lots of dynamite and honorable suffering therefore. So rather than adopting a St Jerome I decided to emerge and try and subvert their language with some of their own cyanide…

Under separate cover I have enclosed the Henry Bond 400 Photographs, very desperate wannabee avant-garde but I do actually quite like it. It is the least I could give you if you want it. Most abstract paintings of any salt do not as a natural law reproduce well but take a look at this private view card of Sam Crabtree, an artist I am in the process of putting on my books. He only paints four or five works a year, all very large and growing stridently in their colour. I am to give him his first solo show next year and everyone else can perish if they don't see what I see.[46]

no FuN without U

'The exhibition "Abstractions from Domestic Sub-urb Scene (Sin)",' Compston wrote in the catalogue, 'consists of more than a dozen London art students and recent graduates who make work that is directly engendered by, or metaphorically linked through allusion to, the domestic environment/Kitsch capital-ist reality of the last thirty years.'[47] As well as work by the chosen artists Compston displayed commer-cial objects and materials, distinguished from the art exhibits by fluorescent market-stall-type labels printed with the slogan 'NOT ART NOT APPROPRIA-TION'. Compston also designed a twenty-foot-long heat-welded plastic banner based on the work of Van Doesberg and Mondrian, to hang in the gallery window. The 'catalogue' was a letterpress-printed poster-size broadsheet stuffed with Compston's high-octane polemics, modelled in style and content on Wyndham-Lewis' Vorticist publication *BLAST!* 'Of course some of the exhibitors may disagree with what I have written,' he graciously acknowledged. 'But since I will only be proved right if, say, the whole of Hounslow is actually demolished and replaced with a human and hybrid Modernism those who do disagree have a better chance to suffer with Bragg than I probably ever will. My love to them.'[48] The designer of this amiable tract, Tom Shaw, became a fixture of the Factual Nonsense scene, con-tributing many of the signature images of the FN

For display in the foyer of the Benjamin Rhodes Gallery, Compston designed a heat-welded plastic banner in the manner of Van Doesberg, bearing the legend 'Avant-Garde and Kitsch'. On the wall at the back hangs *Palettes* (1992), by David J Smith.

On his travels through the 'domestic suburb scene' Compston gathered examples of contemporary commercial manufacture, displayed at the exhibition on this neo-regency corner table.

A dozen art students and recent graduates contributed to the show. Caroline Gregory, from the co-operative A.P.C. exhibited *Cosy Round The Hairpiece* (1992).

aesthetic. Compston recognised this fact in typically extravagant fashion: 'All power to the native charm and ideas of the printer and typographer of this document, Tom Shaw, who has enabled a number of 'crises of consciousness' to occur and will continue to do so. We struggle for Agape all.'[49] (Agape, as defined by the Shorter Oxford English Dictionary, is a love-feast held by the early Christians in connection with the Lord's Supper.)

On 15 October 1992, exactly a week before the opening of Factual Nonsense, Compston was one of thirty friends invited by Gilbert and George to attend their 100th Birthday Dinner, given on the day their combined ages – George was born in Devon in 1942, Gilbert in the Dolomites in 1943 – reached a century, the nine courses washed down with nine different vintage wines, the last an Armagnac of 1893, one hundred years-old. The menu boasted, in the centre of its felt-tipped opening border, a biblical quotation:

27 But Rab-shakeh said unto them, Hath my master sent me to thy master, and to thee, to speak these words? hath he not sent me to the men which sit on the wall, that they may eat their own dung, and drink their own piss with you? (2 KINGS, 18)

no FuN without U

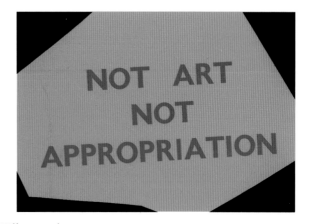

With due reverence to art in all its forms, Gilbert and George named the chef Sylvain Ho Wing Cheong below this quote, whose all-fish meal at La Gaulette in Soho delighted their guests, ranged in facing-fours at four tables, with Gilbert and George seated always in the centre, changing places at each course to a new side of a new table, supported by a waiter's gentle hand at the elbow on the final benignly inebriated moves. Joshua Compston was the youngest person present at this memorable ritual. Nobody else took more seriously than he the tenth of 'The Ten Commandments of Gilbert and George':

Dayglo signs were used to distinguish the bought from the made exhibits in 'Abstractions from Domestic Suburb Scene (Sin)'.

<p style="text-align:center">X</p>

<p style="text-align:center">THOU SHALT GIVE SOMETHING BACK</p>

We identify with anyone who has given his life, abiding by the traditional idea that we are not here to please ourselves or to make ourselves happy. In exchange for the gift of life we have to give something back.

We would not say that we are anything other than what people say we are. Let us experiment together with the viewer. We do not know whether it is all for the best, but who does? We are all lost.

We are all here by mistake, don't you think?[50]

two

Contradiction is the nature of Gilbert and George's life – 'Gilbert and George is singular. They are he.'[1] – and all his/their statements are double-edged, communicating at the same time opposite messages. Though two different people co-occupy the edifice of Gilbert and George, it is impossible to tell what either individually thinks about the remark 'we are all here by mistake.'[2] For everything they do and say, even if alone, is designated a mutual work of art:

London 1970

Gilbert and George, the sculptors, say:

> WE ARE ONLY HUMAN SCULPTORS
> We are only human sculptors in that we get up every day, walking sometimes, reading rarely, eating often, thinking always, smoking moderately, enjoying enjoyment, looking, relaxing to see, loving nightly, finding amusement, encouraging life, fighting boredom, being natural, daydreaming, travelling along, drawing occasionally, talking lightly, tea drinking, feeling tired, dancing sometimes, philosophising a lot, criticising never, whistling tunefully, dying very slowly, laughing nervously, greeting politely and waiting till the day breaks.[3]

OPPOSITE Joshua Compston's head and hand in a Gilbert and George cardboard cutout made by Shoreditch artists Sue Webster and Tim Noble for their stall at Factual Nonsense's second Fête Worse Than Death, held in Hoxton Square in July 1994.

A bashed tin can bearing Webster and Noble's 'British Rubbish' emblem, for their show with this title at the Independent Art Space in June 1996. The catalogue was designed by Tom Shaw.

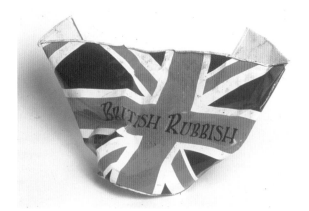

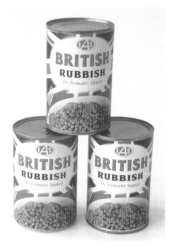

Webster and Noble's 'British Rubbish' baked beans.

Gilbert and George each made a decisive choice in becoming an artist. To counterbalance the accidentality of conception? To cut themselves off from the feelings many creative people retain of having been brought to life by a random act of barely-love between a couple of strangers? In physical terms most of us probably are here by mistake: the core truth of Gilbert and George's provocative Tenth Commandment. It is this pushing of the viewer up against uncomfortable perceptions which connects younger British artists to Gilbert and George. Jake and Dinos Chapman, for example, worked as studio assistants to the 'Singing Sculptures'[4] in the early 1990s, prior to producing their own now-notorious mutant mannequins. In the catalogue of their June 1996 show at the Independent Art Space, 'British Rubbish', Tim Noble and Sue Webster imposed their heads on to several images of Gilbert and George, with particular reference to *Magazine Sculpture*, first exhibited at 15.00 on Saturday 10 May 1969 to an invited audience at the Robert Fraser Gallery in Covent Garden: smiling colour photos of the two then-young artists, with cut-out letters pinned to their suit jackets reading 'GEORGE THE CUNT' and 'GILBERT THE SHIT'. One of the Webster/Noble versions was captioned, in honour of their mentors: 'Everything you have ever done since the day you were born was because you wanted something.'[5]

no FuN without U

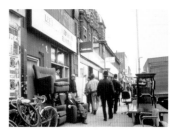

Joshua Compston's friendship with Gilbert and George helped establish his credentials among the new generation of artists with whom he sought to collaborate. During his summer of preparation for the opening of Factual Nonsense he was also supported in these ambitions by the companionship of the influential dealer Maureen Paley. She introduced him to many of her art-world contacts, including the Cologne dealer Aurel Scheibler. Compston wrote a catalogue essay for Scheibler, 'attempting to embody the violent meeting of planes/grating sheets that Factual Nonsense could signify.'[6] Determined to distance himself from his academic past, he insisted on: 'A Key Comment (lest we proceed in the wrong direction): Scholarship and art criticism (that clownish interpretation) have a value but the travesty of anchors, pins and bondage bandages in the field of art have yet to be avoided.'[7] The manuscript is inscribed: 'Written in the house of OH MAUREEN for one of the very few men I have ever loved or ever will do. September 22/23 1992 for his artist Dan Asher.'[8] Paley had recently moved her business back from the West End to a small terraced house in Beck Road, Hackney, rejoining the other established exhibition spaces of significance in the East End, Matt's Gallery, Chisenhale and The Showroom. It made sense for work such as Michael Landy's market trader pieces, the series of paintings Keith Coventry constructed

The shooting of *Ornament (in crisis)* in the artists' Rivington Street studio, with Webster behind the camera – the 'in crisis' was added to the original title after Noble almost drowned, while Webster busied herself saving the goldfish!

Sarah Lucas, *Supersensible* (1995), the artist photographed outside a second-hand furniture shop on the Holloway Road.

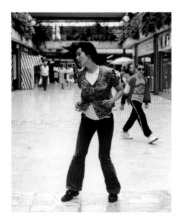

Gillian Wearing, *Dancing in Peckham* (1994), a video of the artist in a shopping arcade, dancing in silence to the remembered music of Gloria Gaynor and Nirvana. Wearing contributed substantial works at all the Factual Nonsense street events.

Compston often dropped by Ben Langlands and Nikki Bell's home in nearby Whitechapel, drawn by his admiration for *Traces of Living* (1986), in which objects rescued by the artists from abandoned East End buildings are memorialised beneath the glass tops of the tables and chairs. Now installed in the artists' home, *Traces of Living* was first exhibited – as here photographed – by Maureen Paley at Interim Art in 1986.

around his studies of council estates, and Gillian Wearing's video *Dancing in Peckham* (1994) to be shown in an environment close to its creative origins. Wearing, winner of the 1997 Turner Prize, has been represented by Interim Art since her first solo show, at City Racing in 1993 (she graduated in Fine Art from Goldsmiths' in 1990, after moving to London from Birmingham to attend an Art and Design course at Chelsea School of Art from 1985 to 1987). Introduced by Paley to Joshua Compston, Wearing contributed memorably to his Fête Worse Than Death '93, the first street event organised by Factual Nonsense. Compston also received encouragement at this time from another East End art-duo, Langlands & Bell, whom he met at one of the West End private views he began religiously to attend. Ben Langlands and Nikki Bell's earlier work included a video study of Borough Market (1986) and intense creative concentration on the rebuilding of their studio in Whitechapel.

We spent a year and a half restoring it and fitting it out. It became a project in itself. During that time we didn't do any other work at all. As we worked on the building we discovered things about its past. We originally thought of it in very neutral terms, although we knew it had been a belt factory and a clothing factory. Then we discovered it had been a stable and an annex to the

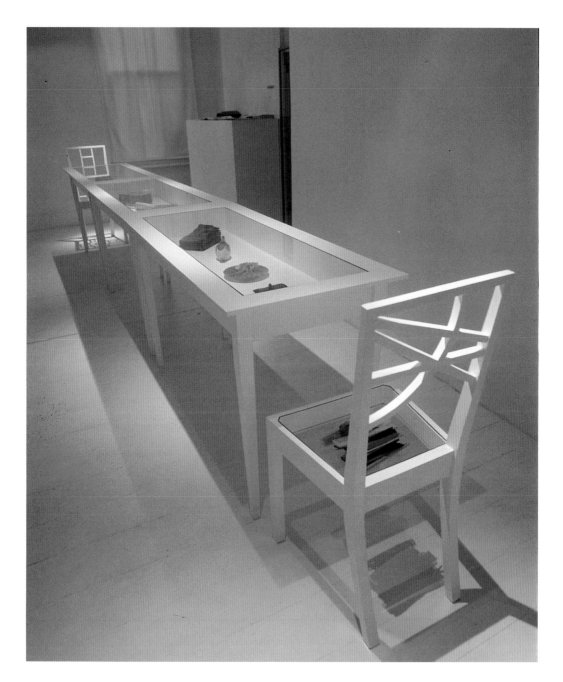

no FuN without U

Compston opened Factual Nonsense on October 22 1992 with an exhibition titled 'A Guide for the Perplexed', the invitation card designed and letter-press printed by Tom Shaw.

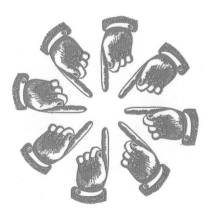

Langlands & Bell's studio, soon after they bought the building in 1987, and began the restoration work.

The view from the studio: Ben Langlands and Nikki Bell's neighbour, a similar character to Damien Hirst's Mr Barnes, sorting through scavenged junk outside his caravan home.

synagogue next door, and a Christmas cracker factory. There had also been a bad fire. Then one day as we finished working on the building a friend showed us a book about murders in London and we found out that there had been a famous murder here in 1874. A brush manufacturer had killed his mistress and buried her under the floor of our workshop. What we had thought of as an anonymous space steadily began to assert an identity. Now it has a new identity for a while.[9]

The building in nearby Shoreditch into which Compston moved also had a past. His immediate predecessor in the tenancy was the graphically-named Best Curve Ltd, suppliers of 'Lingerie and Late-Day Wear' to the Queen Mother. One of the furniture factory's original occupants, in 1881, had been a certain Ebenezer Envill Jnr, French polisher. The possibility of an alternative history made the East End the place for Compston to be – the place, somehow, to feel free.

For his opening exhibition on 22 October 1992 Compston elected to show the work of three little-known abstract painters, towards each of whom he felt a personal commitment: Daz Coffield, his soul-mate during the unhappy year at Camberwell School of Art; Sam Crabtree, a discovery of his for the Courtauld Loan Collection; and David Taborn, an important figure in his earlier intellectual develop-

no FuN without U

ment. Believing, at this stage, in the power of his ideas to secure public attention, Compston declined in press promotion of 'Factual Nonsense presents A Guide For The Perplexed' to mention his being Gilbert and George's very own *Naked Dream*. The invitation, in black and red letterpress on folded cream card, was designed and printed by Tom Shaw, incorporating eight cuffed hands from a nineteenth century block-maker's set, mounted in a circle, the index fingers pointing outwards and inwards to all points of the universe. Given Compston's radical private agenda, this was a perplexingly conventional show of wall-based painting, presented in a traditional public space indistinguishable from dozens of other London galleries. And although there was a big turnout of art glitterati for the private view, with crowds spilling into Charlotte Road's canyon of polychrome brick warehouses, only one picture was sold during the exhibition's five-week run – a small Sam Crabtree, bought by the soprano Sarah Leonard, her voice familiar to fans of the Michael Nyman soundtracks to Peter Greenaway's movies. Compston was unable to disguise disappointment in a card written to a friend: 'I wish that more energy would flow into FN as opposed to out! I still believe it will.'[10]

The next show at Factual Nonsense opened on 11 December, 'Better Than Domestic Shit', marking a

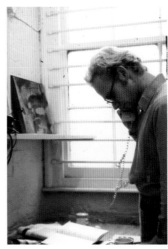

The back room of Compston's Charlotte Road premises, prior to conversion into Factual Nonsense's library and office.

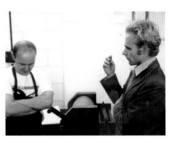

Compston with Shaw, in the printer's Spitalfields workshop.

Compston's visiting card.

Factual Nonsense

Installation shot of 'A Guide for the
Perplexed', on the left David Taborn's
painting *Factual Nonsense* (1991), a quote
from Wittgenstein, adapted by Compston as
the ideal name for his art business, in the
centre Daz Coffield's *Paki* (1992), and on
the right Taborn's *Excide Convention*
(1992).

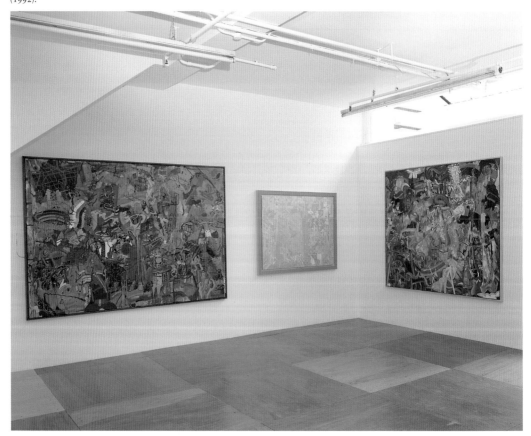

no FuN without U

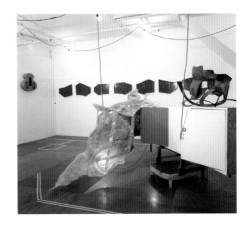

re-engagement with three artists from his August line-up at the Benjamin Rhodes Gallery, David J Smith, Mick Kerr and Rebecca Bower, in which 'the noble motive of the destruction of the world into art is once more at play!!'[11] Compston here argued the potential for machine production of ideal art works, promoting the artist as engineer and using in the display red-and-white-striped police tape and yellow builder's wire strung with light-bulbs to denote 'the sites of production and to illustrate further the industrial manner.'[12] The invitation reproduced a cartoon-cutting from the *Evening Post* of 17 September 1931, extracted from Compston's hoard of carefully filed ephemera. Nothing sold because nothing was for sale.

Fortunately, the third in Factual Nonsense's quick-fire series of exhibitions – seven openings in the first six months – met with some commercial success, with Aurel Scheibler stepping in to buy three of the four large canvases in the solo Crabtree show that opened on 21 January 1993, and the fourth being accepted by FN's landlord in lieu of rent. Under the rubric 'Sam Crabtree's "Utopic Space Manifest" (Amber Series)', the artist's interests were not best served by Compston's free-verse press release: '... Soft barriers or farm fences across, pushing back or hedging in the egg, orifice, ovule of a tear; more to confess and to utter for confetti splatter, scraped

The second show at Factual Nonsense, 'Better Than Domestic Shit', opened on 11 December 1992, exhibiting site-commissioned work by three artists whom Compston had previously shown at the Benjamin Rhodes Gallery. Billed as 'an exploration of potential machine production on an idealist plane ... to replace the present pathetic remnants of liberal culture, the shrimp salad of the Turner Prize', the installation in the centre of the gallery is by Mick Kerr, with David J Smith's blue architectural models behind and Rebecca Bower's guitar piece on the left.

In another corner of the exhibition space, a collection of Turkish money boxes and Honduran shopping bags, titled by Compston *Collective FN Multiple* and captioned: 'These are natural multiples and contain art quite by chance.'

Invitation card, designed by Compston using scraps from his extensive ephemera collection, for 'Sam Crabtree's "Utopic Space Manifest" (Amber Series)', four large canvases exhibited at Factual Nonsense from 21 January to 21 February 1993.

silly, tack and turn in time. Observing the sliding planes, aerial views of the substructure of desire makes one acutely aware of a delicate gheest at play, the shadow of an abstract Cézanne finally puncturing the mass of *La montagne Sainte-Victoire* and taking the principle of passage to its logical extreme …'[13] (Crabtree spoke much better for himself: 'Architectural drawings and aerial diagrams were used as a starting point for the central images in the paintings. The heavily worked surfaces are put through experimental processes. Marks and painted areas accumulate, and are gradually refined until a unity evolves between image and surface.'[14]) On the night of Thursday 18 February Compston's co-tenant from the floor above, Mike Walter, organised an evening of improvised music at Factual Nonsense, with Roger Turner on percussion, Adam Bowman on miscellaneous prepared instruments and he himself playing various saxophones, responding in sound to the sight of Crabtree's Amber Series of four large canvases.

Things were happening so fast around Compston it was difficult enough for him to keep pace with himself, and impossible for others to take seriously all his ideas, the ceaseless sparks disturbing the observer's balance. 'I want here and now. Every minute of the day, intensity of the will,'[15] the artist Louise Bourgeois entered in her diary. It was the

same for Compston. One of the first to peer beneath the surface fireworks and appreciate the qualities of the FN theme was Gavin Turk, who met Compston through Aurel Scheibler, when the three of them hatched in December 1992 a plan to launch a travelling exhibition mounted within an inflatable tent fabricated of bright white plastic ('the idea of this project came about after a number of meetings between Aurel Scheibler and Joshua Compston held in Köln, London and Valencia in the Summer of 1992'[16], initially titled 'The Darling Buds of May (The Tommies Are Back)', subsequently altered to the 'Utopic Space Manifest Module' – USM, for short). Collaboration with Turk helped Compston focus his word-energies and produce a clear descriptive account:

Gavin Turk's module provides a solution to the fundamental problems of display of goods and its relationship to the mass audience. His structure is a

According to Compston, Crabtree's *Amber IV* (1992) 'demonstrates the unnervingly masterful combination of Poussin's rigid order, glancing off Piero's rays – their formal perfection belies the author's age.'

Inspired by the shape of a fresh-from-the-packet piece of PK chewing gum, Gavin Turk designed for Factual Nonsense a transportable exhibition pavilion, called the Utopic Space Manifest Module.

response to the hermetic requirements of the container (the protection, preservation and aesthetic display of Material) and the challenge of perpetual dynamism, vis. the creation of a situation where the container and contained are on the move, visiting and making new audiences.

His researches brought him into contact with various ambitious proposals for space saving modules of the 1960s, notably those of Archigram and the organic and sympathetic structures of, for instance, Corbusier's Ronchamp Chapel. Though these earlier schemes were deemed admirable, it was a sine qua non that this new project should combine different formal and ideological possibilities, including a tactic often employed by artists in this century: the inspiration of a found object. In this case his object was a piece of chewing gum, as the 'roof' and space within USM is based on the form of an unchewed P.K. The shape of this object ideally lends itself to the spanning requirements of the space. Inflated by air, it will rise out of a form that is analogous to a plinth for sculpture.

The brilliance of this design is for four reasons:
a The 'plinth' acts as a base which elevates the structure above the earth, thus acting on a moral level, as well as solving two vital production problems: the base and not the roof can respond to deviants and oddities in the ground level and temperature, in addition to allowing unproblematic access. Thus the 'true' shape

no FuN without U

itself is not bastardised and USM can be seen from afar all the better.

b These problems solved the cladding for this base acts as a hoarding for sponsored imagery, to the extent that the whole base acts as one complete advertisement.

c All of the guts of the structure, the stairways, temperature control panels, compressor, lighting models, backup generator and sundry items, can be contained therein, leaving the goods or press conference unfettered.

d As a result a beautiful new 'sculpture' and formal possibility is created, a model for all time.[17]

Compston's report went on to analyse the cost of the project's development and to argue the module's structural viability by astute comparison with the work of Jan Kaplicky, co-founder of the lateral-thinking architectural practice Future Systems. (Again, Compston reveals an advanced taste, for Future Systems had yet to gain a single significant building commission, their break-through achieved with the Hauer/King glass house in Canonbury, completed in 1993. Public recognition finally arrived with their 1998 show at the Institute of Contemporary Art.) Turk – 'the famous Surrey dissident'[18] – and Compston were unlikely creative partners. Goethe said: 'It is always better to enchant friends a

This is the enemy

The next show at Factual Nonsense was highly personal to Compston – a visual and verbal manifesto, 'Es La Manera!'. For the invitation card he raided his ephemera store of WWII images.

little with the results of our existence than to sadden or to worry them with confessions of how we feel.'[19] Nobody could insist more vehemently than Compston that the world should feel as he does; while Turk accepts existence for what it is. Both these strong young egos would have been able to agree, however, on another Goethe dictum: 'People are always asking me to join in and take sides – well, then, I am on my side.'[20]

Turk lent a hand – 'It should be made clear that FN would like to take this opportunity to thank … G Turk (Ducky Palmer is Brian Doherty)'[21] – with the design of the next show at Factual Nonsense, 'Es La Manera!', a selection of objects close to Compston's heart, displayed and captioned with wit and passion. The invitation card epitomised the Compston canon:

ES LA MANERA!
(Potential Ideals
c1845 – 2000+)
10th March – 30th March 1993
Private View 16th March 1993
6 – 8.30 p.m.

Heroes and Anti-Heroes include:
A.Pugin, Eden Ham, A Aalto, Beat Time, C Voysey,
Bad Brum, Asher Pile, W Kandinsky, J Koons, P Wardle,
S Karakashian, Waugh's Aunt, A Schroeder.

At 'Es La Manera!' Compston displayed many of his most treasured possessions, including a set of Gothic revival keys, c.1845.

On the reverse side of the card, printed in gray and pink, Compston presented the disturbing overlaid images of the bound-feet and ankles of two hanged men and a woman dangling above a column of storm-troopers goose-stepping across naked bodies in an open grave. Beside these photographs the words 'This is the enemy' were printed, a quote from an anti-fascist pamphlet circulated in 1943 by the British Communist Party, a cherished item from Compston's ephemera collection. At the centre of the exhibition stood a section of Victorian box-shelving, rescued from the Courtauld Institute, now stacked with visual messages, including three green sticks of live dynamite, which Compston used to take out from an inside pocket of his jacket and wave in the air at prestigious private views, clearing the gallery. All the names on his invitation list found their place in the exhibition: three Puginesque Gothic revival keys, for example, nailed to the wall, and, on the parapet of his picture store, a cornucopia of congealed oil-paint scraped from the studio floor of another hero of his, Eden Box (neé Ham), whom as a teenager he used regularly to visit in Chiswick during her final years of neglect. Compston's exhibition labels were an integral part of the show:

'Unlock and ye will find'. Pugin keys c.1845 made for a private house, Bilton Grange, near ruined Rugby. Keys

On shelves salvaged from the Courtauld
Institute Compston placed a disparate series
of objects, ranging from three sticks of
dynamite to this FN monogrammed egg,
made for him by a friend from his
schooldays, Zebedee Helm.

Also exhibited was this drawing of a
leopard by Eden Ham, a neighbour in
Strand on the Green, Compston's childhood
home on the river Thames at Chiswick.

made for the house of newly acquired Captain
Mammon. Oh to be a captain, or rather an admiral, who
strutting like the butterfly, can yet face the sharks. These
metal jewels are not Pugin's words, but permit him to
exhort: Their logical extreme is nudity, edit, distil, to a
moral scope of vision, a blink of truth to be homaged
and eventually emulated. Pugin died young, soon after
designing these peas. He was full to the brim and we
must drink his cup.

All Wood 'Row Chair', for homes, meeting halls,
restaurants, etc. Space saving – close nesting. Designed
by Alvar Aalto 1929 and manufactured by Finmar Ltd
1936. Sold from their London Showroom 44 Ranelagh
Road, SW1. Recently praised by Herr Jasper Morrison
in an obscure capitalist tool beauty of a book, Aalto is
soon to be appointed to the First Committee of the
Absolute Form for Daily Diet. He accepted this
appointment with glee and alacrity, as he had been
bitterly disappointed by the bourgeois lack of will to
turn modern art into actual common property. Now is
the Word World to bear witness to your Absolute
Horror of velveteen slime.

Eden Ham c.1987. Acera: windows raped by light. Pues:
send dust scurrying to the skirting. Listen: paint on a
pedestal from forty years of tache, tache, tache on the
table above the crystal smashed, bird silk, watered shape

no FuN without U

Compston was assisted in the presentation of 'Es La Manera!' by Suzi Karakashian, a member of the art collective Orphan Drift, whose beer-bottle-top piece hung ever after in the office at Factual Nonsense.

of her topiary dream. Yes, it's her, a she, a darling. But to you such mystic charm is a dirty anathema; 'cos you're scared. Rapid fire: sod you gits – Yea but to YOU. Your dropsy scum of soul knows knowt about Eden Ham. Viz. Her sphinx like device of 'feeling'. This object is respectfully dedicated to the memory of Eden Box, painter. c. 1909-1987.

Above the open arch leading to the office at the back of the exhibition space Compston pinned five plastic fig leaves, and titled the piece *Five Bores of the Apocalypse*, a reference to the failure of named art critics to notify the public about the FN revolution. The only writer at this time regularly to praise Factual Nonsense was Sarah Kent in *Time Out* – though a substantial interview by Jill Selsman was due to appear in an April issue of the *Evening Standard Magazine*. Asked where he saw himself five years ahead, Compston replied: 'In politics. The gallery is just a front. I want to have a significant influence over the way art is understood, read and used. I want to change the fuddy-duddy aesthetic.'[22]

True to his personal loyalties, Compston followed 'Es La Manera!' with a solo show of David Taborn's recent works on paper and, immediately afterwards, the London launch of Aurel Scheibler's publication on Dan Asher, incorporating an exhibition of the artist's hand-mould plaster sculptures, together with

Installation shot of 'Sight Unseen', an exhibition of sculpture and drawings by the American artist Dan Asher, which opened at Factual Nonsense on 20 May 1993, marking the London launch of a book on the artist, *Guestarbeiter on the Planet*, to which Compston contributed an essay.

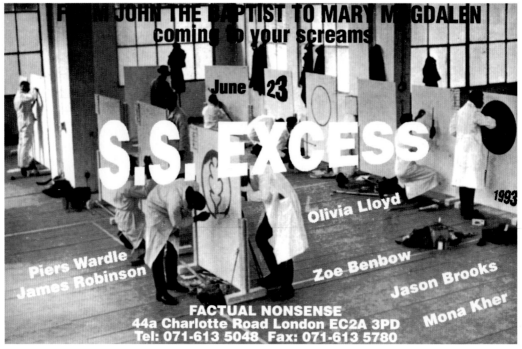

FROM JOHN THE BAPTIST TO MARY MAGDALEN
coming to your screams

June 23

S.S. EXCESS

1993

Olivia Lloyd

Piers Wardle
James Robinson

Zoe Benbow

Jason Brooks

Mona Kher

FACTUAL NONSENSE
44a Charlotte Road London EC2A 3PD
Tel: 071-613 5048 Fax: 071-613 5780

Invitation card to the private view of 'SS EXCESS': 'This is not a ridiculous "Summer Show" ... but presents a prototype solution to the destruction of the common real that is, bar a few Indians in the jungle, about all we have now.'

a series of drawings on Saatchi & Saatchi headed notepaper, supplied to Asher courtesy – somehow – of Factual Nonsense. In parallel, in open-minded response to the request of friends, on the evening of 21 April Compston welcomed the Blue Nose Poets to his premises, for a talk by Al Alvarez about his friendship with Sylvia Plath during the last months of her life, complemented by readings from her poetry. On the next night at Factual Nonsense the tenant from the floor above, Mike Walter, by day an architect, led on his tenor saxophone a tour de force of musical improvisation, accompanied by colleagues from the London Musicians' Collective, with Jim Lebaigue on drums and the veteran trombonist Alan Tomlinson.

By now Compston was into his stride, combining one-off events with gallery installations which, in the vigour of their presentation, were performances in their own right. His press release for the show which opened on 23 June 1993 merits quotation in full:

'S.S. EXCESS'

FROM MARY MAGDALEN TO JOHN THE BAPTIST

1993

ZOE BENBOW, JASON BROOKS, MONA KHER,

PIERS WARDLE, JAMES ROBINSON, OLIVIA LLOYD

Some 'random' details so dear to the heart of my medici:
Well, kiddoes, your favourite comedian is recently
deceased (Les Dawson) and the other one (Enoch
Powell) is not available at the present instance, so ipso
facto it leaves F.N. to provide the most up to date silicon
valley circuitry/connection between the 'artist' and the
'audience' a.k.a. the painter and the tired corporate
raider.

In the ultimate this audience does not or should not
consist of the sort of cardboard gimmicks that stare out
with their frump snob/snub from the pages of the
catalogue exhorting you to participate in the 200th
International Space Man Cologne Art Fair in November
this year, but more the sort of person Victor Gollancz
examined in order to encourage love from the Allies in
'46 after the historical S.S. Excess, or in more recent
terms the kid who 'does drugs' and is sent away. Here is
the desired audience: essentially the sensualist, in league
with gratification, and ripe for conviction.

People have asked what does S.S. Excess mean?

Flippancy will run along now with: IT CONTINUES TO
DOMINATE TO DICTATE TO EXPLODE, WITHIN THE
NEXUS/NECK. THESE ARE THE PENDANTS, PENNANTS THAT
HANG DOWN – THERE WILL BE NO PENITENCE, NO
MUMBLES. GLORY OR DEATH – STRAIGHT UP OR DOWN.

The childrens' alphabet book/ spaghetti would inform
us 'S' of the 'SS' could be for: slimy, simile, seriously,
sprouting, sly, sick, sound, sexy, sinful, simul atque,
seditious.

Enough word games:
Don't you just hate all those theories, critics, books on
post-this and ism-that? We need those who can not only
call a spade a spade but take that spade and ram it down
on the neck that supports: popular entertainment,
artculture, Americanization, kitsch, fascism, until the
tendrils that hold them to the betrayed people collapse
and their polluted blood flows back into the motherland.

Final Paragraph:
FN is not an art nor an art historian, the artists would
demand texts, they have their bibliographies, their
interested art critics, I admire them for their convictions
and their willingness to participate in this experiment. If
anyone asked me I would with good grace and impunity
tell them the where's and the why's, the particular
intimate peculiarities, concerns and briefs of the painters
in this firing line. But that is not the point, this is not a

Work by James Robinson, Olivia Lloyd and
Jason Books on show in 'S.S. EXCESS'.

ridiculous 'Summer Show', nor a 'Gallery Artist Show' (there are none), nor a roundup of 'Painting Today' – leave that to others. What it is, is an attempt to posit certain critical theories not about art i.e. not the stupid line 'he engages with certain issues of Kippenberger sucking on Castro'. But to present a prototype solution to the destruction of the common real that is, bar a few Indians in the jungle, about all we have now. This can either be achieved by the manufacturing of 'spectacles' where no one is master and all is sacrificed for the higher ideal (as here); or by infiltration of the ruling mores, ownership of the Carlton; or of course the running of The Angry Brigade, The Social Revolutionaries etc. For the present time option 'a' has been adopted and as the Duke of Wellington stated 'a revolution by due course of the law' will be pursued. This act/exhibition/spectacle is not an isolated act and next year the onus will be on the re-action, though for humanist ends, of the power enacted at Die Rundgebung der Wettapmfer im Schlokhof zu Ronigsberg.

Opening times remain unchanged: Tuesday to Friday 12 p.m. – 6 p.m. Saturday 10 a.m. – 4 p.m. or by appt. Further information is and always will be available.

ISSUED BY DECREE FROM THE LONDON SHOWROOM OF F.N.
44a CHARLOTTE ROAD, EC2A 3PD.
Tel (071) 613 5048 Fax (071) 613 5780

no FuN without U

This special Compston language was already, as it always remained, formed from the words of the moment, culled from the latest sources – read a day or two earlier in the pages of a newspaper or his current bedside book, seen on advertising hoardings, heard on the radio, and developed in the unending passion of his conversation. There is no way of capturing the full sense of Joshua Compston's original meaning, the fire of the moment dimmed, the contextual nuances lost, even for the friends who at the time shared with him his and their joys and woes.

At another level, the passing of time brings to the ideas and ideals behind the pulse of Compston's personal language a resonance which enhances the original meaning, now that some of what he envisaged has become part of the creative everyday.

three

What I always needed most of all for my own cure and self-restoration, was the conviction of not being so alone, not seeing alone – an enchanting suspicion of kinship and likeness in glance and desire, a moment of relaxation in the assurance of friendship.

Friedrich Nietzsche, *Human, All Too Human*

More than anything else, Joshua Compston wanted to stand among friends together looking out on to life and to know that they all saw the same world. He needed reassurance that what mattered to him, in particular his membership of a creative community, was equally important to the others involved. 'Repeatedly I face up to the fact that I appear to be completely isolated,' he had written in his diary on Friday 4 October 1991. 'This disturbs me. Not only does it makes my position and life that much harder (thus less of benefit can be set in motion) but it also leads to a misreading of me as a crank, a hopeless possibly dangerous outsider. ... So I live for love and the glorious potential of humanity, yet I know none willing or able to attempt to bring this about through the construction of art – paintings, sculpture, architecture, film, music, theatre. Art dictates towards the infinite. How can the encouragement of art everywhere be anything but beneficial? Yet I belong to no circle and perceive no possibility of founding the co-operation and broad mutual agreement as experienced among Modernists pre-1914.'

Compston sensed the real possibility of such a community's existence through meeting Tracey Emin and Sarah Lucas at The Shop in Bethnal Green Road, the project they started in January 1993 in a former doctor's surgery, marketing their iconoclastic art around the corner from the leather merchants and beigel bak-

OPPOSITE Compston acquired from Tracey Emin and Sarah Lucas *The Last Night of The Shop* (1993), a cotton hanging with a collection of safety-pinned badges sold at The Shop in Bethnal Green Road, which the two tenanted from January to July 1993. His favourite artwork, Compston mounted it on the wall behind his desk at Factual Nonsense.

Badge handwritten by
Emin.

More-Emin-than-Lucas
lapel badge.

More-Lucas-than-Emin
lapel badge.

THE CALLING OF ST ANTHONY

integrity
dignity
humour
teeth
hair
heart
love
temper
grip
life
vision
souls
kidneys
eyes
limbs
mind
sight
truth
fortune
faith
friendship
health
home
confidence
taste
smell
way
strength
skill
passion
honour
white cells
red cells
self respect
magic
cool
marbles
etc. etc.

THE PATRON SAINT OF ALL
THINGS LOST

Emin made a bookmark for sale in The
Shop from a piece written while a student at
the Royal College. Compston encouraged
Emin to make art out of her writing.

ers of Brick Lane. The curator and critic Carl Freedman has described the impact on him of this adventure: 'I had deliberately avoided going there but found myself having a cup of tea with them one Sunday afternoon … and ended up spending most of the next three months at The Shop having a totally mad and wonderful time. I think it is probably one of the best pieces of art I have ever seen, or probably better to say experienced … I had lost interest in art since Building One and Tracey and Sarah brought me back to life.'[1] In the window Compston read instructions he had no difficulty following: 'PUBLIC NOTICE Be Faithful to Your Dreams'.

The point about The Shop was the doing as much as the selling of art: the making of badges from card and safety-pins, mounted with newspaper photographs and slogans; the hand-inscribing of T-shirts; the embroidering of boxes; the balancing of mobiles. Emin made into a bookmark a piece she had written in 1990, while still at the Royal College of Art, signed on the back with her inked fingerprint.

The artists closed The Shop after six months, in the style of its entire being, with an all-night party on Emin's birthday, 3 July, sponsored by Zeiss beer and titled 'Fuckin' Fantastic at 30 and Just About Old Enough to Do Whatever She Wants'. The Shop had served its purpose in establishing for the artists personal connections with which they felt comfort-

no FuN without U

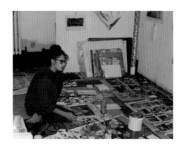

Emin in her Royal College studio in 1990.

able. 'It is important for me to be somewhere I am completely familiar with, where I know people and where I'm in the swing of things,'[2] Lucas feels. Emin remembers: 'I was a real outsider. With the kind of work I make and the beliefs I have about art, I felt there wasn't room for me. I had to make my own room.'[3] They burnt most of what remained unsold. One of the last pieces to leave The Shop was a green field of fabric onto which over a hundred badges were pinned – of Sylvester Stallone, a plate of fish and chips, Marky Mark in Starkers Snaps Riddle, Clarity = Harmony, and, among the diverse others, in Emin's hand, The last night of the shop 3.7.93 – bought by Compston to hang on the wall beside his desk at Factual Nonsense. The modest cheque to pay for his purchase was a long time in delivery. Emin never cashed it.

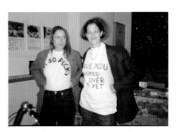

Lucas and Emin wearing two of the T-shirts they made and sold at The Shop.

Contact with Lucas and Emin and their friends at the shop a mile away in Bethnal Green gave Compston the confidence to organise for late July 'the first ever Shoreditch street festival/fête/party/trade fair, normally and naturally known as A Fête Worse Than Death.'[4] In these early days of FN, the triangle of Great Eastern Street, Old Street and Shoreditch High Street still enclosed the remnants of its light-industrial past, with printers, plate-makers, button manufacturers and shoe wholesalers replacing the pre-war furniture trade. Many of the buildings were

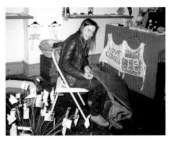

Lucas working in The Shop on her and Emin's commemorative badge piece. In the foreground one of the Lucas mobiles which the artists sold from this converted doctor's surgery, a ten-minute walk from Compston's home in Charlotte Road.

Lucas, *Tracey Emin* (1994). Asked by Emin to write two hundred words on her for a solo show at the South London Gallery in 1997, Lucas responded: 'Dear Tracey. As a question, "What do you think of me?" is very much your style. But it's not mine. Love Sarah.'

Installation shot of Lucas and Emin's joint contribution to the show 'From Army to Armani' at Gallerie Anna-Lix Venture in Geneva in 1993, on the wall a photograph of the two artists sitting on the pavement in the sun outside The Shop.

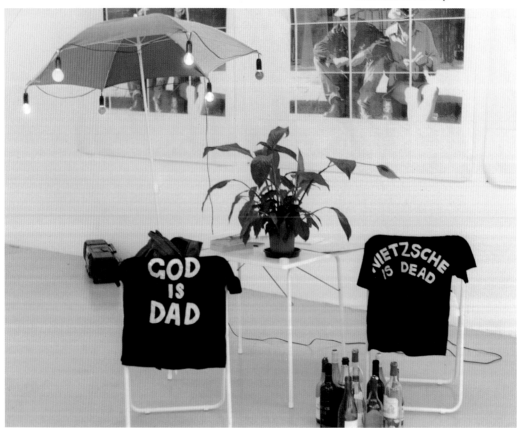

no FuN without U

Emin, *Mine* (1993), on display at The Shop.

Lucas, *Headstone for Tracey* (1994).

Emin, *The Shop 14 January to 3 July 1993* (1993), the ashes from the ceremonial burning of unsold artwork at the closure of The Shop, placed in an old walnut box.

On Saturday 31 July 1993 Compston ignited his first Fête Worse Than Death: 'Located within the notorious triangle of Great Eastern Street, Old Street and Curtain Road, a Victorian artisan area famous for its noble design, irreverence, wit and internal disc drives, the centre of the event is to be the crossroads of Charlotte Road and Rivington Street, continuing down as far as Factual Nonsense in the former and the Tramshed and Barley Mow pub in the latter.' Compston striding towards the Bricklayers Arms, against the backdrop of his own banner hanging for the day outside the Barley Mow.

Compston depended on artist volunteers to mount these events, his main assistant for two years being Andrew Capstick, here shown running a stall outside Factual Nonsense.

half-empty, planning consent for residential use being at that time difficult to obtain. Compston himself lived illegally in the office section of the gallery, at night mounting a ladder to sleep on a rug bed concealed on top of his picture store, with neither showering nor cooking facilities. Like the area itself, he was caught between City opulence to the south and run-down council estates to the north, a no-man's-land ripe for artistic takeover.

The structure of A Fête Worse Than Death was simple: place fifty trestle tables down both sides of the pavement at the crossing of Charlotte Road with Rivington Street, rent out the stalls for a nominal sum to artist friends, persuade others to provide music, food and street entertainment, stoke up studio imaginations during the preceding weeks and on the day itself cheer on competing extravagances of invention – with the extra enticement of traditional fairground booths in the imposing Tramshed, a former electricity sub-station, built to serve London County Council's tramways, and all-day opening of the corner pubs, the Bricklayer's Arms and the Barley Mow. Nothing would have happened, though, without Compston's visionary passion to ignite inspiration. 'I can hear his voice,' Tracey Emin recalls. "We're going to do this thing – Yeah – And we're gonna do it right'.[5] It was hard to resist Compston's combination of rage-driven megalomania and acute

no FuN without U

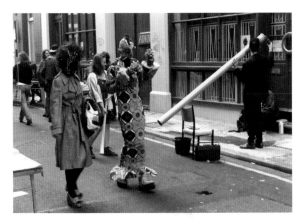

sensitivity. 'Joshua was one of those people who are good at friendship,' Maureen Paley has commented. 'He nurtured people.'[6] He also shared with his artist companions the genuine desire for communal life, a point noted by Peter Blake: 'I think what's so interesting with this generation of artists is that they are all so supportive. They all look after each other. You didn't have that with my generation. I've never seen anything like it before. Joshua was very much part of that.'[7] With A Fête Worse Than Death Compston succeeded in creating a space for artistic life. A list of the people whom he persuaded to join this day-and-night occupation of his home streets reads, in retrospect, like a 'Who's Who' of young British art – picking names at random: Adam Chodzko, Sarah Staton, Damien Hirst, Gary Hume, Sarah Lucas, Gillian Wearing, Gavin Turk, Simon Bill, Angus Fairhurst, Tracey Emin, and many more. Compston's aesthetics were akin to the politics of Mayakovsky, the Russian revolutionary who died by his own hand: 'The streets are our brushes, the squares are our palettes. Drag the pianos out on the streets.'[8] In his characteristically contradictory way, Compston was as long after his time as ahead of it.

There were wonderful sights. Gillian Wearing arrived dressed in a schoolgirl's uniform, accompanied by The Woman With Elongated Arms, whose paid-for hugs were recorded by the artist in Polaroid

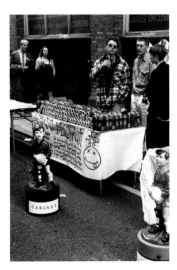

Simon Bill (centre), alias 'Jesus H Christ', in Charlotte Road, with Jason Magnus and Deborah Curtis.

Emin's 'Essential Readings'.

Wearing's 'The Woman with Elongated Arms'.

Turk with Rod Dickinson's 'Crop Circle Bread'.

'REAL ARTISTS' – This breed will offer throughout the afternoon and in every single cranny ... constant amazement!'

snaps. Emin set up a stall for Essential Readings: unorthodox telling of the future from the palms of passing hands. John Bishard and Adam McEwan, immaculately pale, in crew cuts and cream shirts, sold – for 20p – Advice About Absolutely Anything. Impertinent questioners queued to break the artists' deadpan commitment, but never the chink of a smile appeared, while crowds formed to gape and listen, giggling at the gentle humour of their responses. At the next door pitch Gavin Turk offered fairgoers the opportunity to Bash A Rat: an angled gray plastic drainpipe down which he slid a notional rat made of old socks, which they invariably failed to bash with a baseball bat, their aim skewed by the tequila slammers supplied at the stall opposite by Gary Hume, impersonating a Mexican bandit. Mick Kerr, a pre-FN studio tenant in Charlotte Road, stocked his stall with different-sized pieces of colorfully painted plank, from which buyers were expected to select the correct elements later to assemble their own Rietveld-esque chairs, to a plan provided by the artist. Scheduled to run from 14.00 to 02.00, the afternoon atmosphere was relaxed, with stallholders wandering up and down to sample each other's wares, the street decked out by Compston with antique semaphore-flags. Although most people there seemed to be artists and appeared to know each other, the clannish exclusivity of West End art

no FuN without U

Kerr's 'Make a Chair'.

Damien Hirst [left] and Angus Fairhurst borrowed clown costumes for the Fête Worse Than Death, engaged Leigh Bowery to make them up, and hired out their spin-painting equipment for passers-by to make their own art at £1.00 a go.

gatherings was totally absent. They entertained the visitors and themselves, made of the everyday an invention: Rod Dickinson baked crop circle bread; D Rabjohns gave weird pavement haircuts; FN and PPQ staged a battle between rival gangs of pickpockets. And throughout the afternoon a loudly costumed pair of clowns hired out their spin-painting equipment at £1.00 a go, signing the punters' art with their own names: Angus Fairhurst and Damien Hirst. On payment of an extra 50p they exposed themselves, revealing striped cocks and spotted balls, colourfully made-up by fellow artist Leigh Bowery, the subject of a grand series of life-size nude oils by Lucien Freud. 'He did us up right and proper, including our bits,' Hirst told Bowery's biographer. 'We were nervous about doing the clown thing, and the genitals were a good ice breaker.'[9] Their spotted balls mimicked Hirst's own series of dot paintings, named after captions in an old pharmaceutical catalogue: 'Art is like medicine – it can heal. Yet I've always been amazed at how many people believe in medicine but don't believe in art, without questioning either ... Art is about life – there isn't anything else.'[10] Fairhurst and Hirst promised a prize dinner at Green Street, their favourite restaurant at the time, for the 'best' painting – awarded to a beautiful young stranger, whom they met on the appointed night in their clown costumes, again made-up by

Bowery insisted on dot-painting their bollocks and striping their cocks. For an extra 50p, the artists exposed themselves, here to Guy Moberly's camera.

Kerr left his pitch to pay a pound and make this spin painting, signed and dated by fellow-revellers Hirst and Fairhurst.

Staton's 'Voodoo u Love'.

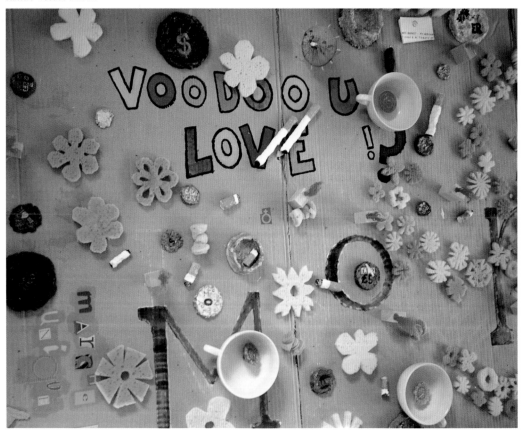

no FuN without U

Carl Freedman and Zoe Benbow, one of the exhibitors at Factual Nonsense's show 'SS EXCESS', watch Hirst at his stall. All-night dancing in the street was to music provided by Funky Funeral Services, the dancers daubed with the clowns' unused colours.

Bowery. 'Pure hedonism combined with creative genius,' was how Emin described A Fête Worse Than Death. 'Needless to say the day ended up with hundreds of people dancing in the street. Joshua was held high on people's shoulders and all of us were chanting 'Long live Joshua!'. He was smiling, with both hands raised in the air like he ruled the world. And he did. He ruled his world – a world he had created and that we all shared.'[11]

The shared joys of this new life contrasted with the anguish of Compston's teenage years, articulated so movingly in his journals and diaries of the time ('I must write the truth. I can't even trust myself now to do this. I think it is quite marvellous that I am still in the normal world despite years of depression. The depression is not invented ... I must make a real effort to communicate, as I know I can.' 24 August 1990). Still never quite believing his ideas really had been heard and understood, the success of FWTD '93 – as it came to be called – astonished him. And indeed it was remarkable that Compston managed to carry with him on this venture so many individualistic artists, persuading them of the specific benefit, to them, of joining in. He achieved all this without compromise of his own personal vision, with all his private enthusiasms on open display. The bewildering choice, for example, of cover image for the programme: a wartime archive photograph of city gents

Angus Fairhurst thanked Josh Compston for a never-to-be forgotten day and night in the Shoreditch streets with the gift of this drawing.

in toad-faced gas masks. Nor did he let-up on extravagant phrase-making, describing himself as 'the master of serious high jinks': 'Brain Burn is the demand for a loving community spirit, which passes more often as horrid attack, atrocious shock (on old ladies): the organic local spirit is long dead, to be laid at the lintel of both the I.R. and the I.R. – Industrial Revenue and Inland Revolution.'[12] His historicist inclination undimmed, Compston worked into the text esoteric reference to the ghost of pop artist Dick Smith still present in Shoreditch from the early 1960s. (In 1997 Smith returned for three months to his old haunts, through temporary exchange of his New York studio with Gary Hume's in Hoxton Square.) True to form the adventure lost money: Factual Nonsense failed to collect sufficient rent to pay the penalty costs on hire of the trestle tables, many of which had disappeared by the time Compston surfaced on Sunday afternoon to clear up the paint-scored street. Also missing were several of the antique flags he had borrowed from the London Architectural Salvage and Supply Co., in the nearby muscular gothic church of St Michael's.

Profit or not, there was now no controlling the FN urge to make of every occasion a public event. In a letter to the Head of Community Relations & Hospitality at Inmarsat, at the company's new headquarters overlooking the Old Street roundabout, Compston

Compston and his girlfriend Leila Sadeghee at Jourdan's '33 Rue de la Glacière', named after a derelict house in Toulon where all the photographs in the exhibition were taken.

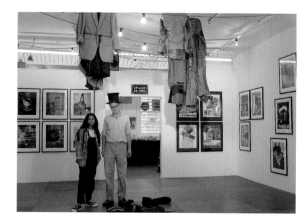

Invitation card to Factual Nonsense's exhibition of photographs by Max Jourdan, opening on 23 September 1993, with the first performance of Molly Nyman's Wind Quintet.

unveiled plans to mount an exhibition called 'Zeiss, the brand name of the beer that is to be supplied to the specially invited first night audience.' He continued: 'The venue is a large free house, called Charlie Wrights, situated in Pitfield Street, just off Old Street. This pub, originally known as 'The Queens Head', has long played a significant part in East End myth and is now run by an energetic Jamaican. John, the landlord, often provides special attractions for his customers and as result of this policy invited me to curate an exhibition in order to bring art back into daily life where it once belonged. The response from the artists I have invited to date has been marvelous. All of them have demonstrated a strong desire to go beyond the gallery system and to participate at grassroots level. It has therefore been decided to employ a system of pseudonyms for the exhibitors, since this will allow the art to exist more 'on its own' than acting on the principle of 'names'. Despite this ploy however a number of the artists are the young turks of today and do exhibit under the eminent auspices of Jay Jopling or Maureen Paley's Interim Art. For your information the following artists will be featured in this show: Max Wigram, Gavin Turk, Jason Brooks, David J Smith, Pauline Daly, Piers Wardle, Alison Gill, Brendan Quick, Sarah Staton, Steven Hughes and Deborah Curtis.'[13] Unable to secure sponsorship from Inmarsat, this exhibition never took place.

Jourdan wrote of '33 Rue de la Glacière': 'On the threshold of the habitable, the house serves as a refuge for a number of vagrants and homeless people.'

The next show at Factual Nonsense itself – '33 Rue de la Glacière': photographs by Max Jourdan of a semi-derelict house in Toulon, discovered while on national service on a French aircraft-carrier – was accompanied by the premiere performance of a wind quintet composed by Molly Nyman, her musicians dressed in tramp costumes designed by Hannah Greenaway. To celebrate the pairing of these notable daughters, Compston served guests at the preview white wine and scorpions on toast: 'The Word of F.N. (c.f. St John), since what has to be written has to be written ... Yeah, but where's the humanity, the humility, the holiday, the real F.N. news? ... Finis. Have a good party, think of England, France, W H Davies, perhaps art and enjoy your scorpions.'[14]

'It is a violent and voracious environment filled with objects and fragments from past and present domestic lives.'

In defense against his fears of isolation, Compston had made himself into a professional party-giver. He habitually used to issue invitations to his birthday parties at Strand on the Green designated as art objects to be treasured: 'A Limited Edition Invitation to Joshua Compston's 21st Birthday & Gaugin's 100th Anniversary on Friday 21 June at 6 p.m.,'[15] was pretentiously signed both by Compston and by the invitation's joint-designer, Daz Coffield. Another year he incorporated the Edwardian letterhead of The Chiswick Savage Club and two 1930s US petroleum adverts into an invitation which read 'SAVAGE JOSHUA INVITES YOU TO A PARTY OF WILD

Private views at Factual Nonsense gained a
reputation for being art events in their own
right, an ambition long cultivated by
Compston, here illustrated by his invitation
to a birthday party at home in Chiswick.

REASON … DRESS: 'COMPEL CONVICTION' (FRIED).'[16]
As a child Compston had constantly sought public
attention, 'entertaining the crowd by crushing toads
and frogs with purple bricks.'[17] Factual Nonsense's
'First 'party' Conference', held at the Barley Mow
between 18 and 22 October 1993, was in many
respects an extension of Compston's childhood tac-
tics, the natural way – he persuaded us to trust – of
being himself.

> A rolling rock of events designed, tailored, and all dried
> up (hardly!) to celebrate the paradigm of Factual
> Nonsense as real life.[18]

> So drop a flippin' switch or two, pick up a piece & uplift
> your splendid soul.[19]

As always with Compston, the anarchic improvisa-
tions of the night were based on stern daytime
didactics. On hearing that the landlord of his
favoured local, the Barley Mow, was looking for
some good-spirited fellow to oversee the premises
during a week's holiday, Compston seized the
opportunity of taking art into that most sociable of
public spaces: the pub! More than this, he wanted
art actually to be made from the drink and chatter
of a publican's life. In order to set the wheels of
invention rolling, he hosted on each of his five days

no FuN without U

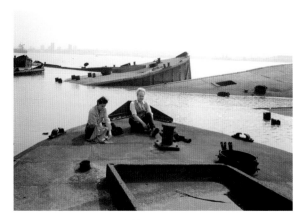

as proxy landlord a different 'afternoon gambit' and evening 'performance', the details circulated to his by-then vast address list via a handbill emblazoned with the colour close-up photograph of a clown's genitals.

On the Wednesday night revellers were promised 'A DEMURE EVENING'S DRINKING WITH SARAH AND TRACEY WITH SPECIAL GUESTS ALBERT IRVIN, STUART MORGAN, MAX WIGRAM' – Irvin being the celebrated painter from an earlier generation whom Compston had exhibited at the Courtauld, Morgan the respected contemporary art critic, and Wigram founder of the Independent Art Space. 'Sometimes when you drink, if you drink enough, even being lonely doesn't hurt,'[20] Tracey Emin wrote in the handbill – five years in advance of her display of drunken truth-telling on a live TV discussion after the 1997 Turner Prize award. On another evening the artists Stuart Brisley and Helen Chadwick were billed to join the dealer Maureen Paley for a pub quiz: 'Polish up your optics, gang, and empty out the ashtrays of your lives because PPQ are here to offer you a sniff of the barmaid's apron with our splendid Quiz Night.'[21] The wildest performance of the week was Leigh Bowery's serving of crushed, cloned and extruded cocktails, with artistic assistance from Angus Fairhurst and Cerith Wyn Evans. For the last night of FN's 'party' conference Compston erected a tent –

his Marquee de Slade – on the street outside the Barley Mow, in which friends drank and danced the night away, to improvised sounds by Mike Walter's Extreme Quartet and the 'Whammyravehair'n-pogpPfunkashmaltzhightechnenergyboingbumboog-iehustleBattyskanklimboshimy'[22] of Gordon Faulds, resident Charlotte Road DJ.

Compston described his feelings mid-event in a letter to Aurel Scheibler:

20 October 1993

Dearest Aurel,

It's been a very weird but happy month, what with last night falling ill, being put to bed by a very true love of my life, Leila Sadeghee. Leigh Bowery, naked and being sucked off, the preview of his new band, Lucian Freud, no doubt with an eye to yet more seduction, Fairhurst and foul serving and making the most amazing cocktails, a tonic to the nation. All this and more, and I was asleep, dreaming I'm sure of being in control, while being out of control.

Tonight I move into the first flat of my life with my love. Sarah Lucas and Tracey Emin move and shake the stuffed cracks of English life in the Barley Mow, thence to the future. We spend our first night in the flat together. History has in the past been broken and splintered by such occasion. I could continue … I always do so in my head in any case.

no FuN without U

Invitation card, designed by Andrew Capstick, to 'Errata!', 'a live and video installation by Sadeghee & Daughters Ltd'.

So anyway I gathered the Material from the Staton and I repeat that she deserves a break, the work is cheap and it would be silly not to take this golden nugget. The work is humorous, would probably like to be subversive and I will work together with her in the future. There we are. Tell me what you think. Ask Tanja or Maureen. I can't wait to see you. Love to all.

Love, Joshua[23]

In no time at all, it seemed, notice of another F.N. event was posted: the simulacrum of a teenage party invite (designed by Andrew Capstick) replete with bubblegum-coloured balloons, to a 'KEG PARTY'[24] at the Charlotte Road home of Compston's newly-acquired lover. His press release flowed:

FACTUAL NONSENSE
in a special solution with
Sadeghee & Daughters Ltd

'ERRATA'
(a live (lived!, living) and video installation)
26 November to 16 December 1993

It has been brought to my attention that you expressed an interest in the forthcoming event of flavoursome 'yummy' chimera-type spectacle nature to be presented

under the auspices of Factual Nonsense, the contemporary art gallery and advertising company started 22 October 1992, though announced in the beginning of the Modernist Myth, the exhibition entitled 'Abstractions From Domestic Suburb Scene (Sin)'.

In brief, the pre-Christmas slot spree is entitled 'ERRATA', a manifestation that revolves around the discovery of the beautiful and radiant teenager Leila Sadeghee, an American citizen of Persian descent, who arrived recently in this country from the University of Vermont ('Groovy UV') fresh from a state of being wide and awash in a weird culture of Drive Thru overload, beer can pyramids, high school sex talk, girls nights out, White Castle burgers, the terms 'humpydinky', 'hook up', 'score!', and other delights of an upper middle class childhood in the 'burbs' of 'Philly'. (Sic)

'ERRATA' will consist of a confessional style video dialogue/conversation, spoken to the camera as if in rap with an imaginary friend, wearing the different guises of her pas self and concentrating on different aspects of the post war High-Kitsch of glorious sub utopia that she had a continual direct coating of until she arrived in this country two months ago. Throughout the large 900 sq ft room in which she lives will be various objects associated with her past, in addition to herself, who will alternate between as state of acting out the past (as in video) and as she is now, distanced and able to accept the consequences of the pursuit of dreams other than the

no FuN without U

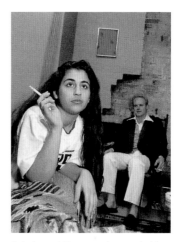

Sadeghee and Compston photographed for *The Independent Magazine* in Sadeghee's loft apartment at 18 Charlotte Road, where 'Errata!' was performed, 'a confessional-style video dialogue/conversation, spoken to the camera as if in rap with an imaginary friend'.

'American Dream', and thereby able to inform the audience of her state of grace now, in addition to be able to accept interviews from the general public on aspects of teenage life in America today – though only seriously stimulating questions will be answered.

The artist is listed as 'Sadeghee & Daughters Ltd' as FN is in this instance acting as a production company, in a similar manner to the way that we organised successful real life events such as 'Fête Worse Than Death' and the 'FN First 'Party' Conference' earlier this year, actions where the main thrust was to 'recreate life' as opposed to the showing of art objects in galleries, and which included such luminations as Ska bands, Lucian Freud, Die Hard Jay, Franco's Pizzas, Leigh Bowery, Hirst and the Fair one, in no particular order. Please ask for the evidence to be submitted for constant approval. There is no extra charge.

Please note that for this exhibition the original premises of FN will be open, with notions of a Wunderkammer at heart, but that 'ERRATA' will take place at 18 Charlotte Road, EC2 and will be open at the following times: Thursday, Friday, Saturday from 12 till 6 p.m. or by appointment.

Further information is and always will be available. Leila Sadeghee can be contacted for lunch interviews in particular.

In an eye-catching illustrated article in *The Independent* magazine of 27 November 1993, Sadeghee is quoted: 'I'll be trying to expose the whole American teen-scene, the soulless masses who just want to drink beer and indulge in pseudo rebellion, spending their parents' money while turning into them. It's a good example of what happens all over the western world – people who create their own microcosms and don't want to look over the wall.'[25] Compston said, in his share of the interview: 'Being an artist would be far too limiting for me. I want the name of the gallery to become an all-encompassing brand name – I'd like to become an enlightened businessman.'[26]

'Whatever I do I will fail,' Compston had confessed to himself in a journal entry on 7 May 1989. 'Because basically I want to rule the world. Have complete command over myself and my millions of subjects. To execute them or adorn them in velvet. To commission cities out of lead, with rum at a penny a pint and murals by Max Ernst everywhere.' ('I do declare that Max Ernst, a painter and man never not beloved by me, is not a contributor to my horror'[27], he noted on a visit to Paris in April 1990.)

Compston at Manzi's, a Turkish restaurant on Kingsland Road, 2 October 1992 – Compston lent this photo for reproduction in the August 1993 edition of *Foreign Student* Magazine.

four

From the outset, Joshua Compston made clear his desire that Factual Nonsense should be much more than a modern art gallery. His aim was not success in any conventional sense: not for him the standard transition from radical East End firebrand into pillar of the West End art establishment. He wanted not to conquer the world but to transform it.

Compston's ideological rants in the studios and pubs of Shoreditch were littered with references to politics and to moral philosophy, garnishing his desire to lead some form of mass movement towards significant social change. If he seriously believed in this as a possibility, then he was deceiving himself. During periods of disappointment – which, given the immensity of his ambitions, were frequent – he tended to produce an off-puttingly loud noise, and was inclined to make an exhibition of himself in order to keep up his spirits. As a boy he used to wail in anguish: 'I want to be free, I want to be a bird,'[1] and although as an adult he accepted, without blame or bitterness, full personal responsibility for the course which his life took, there were times when he privately acknowledged vulnerability behind the invincible exterior. 'Yes, an excellent start to a new position,' he responded in a postcard to encouragement from a friend, 'but in no way are the woods clear of the weeds and tinned [sic] cans yet. Onerous amount still to be dealt with but with results such as

Compston in the Olympia stadium, on a visit to Berlin in May 1995 with the photographer Rut Blees Luxemburg, a neighbour from Shoreditch.

OPPOSITE Autumn 1995 portrait of Compston by Simon Periton, the eyes on his wrist plaster drawn by Gary Hume.

Gavin Turk poking his head through a
Frieze magazine cutout, part of Sue Webster
and Tim Noble's display at Fête Worse
Than Death 94. Turk and his family's move
earlier in that year to live at 22 Charlotte
Road was a result of their close friendship
with Compston.

Wednesday's at least some more candles have
appeared in the cave!'[2] This extraction of hope from
adversity was typical of him. 'Situation is pretty hell-
ish at the moment but somewhat fun as well,' he
wrote on another occasion, 'in the ironic "role"
sense of the word, not canapés and bores parties
which I have learnt aren't all that fine a fare.'[3] At
such times Compston searched aggressively for com-
pany, friend or foe. He claimed to enjoy confronting
his enemies, especially in disagreement about aes-
thetic principles, which, with quaint inappropriate-
ness, he liked to defend with his fists. His instinct
was for an archaic kind of anarchy, far distant from
the ideals of multi-national corporatism towards
which FN was theoretically directed.

Three weeks before the opening of Factual Non-
sense's first show, Compston's main benefactor,
Jeremy Fry, withdrew all financial support, due to
the unexpectedly high costs of a business venture in
Kerala. Three weeks after opening, Factual Non-
sense was technically bankrupt, unable to pay the
wages of its single employee (a part-time gallery
assistant), the rent, the rates, the telephone bill, even
the artist whose picture had been sold. Compston
talked of raising investment capital by selling prefer-
ential shares in the 'concept' of FN, of giving wealth-
ier well-wishers a chance to 'buy into' his future tri-
umphs. 'I am convinced of course that it will work

no FuN without U

Turk, *Tattoo* (1992). Carl Freedman suggests that 'Turk's practice is self-consciously built upon an acute sense of his own identity as an artist working within an international tradition but in London now.'

out,' he noted, 'but the slowness of those who should know better annoys me. But amuses me, in terms of my future moral superiority over them. Perhaps?'[4] His gallery assistant, Susannah Brooke-Webb, who had previously worked at the Saatchi Gallery, suggested that Compston apply to the Princes Youth Business Trust for funding – in pursuit of which, with the help of friends at Instant Muscle, a draft Business Plan of Factual Nonsense appeared in computer-print.

More manifesto than plan, the territory for action was limitless:

Factual Nonsense's operators and associates are confident it can achieve the following:
1 To be a forum for all elements disenchanted with the laxity and ennui of current thinking.
2 To act as a platform for musical experimentation, theatrical expression, and as a site for the promotion of manifestos, poetry, and other forms of literature through public readings.
3 To act as a commissioning body for a number of significant bodies of work which will address themselves to an audience way beyond the usual gallery-goer. These include:
 a An exhibition of coffins designed by sculptors and industrial designers, only some of which are one-offs since to achieve a new attitude towards death it would

Turk, *Godot* (1996), a photograph of the artist in Richmond Park, wearing an egg mask. 'What I wanted was a feeling of this character being outside in the world but still in a cultured space. I wanted to depict something which wasn't able to communicate anything more than the pictorial space it occupied.' Produced in an edition of ten one of which used to hang in Damien Hirst's restaurant Quo Vadis in Greek Street, Soho.

be necessary that some models were available in a cheap massed [sic] produced version. Therefore a City associate is currently researching the potential of starting a chain of avant-garde undertakers which would stock some of these coffins.

b The manufacturing of a large number of plastic banners, some of text only and others of pure abstract colour, which would be displayed in railway stations, shopping centres, stretched across streets, across the façades of buildings and other prominent public spaces. All would be of a large and impressive scale so as to compete for attention with the advertisements that would of course surround them. Some of them would also be paraded around the streets in a manner analogous to the trade guild displays, and the sewn banners that were popular in the East End of London in the 1890s. Artists of all hues would be asked to submit designs while politicians, intellectuals and others with something valid to declare would provide the text slogans. Industrial plastics predominantly used since this material is economical, easy to clean, repair, install and able to withstand outdoor climatic conditions for over five years.

c The commissioning of an exhibition of manifestos and other proclamations of creed, opinion and belief that have been written or published in the last thousand years of Western Culture. The choice of material would be catholic and … etc. etc.

no FuN without U

Turk's, *Betrayal of the Image*, executed in
September 1996 on a fellowship to the art institute
at Schloss Mosbroich, in Leverkusen. The title is
René Magritte's, his actual naming of the work now
universally known by its inscription, *Ceci n'est pas
une pipe*.

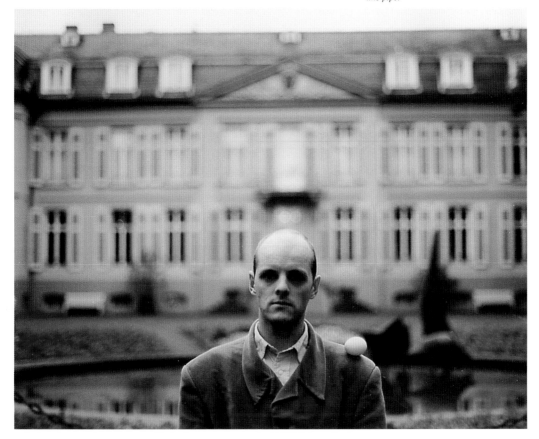

In another section of the report, Compston elaborated plans to set up a space in which artists could work and exhibit 'under the auspices of an umbrella organisational structure that would act on behalf of the galleriste and provide public relations service, opening parties, transparencies, comprehensive insurance and etc. ... The premises would also have a restaurant, a nightclub of cultured 'Grouchoesque' type and a large gallery space that would be under the guidance of Factual Nonsense but also available once a year to the gallery tenants.'[5] Compston mentioned in the report having given instructions to a local graphic designer turned property developer, James Lynch, to identify a suitable building, years before anybody thought of making Shoreditch into the bar-bistro Mecca it has since become.

Despite hearing – on 19 March 1993 – that the Princes Youth Business Trust had awarded him a loan of £5000, the financial pressures on Factual Nonsense remained relentless. Unable to pay his gallery assistant's wages, Compston became entirely dependent on voluntary support from artist friends to keep the premises open and mount exhibitions. The loyalty of his half-dozen closest associates to the FN cause was remarkable, inspired by the integrity of Compston's own twenty-four-hour, seven-days-a-week commitment. Family and friends also remained supportive. Never sure he would be able to

find the money to eat, Compston claimed to have trained his metabolism to accept food whenever it was freely offered – four or five times in a single day if the opportunities occurred, to be carried through several days without further sustenance if necessary. On hearing of his penury, a family friend paid one hundred pounds into accounts at two local cafés, enabling him to eat decent breakfasts on credit for a month. The contrast between the grandiosity of Compston's business plans and his actual circumstances disturbed those who, while believing in his basic talent, feared for his fragile grip on reality. Another friend funded a visit to New York, and Compston's diary entry of 26 April 1994 documents his irrepressible optimism:

Near the MOMA I sit in a cheesy diner elated and
confident that I am due to inherit history, a particular
history, titled, defined and stamped as a conglomerate
within art that becomes, via its process, its products and
its institutional support, readily itself. What the chains
have done and are doing to the other corners of the
common real (shoeshops, restaurants, hotels,
undertakers) can and must be done within art, bridging
out to advertising, media and commerce itself. The
fundamental difference it is and will remain lithe,
revolutionary and utopic – a critical, commercial and
constructed space as a company all in one. These

thoughts are my definitions, they come after much struggle and false leads. But in conversation and reception the reality of the above is proved daily, and people I meet enthuse about the desired incorporation of Factual Nonsense before the end of the year. Now I must do it and in my remaining days here in this marvellous city line up potential others to be conscripted to the FN conviction.[6]

Despite the urgent need to build solid financial foundations for Factual Nonsense, a revision of his first business plan did not emerge until the autumn of 1994, by which time Compston had been forced into living off social security and faced a possession order by Hackney Council's bailiffs for non-payment of business rates. The revised plan, though more realistic in its incremental proposals for development, was still couched in histrionic terms: 'FN aims to be perceived as a syncretic and synergetic corporation that produces and promotes a number of clearly defined products and services that exploit and eventually explode the gap between art, advertising, entertainments, high street retailing and real estate development.'[7] Disarmingly, Compston also acknowledged that he had attempted 'a literal impossibility for one individual unless an artist, in seeking to combine the management of profitable selling exhibitions with the promotion of passionate ideals for cultural

Handbill designed by Compston,
incorporating Gilbert and George's *Naked
Dream* (1991), in which he features in the
flesh, life size.

change.'[8] In his perverse determination to deny being the artist he obviously was, Compston continued to claim superhuman powers for art itself.

Early in the New Year another – again unfinished – version of the business plan was produced, and in March, still without a viable fundraising proposal to hand, Compston turned in desperation to Gilbert and George with the request for a loan. His long letter, headed 'Re: The shape of things to come', admitted: 'I have been so keen and so committed to my tenets and moral needs, so optimistic and enthusiastic about the end game that until recently I had lost sight of reason and business cunning. As a result I cared not a hoot that I was living on continual sandwiches, sleeping on a shelf and facing constant and consuming crisis time and time again. Though I was not an artist my lack of means forced a false bohemian cloak to be applied to me: while still in the burning clutches of youthful idealism I really thought that people would realise the necessity of the movement and that I would only have to act as a martyr for time enough for a mass movement to form. I misjudged the nature of the art world, I realize now that an inherent conservatism rules their ways and that if one is to succeed one has to start thinking of business in order to manipulate from within ... If you think I am mad then I know how I am – ultimately I am not! ... The barefaced request

Gary Hume, *Sentimental Drawing* (1992), executed in oil on newsprint. Appreciative of Compston's ceaseless encouragement to creative endeavour, Hume wrote: 'Artists have egos in a constant state of war. Ravaged between the useless and the underrated.'

is therefore can you lend me £3000 until the middle of May upon which I am happy to pay interest or recognise what would be an extremely helpful gesture in any manner you thought appropriate. I don't wish to ask anyone else and I would not ask such a thing unless I was thoroughly frustrated at not being able to work. I leave it in your hands. Could you give me an answer by the end of the weekend? I remain yours forever. Joshua.'[9]

Gilbert and George did not reply, and in June Compston sent a follow-up letter, headed 'RE: The way we were then', beginning: 'It doth seem that for reasons of your own you no longer have the time nor the energy to entertain either the thought or the reality of FN'[10] By then he had finally edited down his business plan into the impressive 'Proposal for Masthead Sponsorship'. Forthcoming exhibitions and events were listed (notably, plans for the publication of a Sarah Lucas paperback and solo shows of Gary Hume's drawings and of Mat Collishaw's prints), and the gross annual costs budgeted at approximately £74,700. Furthermore, Compston analysed astutely the sponsor's role, detailing the advantages to Factual Nonsense: 'The sponsorship will act as both the lever and the covenant by which it can fill the gap between development cost and development value.'[11] – and outlining some of the benefits to the sponsor, including 'opportunities to be advised on

corporate art programmes, branding through the arts and other modules in which art can work directly within commerce to create enviable and vital public relations between the sponsor company, its clients and customers.'[12]

Through personal contacts, Compston gained appointments with the chief executives of the *Financial Times* and of MAI plc, owner of Express Newspapers, MTV and dozens of other media companies. Their responses were encouraging. The *Financial Times* commissioned Factual Nonsense to produce a feasibility study on the investment acquisition of works by young British artists to match the collection of contemporary art formed by Lord Drogheda, the FT's Chairman in the 1950s and 1960s. While MAI plc set in motion the process for consideration of £30,000 per annum sponsorship of Factual Nonsense for a trial period of three years. After his meeting in Charlotte Road the MAI man commented: 'Messianic energy! I reckon in three years time he'll have achieved the impossible or be dead!'[13]

While promising to produce promptly the material requested to follow-up on these developments, Compston for once appeared reluctant to act. A few weeks later he broke his wrist, as if incapacitating himself purposely: his party trick of climbing out of windows at gatherings to stand on the sill and terrify fellow guests went wrong – falling from a second

Official portrait of 'The Chairman, FN Holdings' by Bid Jones, in ironic acknowledgement of the fact that Compston was the sole, seldom-paid employee of Factual Nonsense.

floor window, he was lucky not to damage himself more seriously. Friends argued the plain necessity that if Factual Nonsense was to survive, Compston had to make contractual commitments to a realistic business plan. But after journeying so long in his solitary quest, Compston was unable to release even partial control, or to contemplate any kind of limitation on his visionary ambitions.

Though his external drive for martyrdom was strong, the inner reason for Compston's reluctance to respond to the *Financial Times* and MAI plc was more complex and moving. The truth is that Compston remained convinced he had not yet done enough to deserve the faith of an independent sponsor; high though his expectations were of others, there was more he needed to prove, to himself, before daring to be helped. He suffered from the excessive demands he made on himself, from critical failure in his own eyes. Behind the bravado Compston lacked, in the theologian Paul Tillich's words, 'the courage to accept oneself as accepted in spite of being unacceptable.'[14]

Direct comparison is invidious, but Compston's proposal – announced already in January 1993 – to accommodate in Factual Nonsense's prospective premises a restaurant, nightclub and gallery space[15] anticipated Damien Hirst's seamless transition from creator of art to owner of a chain of restaurants.

Angus Fairhurst, *Man Abandoned by Space* (1992), a paintings and video installation, illustrative of a point made by the artist in conversation with Marcelo Spinelli: 'A lot of things I've done actually are more about a process I've gone through. Often it's a repetitive process. So I think of all my work as being time-based.'

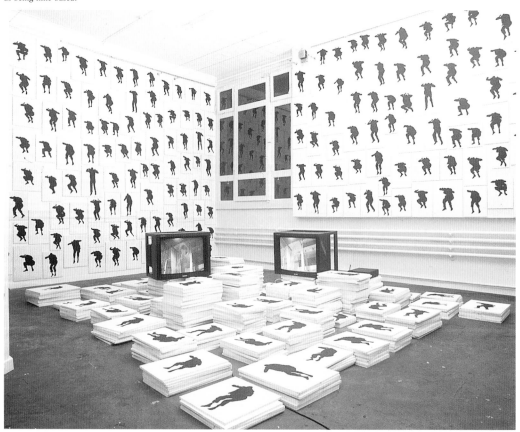

no FuN without U

Fairhurst made a large number of drawings in the early 1990s of gorillas, this characteristically anthropomorphic creature with a shark's fin strapped to its back.

Compston thus saw the future but failed to make it, due both to an inability to manage money and to his inherent impatience, his need to be forever on the run. With this fear of drowning in the mainstream he was perhaps closer to Angus Fairhurst than to Damien Hirst, in particular to the character portrayed in Fairhurst's video of 1995, *A Cheap and Ill-Fitting Gorilla Suit*: 'I start off naked, sewing a piece of furry material into a fairly loose approximation of a gorilla suit. I put it on, stuff it with newspaper, and then jump until the whole suit comes apart and falls off. At the conclusion I'm naked again … You can't always explain everything. That's not even what people want. You have to keep on trying to make things and show their edges. The edge becomes the important part, the part that allows people in.'[16]

Factual Nonsense's financial problems remained unresolved, and a friend of Compston's expressed the concerns of many in an open letter of 13 October 1995, designed to be used publicly for fundraising for FN

Fairhurst, *Short conversation with a cheap suit* (1996), an unending artistic dialogue: 'Gorillas are a useful image because they're very close to human shape, so you can draw them doing human activities without having to characterise or personalise them. They represent a certain kind of thing in mankind.'

I can understand how the strain of living/working as you do at the moment must, at times, feel intolerable. Clearly, if a resolution to FN's financial constraints does not soon emerge, then, for the sake of your own well-being (present and future), you'll have to shift the battle to some other front. And yet I feel you're close to achieving

the base you need from which, step by step, to realize
your ambitious vision.

The June 1995 document 'Proposal for Masthead
Sponsorship' outlines in communicable form the
principles of FN's plan of action. With a determined
tightening of the focus on practicable implementation of
these principles, progress can be made. It is impossible
for the many exciting artists you know to develop their
ideas through FN because you don't have the money to
offer them a business-like service. With no alternative
way of securing public attention to their work they are
pushed into the arms of conventional West End art
dealers such as Jay Jopling and Anthony D'Offay. FN
has no desire to be merely a contemporary art gallery,
but intends to set up something more radical and
creative, a business capable of 'brokering fundamental
social and Material changes'. If such a business existed,
many of the artists of distinction represented by Jopling,
D'Offay etc. would be happy also to participate in FN
projects. Similarly with the working partners (executive
co-directors) whom you seek. You would neither expect
nor recommend anybody else functioning as you do,
without salary or security. Again, if there was a
financially and organisationally defined structure for
bright co-directors to join, they would. The task is to
make firm decisions, right now, as to precisely how FN
should best operate for the next two or three years, and
from where solid finance can be obtained to enable it to

do so.

I would like to propose inviting a selected group of supporters of FN to meet here one late afternoon or early evening this month to help you decide how to proceed. This group should include anybody who you would wish to be an executive director of various branches of FN's proposed activities. You may also wish to invite others who, like me could contribute in a non-executive (and unpaid) capacity. Although working partners are essential in order to have any chance of realising your ambitions, you also need finance, and personal introductions to the Chief Executives of the Financial Times, MAI plc and the Henry Moore Foundation have already thrown up the possibility of funding in the form of, respectively, curatorial fees for forming a collection of contemporary British art, unfettered annual sponsorship and one-off project finance.

It is time now to co-ordinate support for FN. You have done more than enough to prove your very considerable abilities. Let's get together to consolidate FN's achievements to date and build firm foundations for storming the next millennium.[17]

Gilbert and George dedicated this 'For our Darling HARDCORE' envelope to Compston over supper at a Bangladeshi restaurant in Brick Lane in November 1993, later embellished with Gilbert and George China 1993 memorabilia and two CND badges.

None of these troubles stopped Compston planning and producing exhibitions and events. His press release for the Christmas 1993/4 show was in the by-now-expected style: 'Factual Nonsense solves more

The work of Dan Asher and Piers Wardle in an installation shot at Factual Nonsense of 'Hardcore (part one)', on show from 26 November 1993 to 29 January 1994.

Compston and Asher in Aurel Scheibler's gallery in Cologne, October 1992.

problems than it creates with 'HARDCORE' (the first part) with work by Gary Hume, Andrew Capstick, Fiona Rae, Piers Wardle, David Taborn, Darren Coffield, Rebecca Bower, Dan Asher, David J Smith ... The theme tune/advertising slogans for 'Hardcore' are: 'most uneven and weird' (as those not in touch will refer to this manifestation or the whole FN idea in general) – 'the good companions in the crusading years' – 'everyone's going to be complaining about the victorious hanging' ... The works on show or the artists in person, in fact, in the actual quivering flesh, subscribe to notions of Maturity, seriousness to varying degrees and could not be stated to be damn fools, frivolous or silly billies.'[18] Cash crisis forced a delay in the opening of the next exhibition, 'David Taborn's "Seamless Cream"', until mid-May 1994. This invitation marked a first public appearance for the bright red signature sticker FN (no longer F.N.), by which initials Compston by then religiously referred not only to Factual Nonsense but also to himself.

Meanwhile, preparations had long been underway for the publication, in collaboration with The Paragon Press, of a portfolio of fifteen text-based prints, called Other Men's Flowers, taken from the title of Field-Marshal Viscount Wavell's wartime anthology of poetry, itself extracted from Montaigne: 'I have gathered a poesie of other men's flow-

Birthday card to Compston from Andrew
Capstick, inscribed on the reverse 'Onwards
and Upwards! Uniqueness is not forgotten.
1 June 1994'.

ers and nothing but the thread which binds them is my own.'[19] Compston wrote to Scheibler in Cologne on 26 February 1994, telling him that he had been 'curating this project for several months and it is a joy to be working with such a distinguished partner in the Paragon Press, who you will recall published the London Portfolio two years ago, after having completed under the founder's direction, Charles Booth-Clibborn, more than twenty-five projects in seven years working with such artists as Richard Long and John Hilliard.' The letter continued with a couple of characteristic flourishes:

> I keep on being asked by Tracey Emin and occasionally by Sarah Lucas where on earth the Material from their Bethnal Green shop that I deposited with you in November 1993 now is. They want it all back in the very near future, with a full account of what sold and to whom and with any remittance due to them enclosed without delay. The reason they are as it might seem to you and me so demanding is that they burnt the majority of the remaining stock from the shop when it closed down and what you were given for your show is half of all that's left in their possession. They were reluctant to part with it and it was only my insistence that the work would form part of a good show and that the hands that touched it were honourable that made them turn their heads. Please give attention to this matter to avoid the

Compston adjusting Factual Nonsense's display table of press material during a private view.

Compston launched 'Other Men's Flowers' – the title culled from Montaigne: 'I have gathered a poesie of other men's flowers and nothing but the thread which binds them is my own' – in a derelict sawmill off Hoxton Square on 23 June 1994.

darkening of our names.

As regards Crabtree I of course feel as guilty as a choirboy caught undone for owing him £3000 plus for more than a year ... I will soon be in receipt of money, and what can be spared will go to him. This however will be little so please try and pay him off the £2000 outstanding for the Magenta II sale within the next few days otherwise he suffers, as does his work and my conscience etc.'[20]

According to Compston: 'The project has produced an exciting and innovative publication that intrinsically embodies the elegant but underused printing technique of letterpress ... that has allowed and encouraged many hitherto solely image-based artists an opportunity to operate within the realms of 'copy writing', providing them with a platform from which to sound off any phrase, slang discovery, polemical essay or related literary form. The publisher and curator are delighted that the participants 'ran with the bulls' and came up with multifarious intriguing and exciting solutions to the 'instructions'. They produced works that responded to the given brief of a letterpress printed text piece; a stricture that to the uninformed outsider might have looked confining in scope; but proved not to be so when placed in the hands of artists blessed with pungent perceptive capabilities and active intellects, thus

bending the given 'command' twisting and turning on its head.'[21] The fifteen artists content to receive FN's declamatory seal of approval were, in alphabetical order, Henry Bond, Stuart Brisley, Don Brown, Helen Chadwick, Mat Collishaw, Itai Doron, Tracey Emin, Angus Fairhurst, Liam Gillick, Andrew Herman, Gary Hume, Sarah Staton, Sam Taylor-Wood, Gavin Turk and Max Wigram. The names of Sarah Lucas, Louise and Jane Wilson and Gillian Wearing were also included on the original list of intended participators. (Lucas had proposed the text 'SARAH LUCAS IS WHOLE', 'in bold Helvetica with 'W' cut out of the actual page'[22]). The individual responses to Compston's brief are instructive. Helen Chadwick, for example, used a stylised version of her own fluid handwriting to run together the words 'adore/abhor', the script sloping in opposite directions. Tracey Emin wrote out one of her strange, essentially autobiographical stories. Sarah Staton created political slogans which were simultaneously hard-edged and poetic. Gary Hume, declining to compromise his established aesthetic, produced a suitably playful image, the letters drawn in such a way as to communicate several different messages, while appearing at heart to say 'HAPPY'. 'I am happy to hear from Gregor [Muir] that you have made me Happy,' Compston wrote. 'Artwork ready, the revolution continues. As per usual if there is anything I

'Other Men's Flowers' (1994), a portfolio of letterpress prints by fifteen artists selected by Joshua Compston and printed by Tom Shaw for The Paragon Press, with preliminaries designed by Compston, including 'Foot & Mouth', taken from a National Union of Farmers poster of the 1960s.

adore abhor

Helen Chadwick

Andrew Herman

Cunt.

Sam Taylor-Wood

For Joseph Samuels 1981

The first time I met Joe Sonning —
I remember it clearly. I was 12
Staring out of the youth club window —
pushed away lost in a world of my own.
Joe came up behind me — And grabbed at
my bottom.
My first period had started — And what
Joe grabbed was a hand full of something
powerful — we both stood there motionless —
Please Joe I said — Please Joe don't
tell anyone — He smiled — by long swim I like
feels — So what he said — your on the Rag —
It's funny he never did tell anyone — it
stayed an accurate —
I always liked Joe for that —

Paul stood in front of me — tears running
down his face — I've got to go to the
police sir — I've got to tell them
what I know —

Selling hand fulls of Glass to any one
interested —
The last day Paul & Joe spent
together — They'd get into a few scraps
it was to be expected in Margate —
Hoards of Boy trippers would just
Roll into the mains looking for
adventure — Fighting was all part of
that —
BUT this day was different — Paul & Joe
had been getting non stop hassle from
a gang of Marines — Big beefy
ugly total kind arses —
The Day was really heavy — it was
early evening — Paul & Joe sat on the
harbour wall — The sun was muggy
and the green fly were out —
It was going to be storms —
Paul & Joe stopped a few Glass and
decided to go their separate
ways —

I hated it when Paul cried not because
I felt sorry for him — but being Paul we
always felt each others pain —
Joe had been missing for 5 days
No one had seen him — he'd kind of
vanished off the face of the earth —
A difficult thing to do in Margate
A leward seaside town — where you
was nothing to do but blend with the
grannie's dozing — Time around — Piek — be
finished — fight and wish your life
away —

Paul & Joe had spent the Summer
Laring around in the years near the clock
tower — You could always find them
there, drinking cocktails of wacky residue
Joe in his strappers — lou shoeman
braces & boots — Paul with his bleached
blond mohican — day cotton & louring gear.
Both 18 looking good always flash
with pockets full of money —

Three days latter Joes body was
washed up on Margate beach — Puffy
bloated unrecognisable — His black skin
had turned white — and apparently his
fingured nails had been smashed and
every bone in his hands had been
broken —
At the inquest, there was never
any real explanation for this — Every body
knows that Joe couldn't swim — It was
easy to give a verdict of death by
misadventure —

Paul always believed the Marines
had done it — Paul and I cryed together
as we imagined Joes last moments
Clawing to the harbour wall — as one
by one the Marines took it in turns
to stamp on Joes hands
until he finally let go.

Tracey Emin 1994

Tracey Emin

Gary Hume

Don Brown

no FuN without U

Sarah Staton

can provide please tell me by whatever means available.'²³

The portfolio was launched at an exhibition mounted by Compston in a derelict saw-mill off Hoxton Square, with a party billed to be a 'huge, throbbing, old style 1980s "attraction of the month"'²⁴. Typically, not all the prints were yet signed. Mat Collishaw sent on the morning of the show a fax from the Museo d'Arte in Castello di Rivoli, near Turin:

JOSH

HI

REALLY SORRY THAT ALTHOUGH YOU WERE TOP OF MY
LIST OF PRIORITIES I DIDN'T GET TO SIGN THE PRINTS. I
SUGGEST THAT IN TRUE FACTUAL NONSENSE STYLE YOU
SIGN ONE FOR ME OK? IT GOES LIKE THIS ... (Collishaw's
signature).

 GIVE IT A COUPLE OF TRIES + SCRIBBLE IT DOWN. HAVE
A GREAT OPENING. SEE YOU SOON.

MAT²⁵

Itai Dorin

five

Compston began to draw up plans for his second Fête Worse Than Death (FWTD '94) in the early weeks of January, in a determined effort to meet costs in advance. Greatly expanding the scale of the event, he shifted its location to Hoxton Square and the adjoining courtyard of Circus Space, the circus-skills training school on the other side of Old Street, a few hundred yards from Factual Nonsense's Charlotte Road premises. Vitality was returning to the streets of south Shoreditch in response – to a large degree – to the public attention surrounding the activities of Compston and the other artists who had colonised the upper floors of vacant furniture factories.

One of the consequences of this was that a shrewd property developer, Glasshouse Investments, had worked out how to unlock both central government and European grant aid for arts-related building projects. Their major achievement was the recent construction of a high-tech cinema, video and exhibition complex in Hoxton Square, a new home for the London Film Makers' Co-operative. In the 'Proposed Financial and Administrative Structure for the Fête Worse Than Death 1994' which Compston circulated in February, Glasshouse Investments were to supply office facilities and financial management of the core funding he hoped to generate through the Dalston City Partnership, an influential local player in the inner city regeneration game. FN's thorough

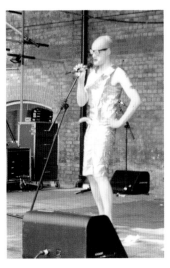

Turk's performance piece at FWTD '94, mimed to David Bowie's song Scary Monsters, while excreting artificial sausages from his false bottom, a string of real sausages cling-filmed across his stomach.

OPPOSITE FWTD '94 collage, the stewards' T-shirt designed by Gavin Turk, the programme designed and printed by Tom Shaw.

Improvised music group Settee, on stage in Circus Space's courtyard at FWTD '94, from left to right, Mike Walter on saxophone, Adam Bohman on prepared strings and amplified objects, John Russell on guitar and Thomas Lehn on Moog synthesisers. The musical performances at FWTD '94 were co-ordinated by Adam McEwan.

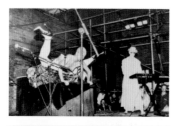

Leigh Bowery formed his neo-punk band Minty for Factual Nonsense's 'First "party" Conference' at the Barley Mow pub in November 1993. In his and Minty's performance at FWTD '94 Bowery gave birth to a crimson-painted naked woman, concealed within the belly of his costume. To shrieks of horror and delight from the audience of a thousand, he then urinated into a glass, from which his offspring drank. These photographs, taken by FN regular Iris Athanasoula, were published in the art paper *AbeSea*.

proposal budgeted for total costs of £24,640, including the request for a £6000 fee for Compston himself, 'the central organiser and overall artistic director,'[1] answerable to an advisory board to be formed of representatives from local businesses and community groups, Hackney Council, Circus Space and the Bass Clef, the jazz club then operative in the basement of the Hoxton Square building later taken over, and in 1998 vacated, by the popular Blue Note. Ever optimistic, Compston envisaged FWTD '94 turning in a profit, to be split between Factual Nonsense and the council, through selling on-site advertising in a manner first proposed for his and Gavin Turk's as-yet-unrealised 'Utopic Space Manifest Module'. At this stage it was also his intention to fence off the surrounding streets and charge a £5 admission fee to the multiple happenings in this day-and-night event.

Such promising organisational discipline was short-lived. Compston soon lost patience with the bureaucratic reality of grant applications, road closure permits and special licence wavers and threw himself instead into communicating this year's ideas to artistic collaborators. With the predictable result that as the scheduled date of 30 July approached, there was little chance of his raising the money to pay for the 'Hybrid 'Pop Culture' Extravaganza' he felt publicly committed to presenting.[2]

no FuN without U

Jessica Voorsanger's *Star Way to Heaven, Addresses to the Stars* at FWTD '94 in Hoxton Square.

While headed for financial disaster, the line-up of delights was indeed impressive, offering 'a wicked funky day out for friend and foe alike.'³ From three in the afternoon until after midnight 'a rolling magic carpet of music and performance'⁴ was presented on the main stage in the Circus Space courtyard, ranging from one-man shows such as Gavin Turk's 'Killers and Cannibals' and Cerith Wyn Evans' 'People should beg God to stop' to the riotous public première of Leigh Bowery's neo-punk band Minty, during which the artist gave birth to a gold-painted naked woman, concealed until the revelatory moment within the belly of his sequinned stage costume. And, of course, there were bands and DJs playing music to dance to, this section of FWTD organised by Adam McEwan. Elsewhere, Ione Meyer's Painted Faces Theatre Co., with special guests Bi Ma Dance and Graeae Theatre Co., performed Scathach of Skye, a Celtic myth transposed into the style of the Beijing Opera; while Blast Theory journeyed in the opposite aesthetic direction with their physical theatre creation 'Invisible Bullets', a four-hour rendition of murder and mayhem in Northern Ireland. At No. 2 Hoxton Square Celestial Bodies, an ambient video instalation by Thomas Gray and Rene Eyre, with music by Julian Moore, was presented in continuously altering form every hour on the hour. Another, more traditional, attraction was a Magic

Blast Theory performed *Invisible Bullets* in Hoxton Square, an enactment of carnage and chaos in Northern Ireland.

Ione Meyer and her Painted Faces Theatre Co. staged a Beijing-Opera-style performance of the Celtic myth *Scathach of Skye*.

Georgie Hopton and Sarah Staton's
Anarchy Hospital.

Compston being operated upon by Nurse
Hopton.

Roundabout made in 1911, powered by an antique steam traction engine.

On the grass beneath the giant old plane trees in the square itself dozens of artists erected their own stall-based mini-shows – as listed, with many intentional inaccuracies, in the official programme: 'London Pride' by Mat Collishaw; 'Chapel of Love' by Georgie Hopton and Mariol Scott; 'Cabinet Gallery's Mutilate the Melon Man' by Simon Bill; 'You can have your cake and eat it' by Philippe Bradshaw and Andrea Mason; 'Deep and Meaningless' by Simon Periton and Sean Kimber; 'Stairway to Heaven, Addresses to the Stars' by Jessica Voorsanger; 'Your Self-Portrait' by Sue Webster and Tim Noble; 'Thick as Two Planks' by Renato Nieimis; 'Tea with Jibby' by Jibby Beane; 'Tinker, Tailor, Soldier, Artist' by Mick Kerr and Penny Govett, and many more. Kerr, renewing his theme of FWTD '93, this time provided paints for punters to decorate his cut-up planks, for which they were awarded a pseudo-Royal certificate: 'This is to certify than in the interests of art ... contributed to the multiple 'Who's Afraid of Red Yellow and Blue?' at A Fête Worse Than Death on 30 July 1994'. From these he made up for his own use a set of chairs, some of which later found their way to The Cantaloupe, an award-winning bar in Charlotte Road. Tracey Emin teamed up with Tom Shaw – who, as usual with FN

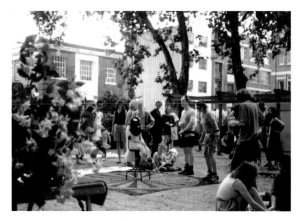

Tracey Emin and Tom Shaw's Rodent Roulette.

events, had designed the posters and invitations – to present Rodent Roulette. They made a large canvas roulette board and placed at the centre a swivel chair, on which the volunteer sat, a rat mask pulled over his head, holding a long stick in his hand. Round and round they whirled the chair, and when it stopped the stick pointed to one or other of the numbered black and red segments, according to which hand-made prizes were distributed. Emin had recently published, in a limited edition of 200, her autobiographical narrative *Exploration of the Soul*, designed and printed by Shaw. On the acknowledgements page at the back she printed: 'I'd like to thank everybody who helped me with this book – Especially Tom for being such an expert – Everyone who helped sew the bags – And of course all those who bought the book in advance – before I'd even written it – Thank you for your faith – Tracey Emin, 1994.'[5] Faithful comradeship was at the heart of these artists' lives. Compston had always encouraged Emin to publish her writings, and in gratitude she gave him a story to print in the FWTD '94 programme – 'Like a fucking dog – when the truth is hard to bear'.

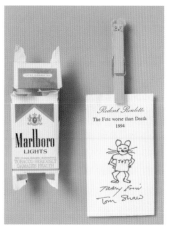

Two of the prizes Emin made to distribute to winners at Rodent Roulette.

LIKE A FUCKING DOG – WHEN THE TRUTH IS HARD TO BEAR

I waved good-bye to my Mum at the schoolgate – it wasn't her fault I smoked –

As I walked back round to the girls' cloakrooms – Tina Divine came scuttering up beside me –

Tina Divine – what a name – she wasn't! Just fat and sweaty – a bit greasy on the centre parting and slightly friendless – most of the other kids felt sorry for her because her Mum had died –

Tracey was that your Mum I just saw you with – what happened about the smoking?

Nothing I said – my Mum knows I smoke. She gives me the odd fag here and there –

Wow said Tina – I always thought you'd have a cool Mum – but I didn't think she'd be old –

Suddenly the whole world stood still – the clouds stopped – the blossom stopped swaying –

And I screwed my face up – and said – At least I've got a fucking mum –

Before Tina could reply – with one all mighty shove, I pushed her down the bank – she rolled like a little lump of dough – smashing into the cherry tree –

As I said Tina didn't have too many friends but she did have her cousin Sally Sayers –

I came out of class a huge crowd had gathered on the field next to the old Flint Huts –

Tina was there waiting with Sally by her side. Sally Sayers wasn't big – but she was butch built like a boy – A hard boy – with muscle – And a thick jaw – when we all got tits her voice broke –

There was no way I was going to get out of this – they weren't letting me pass –

What's up Sally – I said – your willy not grown yet –

Everybody laughed –

Shagged any girls lately – or are you too busy playing football with the boys –

Her fist came flying at my face – it felt like a fucking hammer –

I wobbled a little bit – And I turned my face – And said – Oh yea – lesbo lets see you do that again –

And she did – Crack – right round my head –

Everyone was shouting – Fight – Fight – Fight –

So I coolly took off my blazer and removed my front false teeth – and passed them to Maria
who stood next to me –

Before Sally had time to hit me again – I grabbed her – one hand hold of her hair – the other
tightly on her collar –

And as the bright spring light shone down – I summoned all the Gods – And smashed her face
into the flint wall –

Again and again – And again – blood started to squirt everywhere – The shouts of fight had
stopped – and other girls were trying to pull me off, but they couldn't –

I was like a senseless animal –

And she was becoming nothing –

Finally she fell to the floor – a small sobbing blubber mess – Yellow lumps the size of eggs
began to appear –

Walking away – I pulled my socks back up and tucked my shirt back in –

And turning back – I shouted that will teach you –

NO ONE – Absolutely NO ONE
CALLS my mum OLD –

This story is for Margerite Girlinger – the greatest love of my Mum's life –

For 16 years they'd been (as my Mum would say) MORE than just good friends –

Margerite died of cancer last year –

July 24th 1993

Tracey Emin June '94

Turk's helium balloon for FWTD '94, made in collaboration with Alister Horton and Deborah Curtis.

FACTUAL NONSENSE

purveyors of the

ND (SFM)
Notorious Dream (Struggle for Modernism)

Present the all time consumable T-shirt made out of durable 100% cotton.
Printed in Croydon, home of Kate Moss and D H Lawrence to a design of the much acclaimed genius of the speculative pursuit:

Mr Gavin Turk of Charing Cross Road

Conceived to the most absolute standards of the NEP – an enactment of a collaboration between FN, Phil Taylor and GT.

Consumer Information:
As featured in *The Independent London Magazine* 29 July 1994
As featured at the real time hybrid non-pasteurised entertainment (where it was worn by all the militant troops) 'The Fête Worse Than Death' 1994

Above all remember: FN *makes sense*
so wear your T-shirt with pride in the founding faith of the idealist exchange mechanism.

Guy Moberly's photographs of the FWTD '94, including Simon Bill's Cabinet Gallery's Mutilate the Melon Man, Gillian Wearing's The Latest Greatest Tom Bolan, Jibby Beane's Tea with Jibby, Alison Gill, Roz Lowrie and Emma Rushton's Würst Girls, Maureen Paley at Rod Dickinson's Alien Cakes, Simon Josebury's Placebola, Mick Kerr's Tinker, Tailor, Soldier, Artist, and John Marchant's Biba Love and Commander Marchant's Big Pink Cake.

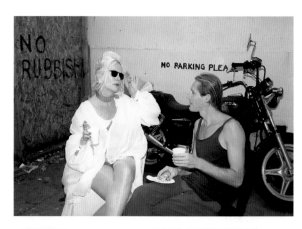

no FuN without U

FWTD '94 was an epic artistic success, attended by over four thousand people on a perfect summer's day, lasting long into the night. In managerial terms, however, it failed. Insufficient liaison with the local community lead to a catalogue of complaints, not least due to the police towing away cars legally parked on residential permits in Hoxton Square on the early morning of the fête, without informing their owners that any such event was taking place. Hackney Council felt compromised and accused Compston of taking unfair advantage of their initial support for his project, the conditions for official endorsement of which were never met. FWTD '94 lost Factual Nonsense over £4000, money it did not possess; there were no funds to pay the agreed expenses of the theatre groups and bands. Compston fell out with Glasshouse Investments, blaming them for his own financial mismanagement. Writs and counter-writs flew, the euphoria of the day itself disintegrated into bitterness and regret.

Although A Fête Worse Than Death '94 later appeared on a shortlist of three for the £5000 British Gas Properties/Arts Council Award 'Working in the Cities', this irony did not, regrettably, extend to Factual Nonsense's winning of the award. Left, along with his debts, with a stack of unused T-shirts, designed by Gavin Turk for the FWTD stewards to wear, Compston cheered himself up by producing a

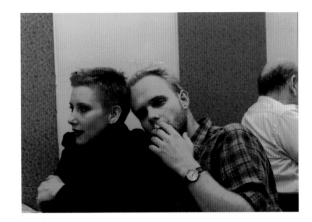

Compston working with Clémentine Deliss in November 1994 on the Africa '95 series of happenings which she curated.

characteristically extravagant sales flyer.

Little was publicly heard of Factual Nonsense for the next nine months; although privately he continued to share his and his friends' enthusiasms, producing in December 1994 an imaginative paper on the Advertising and Profiling of Africa '95 for its Artistic Director Clémentine Deliss, incorporating one of his obsessional themes, the erection of vast street banners. He also engaged in a series of recorded discussions with Iain Forsyth and Jane Pollard, publishers of *Words and Pictures*. The text of a structured conversation which took place on 20 and 21 August 1994, corrected in manuscript by Compston in September, articulated in relative calm his current thinking:

I nurture very strong ideas about how the communicability of art can be increased, thence underlined and emblazoned beyond the notional white columns, white walls, ice box situation ...

It's not part of the artist's job to entertain people. However, they should, in line with white collar workers, organisers, curators, art managers, administrators or whatever you want to call them, find ways of deliberately opening up that media space to become part of a general rule. It's important to try and find ways of splitting and opening up that particular crack in the door while not losing what I believe is the intrinsic high seriousness of

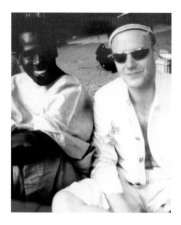

Compston and El Hadji Sy, co-organiser
with Deliss of Africa '95, here shown at
The Hanging Picnic, Factual Nonsense's
summer art event of 1995.

art, it's ability to act as critique and intellectual
construct, a kind of assimilation of our times. So while
not forgetting those imperatives, I think it is important to
find ways of promotion and presentation that do
engender and usher in the notion of entertainment. It's a
matter of forming a holding structure, viz the two Fête
Worse Than Deaths, where salt can be presented as
sugar. Thus contemporary art can be promoted in such a
way that people are not aware of some of its nature and
so they're being entertained, but at the end of the day
they realize that they're receiving a different form of
entertainment, instructions and codices than if they went
to see Danny La Rue in Tottenham Court Road ...

My ends are to try and engender artistic thought and
artistic practices under many different guises, both in
terms of art full of 'art-ness', and artwork that is not
essentially full of 'art-ness', to then bring both of these
entities to the forefront of public taste, and the
possibilities of absolute public consumption ...

My interpretation of sites for FN and art is extremely
wide. So far I've been forced to work with a reasonably
limited number of sites, but at the end of the day, in my
end game, I'll be defining sites for FN activity in terms of
magazines, television, large scale billboard format
advertising and, if it really works and I manage to do
what I'd like to do, within all the streets, identifying and
thence 'branding' certain towns and geographical
areas ...

no FuN without U

I think that given a dose of strong headedness, 'wrong-headedness', tenacity, will, a general understanding of the situation, then if one wanted to, once one has one's space, one can effectively, if one's prepared to take flak, declare anything and everything possible within the realms that one controls. One day it could be a pinball parlour, the next day it could be a brothel, and the third day it could be a show of contemporary shoes. Then it is indeed not actual politics, but it's playing at politics, it's playing at definitions, it's playing at context, it's playing at representation of the holding structure; and within London, it's a reasonably small board in terms of players, but in terms of audience it's potentially immense. If one is absolutely switched on to one's inner necessity, then one can go beyond the play and become actual ...

I think the situation faced by artists at the beginning of this century, and now, is that old scenario of 'us and them'. We all have our different colours, smells, understandings and problems, stratified educational backgrounds and interests, and hence all different forms of art are created that correspond to the different realities outside that art. Therefore, I often think it's a valid and valiant venture when some artists decide to fundamentally address that us and them problem, to make work indicative of their fears and critiques of the shapeless horror of the 'other' ...

Ultimately, the most profound and aggressive risks,

and those that carry within them the possibility of real change and real emancipation from the holding structure of any art gallery, are those that will happen outside the commercial galleries ... Much more than is healthy, artists still consider themselves far too much as artists, and they still consider themselves far too much indebted and enthralled by the gallery situation. To my mind, there's not enough healthy antagonism and healthy disinterest in dealers and art galleries. I think we can mention our friends and colleagues Gilbert and George in relation to this question. They could set up a whole series of alternative sites, completely nothing to do with the gallery structure, make money, empower themselves and increase their truly popular status. But they don't choose to do so, they choose to remain very much definitively as twentieth-century examples of art as life, as artists, and to remain within the gallery structure, albeit on their own terms. It is to be hoped that in twenty years there will be artists of similar status to Gilbert and George who, in a public way, do not need to return to the gallery ...

I think that post-modernism, when it becomes a style, a practice, a way of life is inutterably wrong because what it is doing is academically condensing what is merely available in daily life, and making it into an art form of epicly boring proportions, because the real thing in itself is far more interesting. Popular culture is far more of a come-on in its raw, unmediated un-art-

processed state than it is when it gets into the hands of an artist or an architect or a musician. Unfortunately post-modernism has become manifest in artistic practice, but it shouldn't have done. That art which, while going forward with art goes forward as art and at the same time nevertheless takes stock of itself and acknowledges the 'other', is much more valid than that art which tries to simply acknowledge and represent the other as the other, with no hope behind it. It's quite a fine line but one I adhere to in my daily ablutions.

During this time, while working on successive drafts of FN's business plans and sponsorship proposals, Compston also considered commercial options for making the money to fund his artistic idealism. An inveterate city walker, with a passion for semi-legal exploration of run-down sites and derelict buildings, he thought of hiring out his knowledge of London's byways to property developers on the hunt for neglected areas in which to invest. Keen on a disused synagogue off Brick Lane, Compston tried to persuade Eric Franck, a business man turned contemporary art dealer, to purchase the property and transform it – under his salaried direction – into an experimental art space. Ahead of the fashion for loft spaces, he negotiated from his friend James Lynch the conversion option on an industrial building near the Old Street roundabout, convinced that he could

entice the parents of ex-school friends to exchange their precious homes in Fulham for spacious shells in Shoreditch. Nothing at all resulted from this intense activity. Still desperate for money, Compston applied for part-time posts advertised in the local press, and was bewildered when these efforts too came to nothing. He was particularly hurt by rejection for the job of press and promotion officer at the nearby Perpetual Beauty Carnival Association: 'Imagine my surprise when I learnt today that I have not even been short-listed,' he wrote to a friend. 'Either it is true that there were 'a number of good candidates' or, as I suspect, they felt I would be 'too much' for the post – overqualified in a strange sort of way. Do you think that my application contains faults? If so, then how?'[6] Weary of the struggle, he succumbed to the dream of a fortune-making career in advertising. And again was unable to understand summary rejection, on the grounds of his obvious resistance to any kind of team discipline – obvious, that is, to everyone except him. Compston thought of himself as an entrepreneur. He was, in practice, an artist, with all the inner conflicts and contradictions that entails.

With the approach of summer, Factual Nonsense's reputation demanded the mounting, somehow, of another public event. In organising The Hanging Picnic Compston abandoned all pretence at making money, content with merely covering costs through

Gary Hume's *Jammy Boots (Version 2)* (1995) on the cover of Compston's programme for The Hanging Picnic, 'a module of FN's Fun's practice in the real, an open air art exhibition and a curated picnic' on Saturday 8 July 1995, in Hoxton Square.

COME AND WAVE TO YOUR FRIENDS AS THE REAL BECOMES IMAGINED! COME AND BE ON TV! FN: NO FUN WITHOUT U & FUN CAN SERIOUSLY MAKE YOU FN!

HP is supported by the following:

**Beck's
Bricklayers Arms
London Apprentice
Rob Dawson Moore
London Weekend
Television
Stirling Ackroyd**

Further information
**Tel 0171 613 5048
Fax 0171 613 5780**

Factual Nonsense
44a Charlotte Road
London EC2A 3PD

sponsorship by Beck's Beer, J & B Whisky, Bombay
Sapphire Gin and Stirling Ackroyd, the local estate
agents. Most important of all, London Weekend
Television commissioned a film on his curatorial
policies, documenting the genesis of this, the latest
and, as it happened, the last FN street party.

**COME AND WAVE TO YOUR FRIENDS AS THE REAL
BECOMES IMAGINED! COME AND BE ON TV!**

**FN: NO FUN WITHOUT U & FUN CAN SERIOUSLY
MAKE YOU FN!** [7]

The idea – bold and gentle in its subversiveness –
was to concentrate creative energy on the communal
act of picnicking and leave the works of individual
art, hung on the railings around Hoxton Square, to
fend for themselves. Under FN's aegis a committee
was formed to discuss the aesthetics of contempo-
rary picnics and to select representative art critics,
picture framers, museum directors, collectors, as
well as relevant institutions such as the Arts Council
and the Henry Moore Foundation, to join the jam-
boree. Members of the picnic committee included
Bona Colonna Monatgu, at that time an expert in
Christie's Modern Picture Department, the collector
Penny Govett, and Jane Kelly, an American mer-
chant banker from Merill Lynch's head office in Lon-

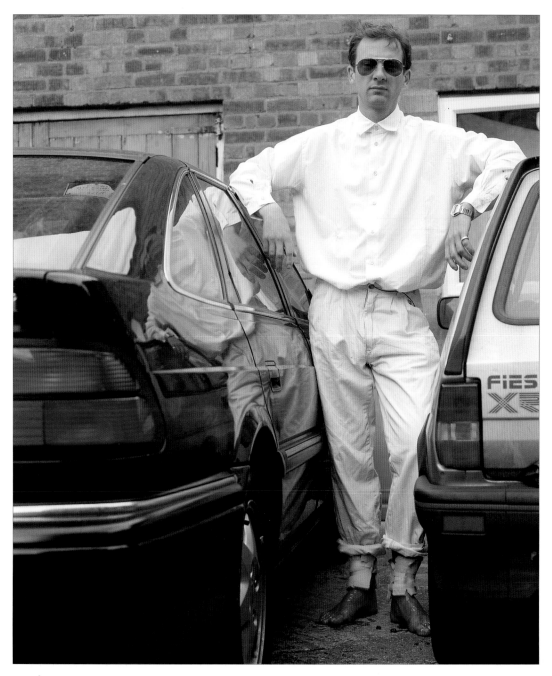

While Compston curated the picnic committee, leading energetic discussion about the painterly aesthetics of plein air entertainment, the artists were left to display whatever they liked on the railings of Hoxton Square. Hume exhibited After Vermeer (1994).

don, all under orders from Compston to curate this fête champêtre on sound historical principles, with specific reference to the exemplary Englishness of Bertie Wooster, to the Eastender tradition of outings to the races at Epsom, and to Courbet's tent. The combination of intellectual seriousness and ludic imagination, together with the sheer dynamism with which Compston infused FN events, was vital to their success. There has been nothing quite like them, before or since.

Blessed with beautiful weather, it really was a day to remember. In an article in The Daily Telegraph Richard Dorment, one of the first critics publicly to champion Gilbert and George's life of art, called Compston 'a visionary': 'The whole neighborhood was invited so that mothers wheeling their babies in prams rubbed shoulders with some of Britain's biggest collectors. The sense of uncomplicated enjoyment shared by artists and public alike bridged the usual chasms between the two worlds.' Dorment found especially entertaining Tim Noble's contribution to The Hanging Picnic, a speaking bird box nailed high up the trunk of a plane tree: 'At first we mistake the sounds which are amplified around the park, for a squawking crow. Only gradually do we realise that the irritating noise is actually a stream of recorded obscenities manipulated in such a way that every once in a while a single word can be heard

clearly. Obviously such a work is impossible to show indoors. Outside in the square it worked beautifully. There, it makes me laugh because it represents an imaginative way of dealing with one of urban life's myriad irritations. Having heard it, when I now cross paths with the local wino who sits in our park hurling abuse at passers by, I smile. I don't mind him nearly as much as I used to because I think of him as a crow.'[8] Sue Webster, Noble's partner-in-art, hung on the railings a photograph of herself with her head stuck impossibly between the solid iron uprights, precisely to scale, in the exact spot where the shot was taken. Renato Neimis – whose work features in the Saatchi Collection, along with Webster and Noble's – exhibited rows of mounted and framed miniature relief models of combat aircraft, religiously accurate in shape and livery, each labelled with its wartime history. Mick Kerr, who was captain of the local rugby team, the Old St Onions – home ground, the Bricklayers Arms – brought out for his picnic the wildly-painted chairs from FWTD '94, and at his crowded pitch on the railings encouraged passers-by to number their own rugby shirts. While Jessica Voorsanger showed her portraits of The Brady Bunch, painted on luscious black velvet, Elizabeth Manchester bicycled around the square all day selling ice creams in condoms from her sunshaded rickshaw refrigerator, and Mat Collishaw

Tim Noble installing his speaking crows in one of the large plane trees of Hoxton Square.

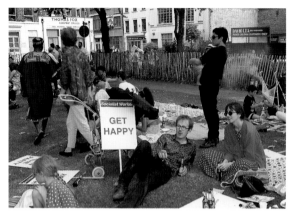

Hoxton Square towards the close of the day
of The Hanging Picnic.

designed the sign to the portable public lavatories.
The two local policeman on duty, their presence
redundant, entered into the party spirit by tying no-
entry tape between a lamppost and the railings, and
labelling their signed art work *Roped-Off Area*. The
cover to the flyer for The Hanging Picnic featured, in
full colour, Gary Hume's *Jammy Boots (Version 2)*, a
photograph of the artist's feet coated in strawberry
jam, wearing puttees made of slices of white bread
secured to his ankles by masking tape, a loaf of
Mother's Pride on the pavement in front of him.

Dressed British-India style in a high-collared white
tunic, Compston rushed around the site of his inven-
tion pursued by a camera crew, enjoying himself
enormously. The film, directed by Liz Friend for the
Opening Slots series, received its first public screen-
ing on 30 November at a party Compston threw in
the old Tramshed in Rivington Street, three nights
before its TV release by LWT. On camera Compston's
contradictions, large enough in real life, were magni-
fied. He looked and sounded what he was: an old-
for-his-age Englishman, arrogant and condescending
and ridiculous; and, at the same time, a strangely
moving visionary figure.

In parallel with work on The Hanging Picnic, the
exhibition programme at Factual Nonsense contin-
ued fitfully. Thursday evening 23 March saw the
opening of William Shoebridge's first London show,

Anthony Oliver's photographs of the Hanging Picnic, including the landlady of the Bricklayers Arms serving alcoholic fruit cocktails, 'We Like You' by Art in Ruins, Compston and his assistant for the day Ra Zamora entering the Mat Collishaw-signposted Poly Loos, and the contribution of two local policemen, *Roped Off Area* (1995).

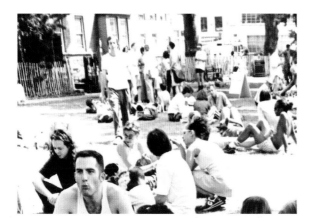

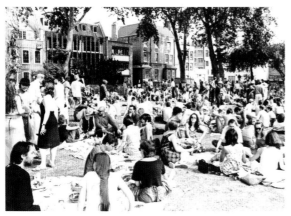

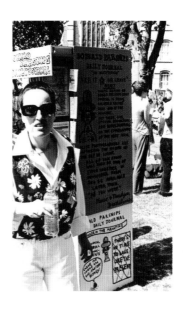

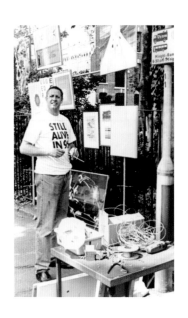

no FuN without U

Rut Blees Luxemburg's portrait of Compston, taken in Herefordshire in April 1995.

titled 'Assorted States', a series of photographs 'blotched away from illusory notions of sickness or disease.'[9] Shoebridge lived locally, in a council tower block, where he regularly hosted exhibitions of fellow-artists' work; for his contribution to FWTD '94 he had erected 'Kissing Booth' in Hoxton Square, a crusader-style linen tent into which couples retreated from the eyes of the crowd to cuddle. Shoebridge was one of the many neighbourhood artists who called in regularly at Factual Nonsense, to share ideas, maybe to consult the extensive art reference library, or to drink coffee with other local artists as they arranged their days. These contacts were of mutual benefit: a kind of communal nurturing. Compston desperately needed the support, physical and emotional, of his artist-friends and neighbours in Shoreditch to sustain self-belief. The autumn show 'HARDCORE' (Part II) was thus designed as a public 'demonstration of affiliation and respect'[10] for a select few of those whose loyalty Compston most valued, not by claim to any shared aesthetic identity or common thread of intellectual interests, but more for what he saw as an intuitive communion at the heart of their lives. The press release sought to express his faith in these chosen exhibitors:

The facts are as follows:
Mat Collishaw, excellent arbiter of suspended humanism

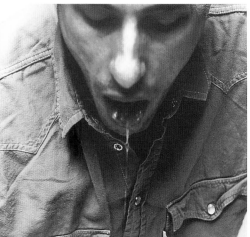

Installation shot of Shoreditch artist
William Shoebridge's Assorted States, with
view through to the Factual Nonsense office.

Shoebridge, Ms Krystufec, Men Darling Do!
(1995), described by Compston in another
of his renowned press releases: 'The small
panels act as potential leitmotifs: out of the
individuals' private life into a fluid splitting
of the body into an experiential territory of
chimera and positive degradation mapped
out in the large panels.'

('You have to find a way to seduce them, or prick their
consciences a bit.'), has worked with FN on a number of
projects, most recently with his pertinent reframing of
Hugh and Divine for The Hanging Picnic lavatories. The
deadpan humour and active irony of these images
succinctly value-adds to the film for which they were
made. For this show he has produced a new
photographic work, made while in residence at Camden
Arts Centre.

No present day conversation held in proper or
improper company would be complete without reference
to the delicious tautological inquiries being made by
Gary Hume. This artist, having worked with us most
memorably as the gangster in the Fête Worse Than Death
1993 and as the virgin criminal 'Looking Forward to It'
in the aforementioned film, is also honoring us with a
new painting, a work which will intrigue those who are
still digesting his exhibition at the ICA.

Gavin Turk, famous and distinguished leader in the
manufacture of contemporary icons, framer of
reliquaries and fountain of liberated erudition, has been
of such gravity within FN that he even allowed us the
enjoyment of his beautiful son, Curtis, as model for FN's
Black shirts in a de Chirico perspective on the FWTD '94
programme. Aware of the 'contemporary nightmare', he
has nevertheless most graciously made a new sculpture
for the show, a piece directly sprung spinning from his
studio in the Charing Cross Road.

Installation shot of 'HARDCORE' (Part II)', which ran from 29 September to 4 November 1995. In the foreground Turk's *En plein air* (1995), on the walls behind photographic pieces by Brown and Collishaw.

Don Brown, master manipulator and fabulously exacting, made one of Other Men's Flowers wittiest and most elegant prints, and while to date our wry and informed conversations have not taken us to the far side, the photograph that will represent him on this occasion is a fulsome testament to his abiding concern to order, distil and remodel as he will. And he will!

Currently cruising along with their 'Naked Shit Pictures' at the South London Gallery, Gilbert and George are a solid state example of the nurturing of a thrusting society, something which FN actively encourages. Embodying an aggressive but attractive tilt towards *gesamtkunstwerk*, their work *Naked Dream*, part of the 'New Democratic Pictures', figures within its centre the crucified Chairman of FN ('potentially available for humorous martyrdom': *Time Out* review, 11–18 November 1992). As a result this image has become seminal as an advert for FN or as an image akin to a portrait. The point is liberation begins with mutual respect – or not at all. Their work on this occasion will be vintage G & G, work full of 'Brit Pop' – before the term was even coined!!

Robert Whittaker, though initially encountered by chance in a French playground at the cusp of the present decade and thence more recently at the opening of his brilliant show 'Robert Whittaker Photographs 1965–70' at the National Portrait Gallery, is the only artist in 'HARDCORE' (Part II) who has not had any prior

no FuN without U

Hume's *Garden Painting No. 4* (1995-6), altered after the Factual Nonsense show and re-exhibited at the Saatchi Collection in 1997. Hume has said: 'If you achieved what you intended it would be much too literal. Hopefully there is a difference between what makes something able to be made and the final object. That's what gives the work its breadth and scope.'

Landscape (1995) by Don Brown, described by Compston in the show's press release: 'Master manipulator and fabulously exacting ... the photograph that will represent him on this occasion is a fulsome testament to his abiding concern to order, distil and remodel as he will. And he will!!'

involvement with FN. However, never one to be deterred by this omission, he kindly accepted the invitation to make the art for the private view card. This bizarre image teases all our understandings of exactly what it is that makes the present scene so hardcore, so appealing and so relevant. Prepare to be surprised by his submission as history never dies, it only gets better.

A few weeks later Turk opened a solo show at Aurel Scheibler's gallery in Cologne. Compston was too broke to attend, and sent his apologies by fax on 10 November:

Dearest Gavin and Aurel,
I was going to write you some cryptic references to the situation here being rather unlike that of der staatsmann that FN as FN as I/it can become. The flames are licking the side walls of the palace of passionate pride, the last powder keg is covered in striped sodden cut rags, no earth remains free to fall upon ... whence umbrella to break fall etc. etc. that sort of thing.

Of course I wince with the vulgar shame of being unable to be a specially invited witness to the excellent union of Gavin's blood (his work and genius) and Aurel's soil (his space and priceless charm) at this point in history.

I would open a betting book upon this being the truth so it obviously really annoys me that I will most

definitely be unable to make it tomorrow. There is far too much trouble at the mill – all the machinery would be lost if I fled.

However an excellent event passed this morning. Just when I was planning my Lord Lucan act I discovered that this property bond that a relative bought me (and I thought inoperative until he died, hence I never though about it because I love him) is active and startling and will bring me pleasure and potential for a few months. I will no longer have to go to Buenos Aires or Sheffield in order to regain my true sense of freedom and identity.

Jai Hind and have an excellent occasion!!

Lots of love, Joshua[11]

Brown, N Scale (1995), tiny model figures on a plinth, representing figures in the white cube of a picture gallery.

In December Compston organised a series of Contemporary Art Lectures at the University of Westminster, involving Tracey Emin, Piers Wardle, Adam Chodzko, Cerith Wyn Evans and Gregor Muir. Plans were laid to make and market a video of the events. Another unfinished project of this period was the letterpress printing by Alan Kitching at The Typography Workshop of a series of FN broadsides. And – back to reality – on 9 January 1996 Compston answered an advertisement in The Guardian for the job of part-time rent officer at Acme Studio in Bow. A letter of 22 January to the Princes Youth Business Trust, apologising for continued non-payment of interest on the FN loan, expressed his dismay at the

From Brown's series 18 Figures (1994), photographs taken from the top of St Paul's Cathedral, a work discussed with and admired by Compston, later exhibited at Sadie Coles' HQ, Heddon Street, in the artist's November 1997 solo show.

situation in which he found himself: 'I think you know that I work extremely hard, try many different options and persevere to levels prejudicial to my health. As you also know I have not tried to wriggle out of my legal and moral responsibilities nor simply disappear ... Though as you can imagine it is often tempting to throw in my towel, accept defeat and apply for a job in telesales I am not broken yet and will attempt to find some work appropriate to my training and experience.'[12] Compston's fax of 29 January to Scott Blythe at MoMart expanded on this emotive theme: 'The fact of the matter is that I have now mounted, in my capacity of FN's director, four public entertainments since 1993. All of these have been very much enjoyed and appreciated by public and art world alike, have brought sales, contracts and critical coverage to many of the artists involved and yet have also cost me a great deal of pain. Collectively they have taken months of exacting work to ensure that they are both legal and successful yet to date they have remained unsupported to the extent that they have lost money ... Thus it is with great sadness that it is unlikely I will be providing such entertainments again.'[13]

The last Factual Nonsense exhibition in Charlotte Road was a solo show of the work of Renato Niemis, 'Slugs and Snails and Puppy Dogs Tails', running from 24 November 1995 until the end of

Niemis, *Inconnu* (1995) at the Imperial War Museum, the installation which first drew Compston into the artist's individualistic world.

January 1996. Fascinated by an installation of Niemis' at the Imperial War Museum, he shared with this artist a passion for creative questioning, in visual form, of the conventions of modern history, in this instance, the miniature model-maker's love/hate relationship with the aeroplanes and armaments of the Second World War.

FN published an informative fold-out pamphlet for the exhibition, with an essay by Sarah Kent, the *Time Out* art critic, who had already written enthusiastically about Niemis in her book *Shark Infested Waters* (1994). Before turning full-time to art, Niemis had worked as an electronics engineer for Marconi, developing the radar systems used in the command and control aircraft, Nimrod. 'You could say that technology is neutral until we make it otherwise,' Niemis argues. 'Ironically, warfare is one of the main forces for technological advancement, especially where miniaturisation is concerned. The amount of technology packed inside a missile head – a smart bomb – is enormous.'[14] For his Factual Nonsense show Niemis made a perfect scale model of a sub-machine gun, mounted on the floor of the gallery facing the door, imposing a dislocational threat to all who entered. Niemis later produced – in 1997 – a memorial sculpture for the entrance to Norman Foster's American Air Museum at Duxford, a Battle-of-Britain airfield eight miles out into the

no FuN without U

Renato Niemis *Eat me, Drink me* (1993), described by Sarah Kent in her book *Shark Infested Waters: The Saatchi Collection of British Art in the 90s*: 'The title refers to Alice's experiences through the looking glass and to the ease with which children enter the realms of the imaginary. The sculptures relate to the models that the artist built in childhood: to the magical transformation of balsa wood and card into recognisable structures.'

The last exhibition at Factual Nonsense, was a Renato Niemis solo show 'Slugs and Snails and Puppy Dogs Tails'. Of his hundreds of scaled and decorated model-fighter planes the artist says: 'We have lived through so many wars but always at a distance. I'm trying to find the reality, and struggling to come to terms with my interest in war over the last twenty-five years.'

At the centre of the Factual Nonsense exhibition space Niemis placed, facing the door, his quarter-size model of a German light machine gun.

fens from Cambridge: fifty-two plate glass sheets etched with to-scale outlines of all the aircraft missing in action from the Eighth and Ninth US Army Air Force and US Navy operations during the Second World War.

'Many artists fight each other, for power, money, recognition,' the composer Iannis Xenakis, himself a war hero, observes. 'But in the final analysis this is what it comes down to: you throw a bottle in the water and somebody picks it up.'[15] Compston sought at Factual Nonsense for power through collaboration rather than competition with the artists of his generation. Aware of his own need for attention, he always made the time to attend to, and to think about and seek to understand the working lives of those for whom he cared. In January 1996 Compston was delighted to be commissioned for regular monthly articles for publication in a new art magazine, *Code*. His first piece described, in vivid admiration, a visit to Gavin Turk's studio:

The studio in Charing Cross Road, chosen for its proximity to the necessities of London life ('What weirdo would want to work in E17?'), has acted out an inspired and often very public role since Turk's restoration of the room in 1992 … Vodka driven 'Office Christmas Parties' have been hosted and Gilbert and George have also been known to come for a cackle.

Niemis' *Counting the Cost* (1997), a memorial sculpture which lines the entrance route to Norman Foster's Amercian Air Museum at Duxford, Cambridgeshire.

However it is perhaps the exhibitions for fellow artists that have been presented within the studio that most aptly demonstrate its public side. Conceived with an optimistic spirit, solo shows have been awarded to artists such as Renato Niemis, whose sly model of an art gallery now resides in the Saatchi Collection. Turk speaks of this showcasing of others art as being analogous to being 'in and out of love, its problem and its strength', but is an adjunct to Turk's practice essentially generous in its conception ...

His last project 'Gavin Turk Painting Collection Celebrity Charity Gala Evening' which opened in December was perhaps the most left field to date. On a garish burgundy wall hung a dolly mixture of images by Bartlett architecture students pretending to be painters in order to make a 'pseudo-psychological painting environment'. Among these was one that suitably embodied the show's formal irreverence: Dan Rochard's work 'Jenny, Barbara and Cindy – strange isn't it the way they follow you round the room' displayed the breasts of three prominent New York-based artists of the 1980s. Even the most classical work, a study of hands by Deborah Curtis – Turk's beautiful girlfriend, often compared by the media to Isabella Rosellini – had a putrefying quality to it.

Surveying the Soho rooftops I'm told that future projects may include a Drugs Bar, a Judo Workshop, 'germ cell dinner parties' and a Dan Flavin show of a

no FuN without U

Detail of one of the fifty-two panels engraved with the precise outline of all 70311 American aircraft lost during the Second World War.

1960s neon piece in the very point where Lovely Girls Always were replaced with Lovely Ideas Always. Maybe one day he'll charge for his personal services. Until then you can freely climb past Perfect Fried Chicken.'[16]

Compston's second article emerged from interviewing another friend, Dr Clémentine Deliss, founding editor of the cross-cultural artist's publication *Metronome*: 'Thus it is that a crisp Friday in Notting Hill I pretend to be Dr Freud. Fired by my subject we converse about her childhood to ascertain if a certain reading is valid. Namely that culture is a carrier for her intellect, a series of means rather than a defined meal ticket within civil service arts, the alternative chosen by many of her contemporaries. To use Tracey Emin's words: where does work, art and life enact an 'Exploration of the Soul'?'[17] Compston often referred to Emin's book, the flyleaf of every copy of which she had inscribed 'I wanted this to be the Truth'[18] – at the opening of his record of a teenage trip to Newcastle, entitled 'Notes on the North. December 1986', Compston had written: 'Investigation: to find the truth'[19].

In the years given to him, Compston had time to do little more than place a message in a beer bottle and hurl it into the ocean. Maybe Xenakis is right, and there is nothing else anyone can do: 'Composition, action is nothing but a struggle for existence.

To be. If, however, I imitate the past, I do nothing, and consequently I am not. In other words, I am sure that I exist only if I do something different. The difference is the proof of existence, of knowledge, of participation in the affairs of the world. I'm convinced of that.'[20] Compston at least succeeded in being different. Sadly, he never learnt how best to live with his passion.

Niemis, Childhood's End, 13 March 1996 (1996), a computer drawing of the gun used in the Dunblane massacre, its parts given the names of the children and teacher killed.

1	Megan
2	Abigail
3	Hannah
4	Andrew
5	Amie
6	Emma
7	Melissa
8	Robert
9	Victoria
10	Benjamin
11	Charlotte
12	Mark
13	Robbie
14	Joanna
15	Stewart
16	John
17	Coll
18	Sophie
19	Kevin
20	Ryan
21	Emily
22	Ross
23	Mhairi
24	David
25	Victoria
26	Mathew
27	Brett
28	Amy

Browning 9mm Pistol

Counting the cost of the use of a mechanism whose sole function is to fire projectiles at lethal velocities

Childhoods End

Renato Niemis

13 March 1996

six

The detailing here of the Factual Nonsense story with only marginal reference to other art events mirrors the impact both of Joshua Compston's personal presence and the FN experience as a whole. There was no in-between, no respite, no spare moment to draw breath, for progenitor or participator. Factual Nonsense was Compston, it represented and consumed him. With a force born in the emotional and spiritual depths of his childhood solitude, he strove throughout his entire Being for significance. Nothing existed for him outside his vision of 'FN the entity, the international conglomerate ... and the establishment of its brand name in daily life.'[1] The 'imperious ardour'[2] with which Compston argued his cause antagonised many on the London art circuit. He seemed not to mind, even courted accusations of megalomania, challenging the conventions of good taste in – according to *The Independent* – 'cranky bombastic prose'[3]:

A Model of Clarity and Far Reaching Penetration
(A Monster of Cunning and World Domination)[4]

It would be foolish for sympathisers to claim that Compston always made communicable sense, either on the page or in person. He ranted, relished the roll of words from his lips, played with the sounds and symbols of ideas. After teaching himself to type dur-

OPPOSITE Compston posing before the camera of Beatles photographer Bob Whittaker, an image used on the invitation to Factual nonsense's 'HARDCORE (Part II)'.

ing the opening months at Factual Nonsense, Compston was able to compose his fabled press releases without hesitation or correction, printing them up and posting them out as they shaped themselves in a matter of minutes on the computer screen. He loved the sound of words, heard in the fall of sentences a voice he began to recognise as his alone. And to him it did all make sense, from beginning to end, with remarkable consistency in guiding themes and principles. He was consistent also in his faults: a disastrously unreliable time-keeper, Compston was incapable of conforming to Factual Nonsense's advertised opening times, and seldom arrived punctually for any appointment. Presented by Victoria Scheibler with the gift of a return air ticket to Beijing to join Gilbert and George on their August 1993 exhibition tour of China, he missed the flight and had to wait two days to secure a place on another. Compston, along with many of his artist friends, experimented socially with drugs to sustain the all-night party habit, though he in fact needed no external stimulant to dance on tables and make an exhibition of himself. He was himself the catalyst, the party enhancer. 'Life seems to me essentially passion, conflict, rage,' the philosopher Bertrand Russell wrote in a letter. 'Moments of peace are brief and destroy themselves.'[5] Some words of Compston's, also expressed in a letter to a friend, written a

no FuN without U

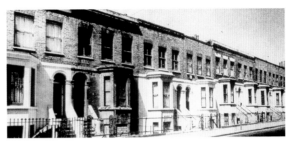

Archive photograph of Grove Road, taken in 1983. The whole of this side of the street was condemned and was demolished in 1993, except for 193, from which Rachel Whiteread cast in concrete her *House*.

few weeks after his eighteenth birthday, are an unwitting extension of Russell's: 'Usually I am an over-serious person … Knowing that when one is happy one *is* actually happy is a difficult concept to remember. Misery and destruction seem to come far more easily.'[6]

Factual Nonsense was by no means the best-known East End art phenomenon of the 1990s. The annual Whitechapel Open, an exhibition of work by young artists, had expanded to include scheduled visits by minibus to the hundreds of studios for which Bow, Bethnal Green, Dalston and Stoke Newington were famous, whole neighbourhoods teeming with creative life. Much the most celebrated East End artistic event coinciding with the three-and-a-half years of FN's brilliant brief life in Shoreditch had nothing at all to do with Compston: the creation – and eventual demolition – of Rachel Whiteread's *House* in Grove Road, Bow. Through the patronage of Artangel, James Lingwood's enlightened foundation specialising in architecture-based projects, with whom the artist had been discussing her plan since 1991, together with sponsorship from Beck's and valuable supportive work by the dealer Karsten Schubert, Whiteread obtained on 2 August 1993 a temporary lease on No. 193 Grove Road, the last house standing in a condemned Victorian terrace. Under the overall supervision of building technicians

Interior of *House*, in the process of creation.

The demolition of *House*, 11 January 1994, by order of Tower Hamlets council in east London.

Rachel Whiteread, *House* (1993), praised by the art critic Andrew Graham-Dixon as 'one of the most extraordinary public sculptures to have been created by any English artist working this century.'

Atelier One, she proceeded to construct a concrete cast of the inside of the whole house, room by room, giving shape to the negative space of generations of family life. Already the subject of furious debate among the councillors of Tower Hamlets – Councillor Eric Flounders, chair of the Bow Parks Board: 'We will be brave enough to ignore the fusillade of froth from the arts lobby and remove the monstrosity as soon as the contract allows.'7 – the 'sculpture' was completed by the end of October, when dismantlement of the scaffold and tarpaulins attracted thousands more visitors and hundreds of column inches of press comment. The smooth sides of the piece also drew competing graffiti, WOT FOR and WHY NOT providing appropriate summaries of the contrary arguments. An early-day motion in the House of Commons urged the council to consider allowing the work to stand permanently in what was by then a canal-side park: 'That this House congratulates Rachel Whiteread on winning the Turner Prize as best modern artist of the year; recognises that good art is often challenging and controversial; believes it would be an act of intolerance and philistinism to destroy her sculpture in Grove Road, Bow before more people have had the opportunity to see it; and call upon Tower Hamlets Council to allow it to remain for three months and during that time consult local people about whether or not it should

no FuN without U

Simon Bill, *Jellyfish David C Mair* (1997),
one of a series of miniature oil paintings
executed on copper engraver's plates of
business visiting cards, found in Heddon
Street, in London's West End.

be destroyed.'[8] Whiteread confirmed that *House*
was, in part, a political statement, intended to
arouse strong public feeling. Andrew Graham-Dixon
correctly understood that with *House* 'the artist has
asserted her right to construct her own world out of
the materials of this one, to make a fantasy real and
palpable.'[9] Works of art exist primarily in felt-mem-
ory, this piece solely so, for it was demolished on 11
January 1994 and the site grassed over.

Compston admired *House* and redirected many
FN visitors on the two-mile journey east to see it,
although he never claimed personal connectedness
with Whiteread. At the same time, an artist with
whom he remained closely involved, Gavin Turk,
was exhibiting 'Collected Works 1989–1993'
through the influential dealer Jay Jopling of White
Cube. Turk's stratagem for handling the external
business of being an artist was very different from
Whiteread's: where her determined inaccessibility
tended somehow to fuel public controversy, his
sociable enthusiasm disarmed potential critics. The
painter Simon Bill, his friend from student days at
the Royal College, explained in the catalogue of the
show: 'Gavin Turk's work is about "Gavin Turk", a
fictional artist whose oeuvre he (Gavin) is construct-
ing in his (Gavin's) absence. "Gavin Turk" is Gavin
Turk's pseudonym.'[10] While many of Turk's pieces
do indeed incorporate the signature he has created

for 'Gavin Turk', unrelated to his private mark on passport and bank account, the major work in this exhibition was a life-size waxwork of himself as the pop star Sid Vicious performing Sinatra's *My Way*, standing in the confrontational pose Andy Warhol used in his iconic silk-screen image of Elvis Presley. These multiple cross-cultural references in *Pop* (1993) are typical of Turk, 'whose output', according to Compston, 'displays a mastery of the 'blur' technique, a cunning symbolism that is not postmodern in any redundant, childish sense ... but is the creation of a surface worth examining for its stitches and intricacies.'[11] Other Turk work contextualised art arguments initiated by Marcel Duchamp, René Magritte, Yves Klein and – his particular passion – Piero Manzoni. 'Art is stammering,' Turk himself has said, 'we are almost at the end point, the last work.'[12]

Compston loved all this, his early appreciation of Turk documented in a fax of 15 April 1993 to Aurel Scheibler:

What I admire about Gavin is his incredibly delicate and ambitious play with contemporary art practice. He deliberately teases people with his work, employing different manners to present artist-as-myth illusions ... and has come up with various solutions to being an artist in the late twentieth century, rather than a producer of mere consumer objects. He has entered the capitalist

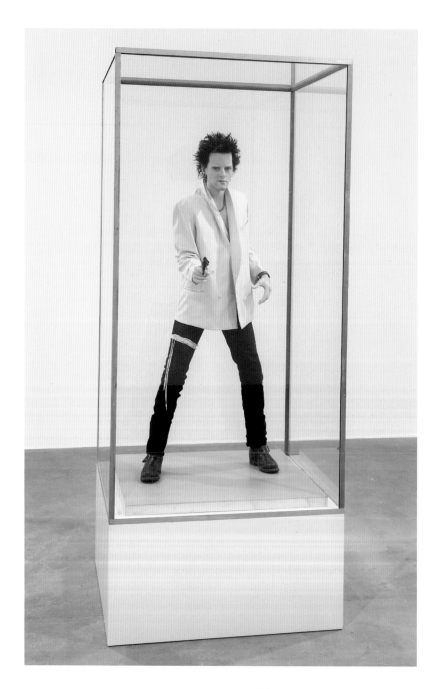

no FuN without U

Gavin Turk, *Pop* (1993), a life-size wax cast of the artist as Sid Vicious performing My Way with the confrontational pose of Elvis Presley as represented by Andy Warhol in his 1963 screenprint. Simon Bill wrote in Turk's 1993 catalogue: 'The thing is (and keep this under your hat), artists don't really create anything at all; they just rearrange things that come to hand. Pop!'

market in a completely honest way by pitching himself at the service of making more than just art. He wants to go into mass production, a sort of art factory, which I find a very tantalising idea. He might design Gavin Turk sunglasses, for example, works of design not art, available to everyone for £20 or so, but made with the authority of an artist.

Recently, though, he has been working on a plastic and wax model of himself pointing a piston in the classic Sid Vicious pose, in turn borrowed from Elvis Presley, Marlon Brando, James Dean and the cult genre. The message could be 'artist as hero' but he catches exactly the right mood by executing it with such style, aplomb and correctness.[13]

Compston longed to develop ideas for FN shows and projects with Turk, whose reputation was further enhanced by inclusion in the Saatchi Gallery's exhibition 'Young British Artists IV', running from April through June 1995. Sadly, Factual Nonsense never established a solid enough base to translate Compston's empathy for the working lives of artist friends into a realistic prospect of earning for them, or for himself, a living.

Notorious for his party exuberance, Compston was equally renowned for his morose antagonism to the machinations of the art market: 'I walk in, erect, elegant in an old fashioned way,' he wrote in his journal

Fairhurst, *Ultramarine Attachment (Laura Loves Fish)* (1992), a cibachrome print with garment attachments, 'Some Went Mad, Some Ran Away ...', curated by Damien Hirst.

after attending one of Jeremy Fry's artistic evenings. 'Am too mentally pissed and preoccupied to speak much. I dryly dribbled out a few non-sequiturs. But really the whole paraphernalia of the social art world, the grubby bodies that bring painter to public, patron or public collection to artist, I find most odious and actually nauseous at times.'[14]

The headline-catching art event of the summer of 1994 was an international show at the Serpentine Gallery, curated by Damien Hirst and titled 'Some Went Mad, Some Ran Away ...'. Angus Fairhurst, Marcus Harvey, Abigail Lane and Jane Simpson were the English artists Hirst chose to accompany him on the exhibition's subsequent tour of Helsinki, Hanover and Chicago. Hirst's contribution, *Away From The Flock* (1994), a frisky Suffolk Down lamb suspended in a tank of formaldehyde, was vandalised by a visitor to the gallery who managed to lift the tank's lid and pour in black ink to discolour the preservative, replacing the title label with one of his own: *Mark Bridger: Black Sheep. May 9, 1994.* At his trial at Bow Street Magistrates Court on charges of criminal damage, Bridger identified himself as an artist and claimed that his intervention 'was meant as an interesting addendum to the work.' 'I see Hirst as an unconventional artist,' he continued. 'I thought he would appreciate the breach of convention. That's what happens with his art. It's

no FuN without U

Installation shot of the 1995 show at the South London Gallery curated by Carl Freedman, 'Minky Manky', with Hirst's *And Still Pursuing Impossible Desires* (1995).

part of the reason it's there. To provide some meaning for someone.'[15] Questioned in court, Hirst denied that *Away From The Flock* was designed to shock and thereby to provoke an antagonistic response: 'I wanted people to think about themselves, about their lives, their mortality.'[16] In an essay published in the exhibition catalogue Richard Shone expanded on the theme: 'Here in this show is art for which Hirst feels an affinity through cross-fertilisation of images and obsessions. It reflects his own fascination with objects that symbolise extreme states, sometimes convulsive, sometimes mute. He shows us the melancholy results of prescience, the day that follows birth, violence after order, the particular leitmotifs of what D H Lawrence called "this essentially tragic age".'[17]

Hirst, *A Celebration at Least* (1994), illustrated in the 'Minky Manky' catalogue. In an interview with Freedman, Hirst comments: 'I like the idea of a sculpture having a function where it is against something impossible, like against gravity, a refusal to face the facts.'

The following spring Carl Freedman – 'shy, sharp and caustic,'[18] according to *The Guardian* – declared his curatorial hand in 'Minky Manky' at the South London Art Gallery, featuring Mat Collishaw, Gilbert and George, Sarah Lucas, Steven Pippin, Critical Décor, Gary Hume, Tracey Emin and Damien Hirst. For the catalogue Freedman interviewed not only the artists but also himself: '"Minky Manky" is about life, both in the profound sense in that it deals with fundamental questions of existence, and in the everyday sense in that it deals with the mundane and the familiar. You could say it's an

Hume, *After Petra's Christo* (1995). Hume told Freedman: 'I see things in magazines, and newspapers, and every now and then photographs that I might take. Then again I might have an idea about something and go to the library to find a picture of it ... I love colour because I love light. Light is everything.'

Lucas, *Where does it all end?* (1994), a wax cast of the artist's own mouth, with cigarette butt. 'I use myself in pictures because I'm a good candidate for what I'm after, and also it does seem to add something to it because it's me.'

exhibition about everything with a potential audience of everybody. Indirectly it is also an investigation into the phenomena of the artist, and presents the artist as an expressing subject, which rejects the idea of the death of the author. I wanted to include the artist as a subject, and explore the relationship between the art on the wall and its creator, to make the whole thing more humanistic.' He selected from among his circle of artist friends those who see themselves as 'outsiders, maybe a little disturbed, always intense, pushing things, being excessive ... But with this there is also something melancholic ... I think this is some peoples' natural disposition and it constantly colours their view of the world. And I'm always attracted to this feeling.'[19] In their conversations with Freedman the artists revealed kindred attitudes to their lives and work:

LUCAS 'I make things how I am, how I'd quite naturally do something. And also, because I've been doing it for some time now, I feel as if the way I make things is at my finger tips. I always admired Jimmy Hendrix for that, because I thought he had it at his finger tips, right at his finger tips. He played the guitar like it was part of him, straight out of his heart, not mediated. And that's how I want to make art.'

HUME 'The activity of making art is itself enjoyable. Not

no FuN without U

just the putting of paint on a surface, but the whole activity of not going to work, not having to do anything that I choose not to do.'

EMIN 'I feel good when people come up and see my work and they don't talk about art but talk about life, about real things and things which really matter. And when people start to try to work out what my art means, then I know I'm doing a bad job.'

COLLISHAW 'Within this process of looking there is a desire to overcome an isolated way of seeing things. To bring things together in such a way that they throw light on one another. Things which may seem at opposite ends of a spectrum are still somehow connected ... There is a genuine fear of things out of our control, of not knowing what is around the corner. Yet there is also a curiosity and fascination. It's the temptation of the unknown.'

HIRST 'I always made things and drew. But there was a point when I realised that I could be an artist as a job, and I thought – fucking hell, that's what I've been doing. I always thought doing a job meant doing something that you don't enjoy ... It's not art but the art world which is restricting.'[20]

Gilbert and George had never been to the South Lon-

Emin, *Everyone I've ever slept with 1963 to 1995* (1995) first exhibited at the South London Gallery in 'Minky Manky', later shown – as here photographed – in Minneapolis. The first to be listed on the walls of Emin's tent is her twin brother, Paul. In a conversation with Freedman, published in the 'Minky Manky' catalogue, Emin said: 'Being a twin, I wasn't supposed to be here anyway. It was pure fluke that I arrived on this earth and it was a struggle. And seeing as I've got here I may as well stay and make the best of it.'

A birthday party for Tracey Emin, July 1994, in Carl Freedman's garden in Greenwich: on the left of the picture, Joshua Compston; at the back, with dyed blonde hair, Angus Fairhurst, seated opposite Sarah Lucas; in the group on the grass, Tamara Chodzko, Mat Collishaw, Guy Mannes Abbott, Virginia Nmarcho and David Pugh of Critical Decor.

Tracey Emin received her own solo exhibition at the South London Gallery in 1997, in which she included *Love Poem* (1996), an eight-foot-by-eight-foot appliqué blanket, dedicated to Carl Freedman.

Emin with her identity bag, on a beach in California, during her 1994 tour of America with Carl Freedman, doing reading performances from her autobiographical-book piece, *Exploration of the Soul*, designed and printed by Tom Shaw in a limited edition of 200.

Emin at her flat in Cooper's Close, Waterloo, appliquéing letters on to her grandmother's chair.

Emin carrying the same chair into Monument Valley to be photographed by Carl Freedman for a work which became *Outside Myself* (1994).

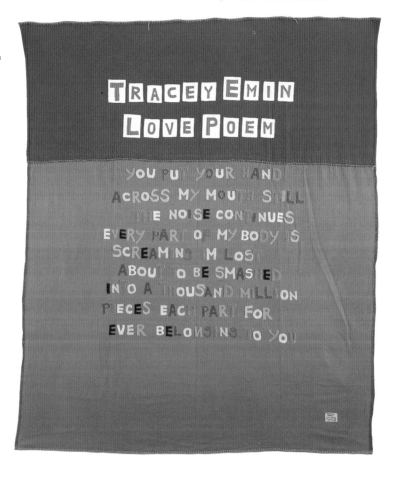

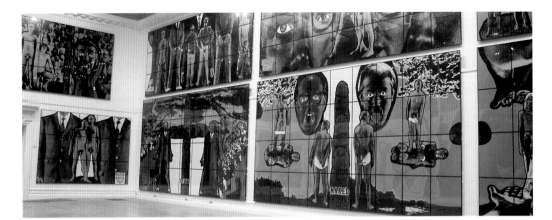

don Art Gallery before Freedman selected their work for 'Minky Manky'. In an interview printed in the catalogue George responded to Freedman's suggestion that destiny had brought Gilbert and he together to become a single artist: 'We do believe in some greater power. We even sometimes feel that we have a hand over us, guiding us. It was something that happened to us, I'm sure of that. It wasn't something that we decided. It just came about. Like all the best things really.'[21] Impressed by the chapel-like character of this high-ceilinged Edwardian space, Gilbert and George arranged to unveil their next controversial set of images at the South London Art Gallery, 'The Naked Shit Pictures', in a show which ran from 5 September to 15 October 1995. 'About man's fate and about his nakedness in the eternal silences of infinite spaces,'[22] this group of work appeared directly to face the prospect of Gilbert and George's death, as if one of them – George – felt in specific danger, illustrated most poignantly in *Ill World*, where Gilbert holds his naked friend in the pose of Michelangelo's *Pietà*, and in *Carriers*, where in the wide-angle background photograph a grim Gilbert walks alone down the Whitechapel Road. Dominated by grey-blue tones new to their work, with 'The Naked Shit Pictures' Gilbert and George mounted their own memorial exhibition, and miraculously survived, were revived in body and spirit by

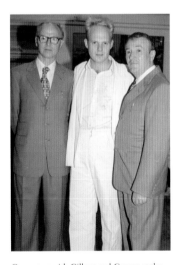

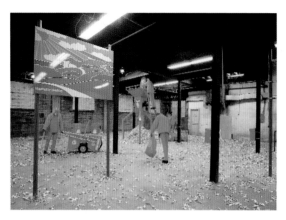

Michael Landy, Scrapheap Services (1995)
at the Soap Factory in Minneapolis, 22
October 1995 till 7 January 1996. Landy
explained in an interview published in the
catalogue: 'Scrapheap Services is a bogus
cleaning company. It doesn't actually exist,
but I had to find co-ordinated identity. I
bought lots of cleaning devices, brushes,
litter pickers, refuse barrows and bins, and
uniforms, and I built an 11-foot shredder
that discards people ... Scrapheap Services
could be what the end of the world will
look like. I always thought there would be a
garish, fluorescent, nauseating look to the
end of the world.'

the experience of intimate exposure.

Freedman chose Gilbert and George as the only
artist from an earlier generation to show in 'Minky
Manky' because he felt that their work inhabited
similar interests and concerns. Richard Flood – cura-
tor of the first major museum exhibition of young
British artists to be mounted in America, 'BRIL-
LIANT! New Art from London', opening in Min-
neapolis in October 1995 – also identified the com-
mon ground occupied by Gilbert and George and
younger British artists: 'The East London seen in
their photo-constructs is a rotting piece of real estate
whose inhabitants can no more escape than they can
fly ... Like statisticians dispatched to a massacre to
keep track of the body count ... Gilbert and George
manage to suggest an apocalyptic West where the
flies are buzzing around a corpse that has yet to
drop.'[23] The reference here was clearly to Damien
Hirst. He and Gary Hume had already enjoyed suc-
cessful solo shows in commercial galleries in New
York; as had Sarah Lucas, with a prestigious com-
mission for the Projects Room at the Museum of
Modern Art. These three were joined in Minneapolis
by Henry Bond and Liam Gillick (working in part-
nership), Glenn Brown, Jake and Dinos Chapman
(also by then an established team: 'I think we both
hoped that if we could produce work from the point
of view of our fanatical banter that it would always

Damien Hirst's Dead Ends Died Out, Explained (1993). 'I love cigarettes for lots of reasons. Worldwide it's the biggest thing that people do ... The other reason I love smoking is that it's a mini-universe with its own life cycle. You have a cigarette and an ashtray, and you need a lighter or matches. You start, and when you're finished, it's over and you light another. So there's a constant cycle which you can see a lot better than you can see your own life.'

Sarah Lucas, Bucket of Tea 1 (1994). In an interview for the 'Brilliant!' catalogue Lucas said: 'I'm saying nothing. Just look at the picture and think what you like.'

Gary Hume, Me as King Cnute (1995), a five-minute video tape exhibited at 'Brilliant!' in Minneapolis, and subsequently in Houston, Texas.

Chris Ofili, photographed in Charlotte Road at Gavin Turk's Live Stock Market in August 1997, with his message painted on a plank, at Mick Kerr's stall.

retain an element of conversational flow'[24]), Adam Chodzko, Mat Collishaw, Tracey Emin ('I'm here, I'm stuck on this earth and I have to fill my time doing something, or I'd go insane'[25]), Angus Fairhurst, Anya Gallaccio, Michael Landy, Abigail Lane, Chris Ofili, Steven Pippin, Alxandro Raho, Georgina Starr, Sam Taylor-Wood, Gillian Wearing ('I get the nasty elements in with the good elements as well. I think that's what makes it more real'[26]), and Rachel Whiteread. A majority of these high-profile artists were involved, at one time or another, with events at Factual Nonsense, although even the youngest, Georgina Starr, was older than Compston. 'For me the chance event is just the beginning and then I work on them and work on them. My pieces are absolutely opposed to the idea of randomness,' Starr said in her catalogue interview. 'To me, trivial things are just as meaningful as things that are supposed to be important. Artists choose things to be interested in and they want to investigate whether they are or not. But it doesn't matter because they've devoted their lives to finding out about it all.'[27] In this statement she revealed a single-mindedness comparable to Compston's. And at Live Stock Market, the celebration organised by Gavin Turk in Charlotte Road on FN Day '97, Starr contributed memorably to renewal of the collaborative spirit first expressed by others in these streets at FWTD '93.

no FuN without U

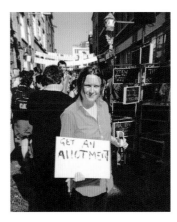

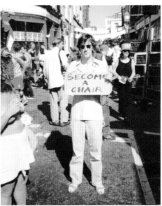

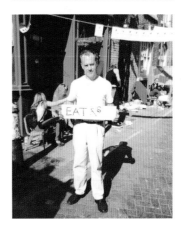

Starr, like Freedman and Hirst brought up in
Leeds, found Compston's young-fogey style of dress
and laddish exhibitionism alienating. The naïveté of
his political views also irritated many, in particular
the 'ironic' fascist references within the FN graphic
image. Certain statements in Compston's press
releases, designed in the mould of Gilbert and
George to both tease and provoke, gave to those yet
to be convinced by the Factual Nonsense record
additional doubts about the underlying soundness of
his ideals. At one street event stewards in their black
T-shirts with red FN logo were mistaken for mem-
bers of the British Nazi Party, fears fuelled by senti-
ments expressed in a printed flyer: 'Organise a polit-
ical party, with an underground guerrilla wing, that
is devoted to the establishment of a state of "High
Formalism" (the gallery's fax etc. is at your disposal
if you wish to order Semtex).'[28] The increasingly
strident tone with which Compston broadcast his
news and views sought to conceal, largely from him-
self, the desperation of his desire to make a public
impact: 'A brief respite was provided by China and
never was the old catchphrase 'Yellow Peril' so fun-
damentally true. They will imperil us with their
bright radiant future. They deserve it. "I have seen
the future and it works".'[29] These public pronounce-
ments too often lacked the humanity of his personal
communications: 'The Great Wall has cut a track in

my mind. Still working out what (it will never be exact) it is that makes that country rise and rise while the rest settles down to morbid decline. Food indifferent. Westerners annoying. More later. Love Joshua.'[30] 'Some other evening,' he had noted in his diary on 31 August 1993, 'I sit on a table in the middle of the slums, wearing a suit apparently the envy of Gilbert and George, incredibly tired, with no money either here or abroad, no girlfriend – not even a kiss – and a host of large problems. I do not pity myself and all I ask, and ever ask, is the love of a good woman. All else may as well go to hell. Please, Confucius, grant me that.'

The novelist Doris Lessing, involved in politics all her life, for many years a member of the Communist Party, saw in the youthful theatre critic Kenneth Tynan a sense of doomed helplessness which was also recognisable in Compston:

> At first I thought he was mocking himself, as he so often did, but no, he meant it … for there are times when the little horizons of the British simply stun observers into a sort of despair … He saw himself as a brilliant projectile hurled against the philistinism of the British theatre but already falling back, having reached too high too soon … He was archetypically that character who liked to shock by saying he was a communist or a Marxist, while he would rather die than actually join the Party. These

people always have a kind of political innocence, or ignorance, because their thoughts are all in the air – are never brought down to earth ... Ken was heartbreaking. When he died so horribly, and so much too young, my feelings about his always ominous brilliance turned out to be justified, but that was hardly a consolation. There are people whose deaths leave an unfillable empty space.'[31]

And yet Compston was not as isolated as he himself sometimes feared, the complex language in which he struggled to express his ideas about art, influenced to some degree by the elliptical prescriptions of the intellectual gurus of the 1980s – Jacques Derrida, Jean-François Lyotard and the rest. Hume, in a published conversation of September 1989 about his door paintings, was then turning phrases later adapted by Compston to his own unique ends: 'There is no essential core of meaning but they are meaningful through cognition and in their relation to the synchronic state of art and society, while they remain an empty sign, a door motif in a potentially endless series – simultaneously spacious and oppressive.'[32] Always thoughtful and articulate, in the 1990s Hume developed a more personal language to describe the altered direction of work which ceaselessly followed from his studio-home in an industrial building off Hoxton Square. (A hip American was

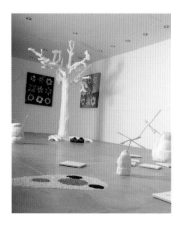

Sarah Staton installation, Hale Gallery in Deptford High Street in 1994, titled *Joy, Joy, Joy ...*, a joint reference to the work ot two artists she admired, Sigmar Polke's painting *Carl Andre Delft* and Rosemary Trockel's drawing *Frerde*, inspired by the Polke piece, interwoven with Staton's personal memories of a teenage visit to Holland and with her present political concerns.

recently overheard saying to his partner on exiting the premises: 'I like it. Really low key. Like Dennis Hopper's bunker'.) Turk, writing in *Frieze* about his art-school exploration of the artist's shit theme, also demonstrates his sharing of the Compston aesthetic: 'Eventually the name Manzoni caught up with the idea of presenting one's shit as one's art – an idea that artists frequently return to. An inescapable making process: the getting rid of stuff; the recycling of material; the creation of a substance that stands as a testament to being alive; making one's mark; a non-hierarchical signature or sign of existence; an exegesis. At art school, I had only seen the work itself in reproduction (of the poor, photocopied kind), when I was asked to give a presentation and wanted to show a slide of one of Manzoni's works. I found myself passing a stool of my own into a glass jar and, adding no preservatives, replaced the lid and forged a signed label for the front.'[33]

When Factual Nonsense opened in October 1992 the artists with whom Compston worked were as short of cash as he was. In subsequent years, though, many of them proved to be much better managers of money. For advice on the lease of The Shop, Emin approached the solicitor Stuart Evans of Simmons & Simmons, a keen collector of contemporary art, paying for his firm's services with the gift of her *Outside Myself* (Monument Valley, reading 'Exploration of

Staton's 'SupaStore', a mobile installation of artists' multiples for sale, was launched at 148 Charing Cross Road, London in 1993, here seen at Laure Genillard's gallery in 1994 as 'SupaStore Boutique'. 'Supastore' was subsequently presented in Manchester, San Francisco, New York, Lake Constance and many other venues.

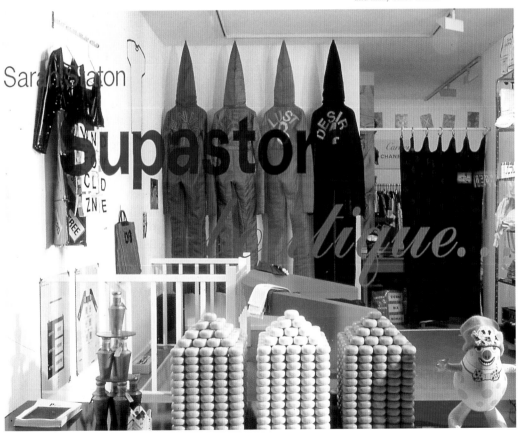

Staton, papier-mâché cigarette pack and
Andrea & Philippe lighter, both marketed
by 'Supastore'. The cigarette lighter, printed
with the image of a pillbox, is part of the
'Landfill' project, the recording and
preserving of British pillboxes, launched
with Compston's enthusiastic support in
1994 and exhibited at the Independent Art
Space in May 1997.

the Soul'). Evans also helped Emin with the legal
costs of setting up her museum in Waterloo Road,
financed by the issue of 'Emin Bonds' and
announced in a pink circular: 'I am opening my own
museum, a place dedicated to my life and to my art.
Although small, it will have the feeling of majestic
serenity. The museum will open December 1995.'[34]
Sarah Staton took over in 1999 the lease of Emin's
Waterloo Road premises and there continues to
develop new ideas for her 'SupaStore' of artist multi-
ples, founded in 1993, the final presentation in its
original form given in the autumn of 1998 at The
Tannery in Bermondsey Street, round the corner
from the artist's home.

Compston talked grandly of FN publishing sub-
sidiaries, wrote about the manufacturing and mar-
keting of FN commissioned designs, but managed to
achieve none of these practical things. In his last
published interview, in the December 1995 issue of
Detour, a local magazine, Compston said: 'My best
Christmas present would be a home of my own. I
don't have a private income or patron. If my project
fails I've nothing to fall back on … The future really
is turning, but the here is really now.'[35]

Chaotic in the management of his own financial
affairs, Compston was surprisingly good at sorting
out other people's difficulties. When Gary Hume was
confronted in November 1993 at his studio home in

Adam McEwan, *I Want to Live* (1994) gloves at Sarah Staton's 'SupaStore Boutique'.

Hoxton Square with a giant bill – £8,433.84 – from Thames Water and the threat of disconnection in seven days, in distress, he asked FN for help. The letter Compston wrote, in Hume's name, was in a style all of his own, a fluid mix of the personal and professional: 'I have a number of important matters to bring to your attention … but my main point of debate is the whole foundation of the operative process that is adopted to calculate such charges, which without further ado has resulted in a demand for a most outrageous amount.' An analysis of meter versus rate charge systems followed, concluding: 'You should also note that at the present time of writing I [i.e. Gary Hume] have in my possession no sum of money even near the amount you demand, no financial assets exist to be seized nor goods to the value of. You should also realize that I am an artist and as you may be aware the process of selling contemporary art is a precarious business where it is impossible to calculate with any degree of certainty the cash flow for any given month, particularly as is the situation here, without the benefit of grant aid from government-funded organisations, private backers, nor a dealer in this country.'[35] After further correspondence, Hume's Thames Water bill was reduced, by the grace of Compston's pen, to zero.

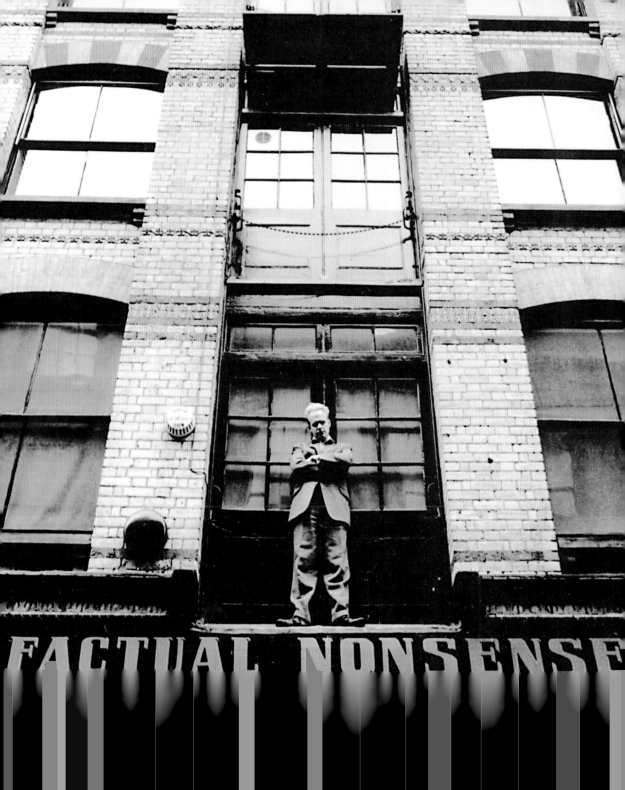

FACTUAL NONSENSE

seven

I die and I die. But I must try and burn before I do. I must try and become one of the fires, the beautiful calamities that keep the hopes up of many.

Joshua Compston, journal entry, 6 May 1989

Late on the night of Saturday 9 March 1996 Joshua Compston was found dead on a rug bed on top of his picture store at Factual Nonsense. His body had lain there, out of sight, for four days. Noticing – not for the first time – Compston's desk lamp burning unattended on the Tuesday evening through into Wednesday morning his landlord, who lived on the upper floors of the ex-furniture factory, had let himself in to switch off the light. The next day the landlord again entered the premises, to collect a fax. Then on the Friday Leila Sadeghee, Compston's girlfriend, arranged to call by to retrieve her laptop computer, borrowed the previous weekend and not yet returned. On seeing beside the desk Compston's briefcase, containing empty wallet, a spectacles case and half-opened letters, Sadeghee expressed her concern at his unannounced absence from regular haunts and speculated that he may indeed have 'disappeared' to South America, a threat several times repeated during the previous weeks, Factual Nonsense's permanent state of financial chaos no longer sustainable even by him. At eleven the next night his stepfather telephoned to ask if anybody had thought of checking the roof of the picture store, as Compston had never before gone missing for more than a couple of days without informing his mother of his whereabouts. By this time he was – in the words of the young policeman who clambered up the ladder

Joshua Compston died at Factual Nonsense in the early morning hours of 6 March 1996. He was buried at Kensal Green Cemetery in west London on 22 March, here mourned by his sister Emily, his mother Bronwen Lenton and the family's bull-terrier, Stubbs.

Compston aged four, redesigning his room.

to double-check the fatal discovery – stone-cold, several-days dead. On his desk the clip of working papers included an unfinished piece of freshly amended typescript: 'The stupid smile of current social structure dictates that truth is always repressed in favour of a purely economic *raison d'être* ... Systemise the shit out of you if they could ... Bodies (dead) as markets Warhol, Mapplethorpe, Dean, Monroe ... 25 years gone to waste.'[1]

It emerged that Compston had prophesied for himself an early death, regularly warning his family that he did not expect to live beyond the age of twenty-five. 'For a long time I was caught up in a hideous charade, a sort of black comedy whereby I would live with the intention of almost relishing all the misery that I could find,' he wrote, aged barely eighteen, to a friend. 'Maybe I tried to make myself the epitome of 'absence, darknesse, death, things which are not'. I was amused by the way I toyed with my life. I would inwardly chuckle with the thought of drinking my painting white spirit. Chuckle because I couldn't have some orange juice (there was none left in the house). True, I never actually tried with a 100% desire for death, but some of the actions I perpetrated a few months ago could have gone wrong. Or right as the case may be.'[2] On 6 December of this same year, 1988, he wrote, to himself: 'This disease inside me cannot find a way of

escape. I may be able to prevent my mouth working but there is nothing I can do to stop myself thinking. Why do I write? In the effort to stop myself becoming a gibberish wreck and in the effort to understand. Just UNDERSTAND. Yes another fool on his poxy little journey. This thing I refer to as 'a disease', is it the proper word? Maybe this is the nucleus that drives and animates my life? Remove this part of me and what is left? Remove the part of me that is labelled 'disturbed' and what is left? Weakness and cliques revolt me. Yet the energy that provides the means to be outside them is gradually destroying the coherence that I need to express. The Art in me is destroying the Art in me? The good in me is the bad in me? We shall see.'[3] On the last day of 1988 Compston wrote in his occasional journal both of his ambitions and of his fears:

> When I die I think that I may have been valued living. But this still does not give a reason for living. Just because the literary magazines or the Campden Hill parties laud me, it does not mean that one should live. Just because I die with estate of £20 million, or books that rank as classics, it does not mean that one should live. However worthwhile I become, however great a contribution to the Arts I make I will be a human and I will die. And no one can prove that I should ever have lived, spoke, defecated, conserved, bought, sold, wrote,

'*Happy' Head*, another Compston sculpture, 1987.

Detail of Compston's teenage room in Strand on the Green, Chiswick, including two paintings by him, and the cornucopia of paint scraped from the floor of Eden Ham's studio, exhibited at Factual Nonsense in 'Es La Manera!' in 1993.

Accumulation of objects found and made by Compston, stored in personalised order in his childhood room. Damien Hirst has said of the collages [see illustration page 11] he made from the possessions of Mr Barnes: 'Collecting this stuff became his life, his passion. He wanted total fulfilment and satisfaction. But he didn't call it art. And that's why it gets to me. To ignore everything and get involved in this creative process, and it just merges into your life and your life merges into it, and that's it. It's a complete fusion of art and life.'

wiped, polished, gesticulated, ejaculated, admired, hated …

But I will not kill myself. It is not out of cowardice (though some say suicide is inherently cowardly – bring on the white feathers), I will not kill myself because I might as well live and try to fulfil some of my ambitions. One can't prove their worth but it might be fun and colourful to live surrounded by art and enough money to support all my eccentric whims …

At this moment I am frightened. Frightened of what I am now. Frightened that I exist everywhere. That people who have never seen me have information on me. Bits of me are all over the place. People who know me shouldn't know me. My intolerance has led to people's dogmatism, where they don't look at me anymore, simply thinking that I am no more. And maybe I am.

Sometimes I wish I wanted to be conventional. But I must spurn this desire. It's weak and dishonest.[4]

Two years later a journal entry for 17 August 1990 reads: 'I must surely die soon. I float far above. I can pretend to be quite attached but most of the time I exist only in the fantasy of death. It is funny to think of the time when I will not exist, and I think it may be soon.' And in a note scribbled sitting on a stile near Petersfield, on 14 July 1991: 'The indignity of dying is disgusting. The disfigurement of dying is disquieting. The disablement of the process of death

no FuN without U

another demon, but this one a natural one; unlike the horrors I fight in contemporary society. Thus I do not fear death, never have done.' This same apocalyptic tone colours the introduction he had earlier composed to accompany the photographic record he made of 'Joshua's Room at the Top'[5], in his mother's house at Strand on the Green, Chiswick:

I am a floundering mess, a fish gasping for air on the side of the sea in Wales. But I seek meaning (how bloody). Some pursue this through the employment of metaphysics, others the Koran, or the machine pistol or through good whiskey. I seek to find the 'divinity of art', the use of art to produce a religious sense that comes from man not God.

This room is the inadequate result. If I batter the dull and succeed whole houses, even cities will be created in such a way. Everything's ultimately a joke but one must make a passionate and concerted effort to forget this fact. Those who do not make the effort to destroy the daily dullness will be cast into the flames.

Joshua
Compston

Furthermore I live in a Mertz, a collage, a performance installation. The photographs should indicate this.[6]

Compston was last seen alive by Gavin Turk and a couple of other friends at closing time at the Barley

'I am a foundering mess, a fish gasping for air on the side of the sea in Wales,' Compston opened the documentary record he made of his room in Chiswick, this detail showing, in the top right-hand corner, the artwork he made from the skeletons of eight sparrows he found drowned in a drain.

William Morris wallpaper pattern from which the design of Compston's coffin was drawn, worked on by Gavin Turk, Gary Hume, Georgie Hopton, Fiona Rae and Deborah Curtis.

Mow on Tuesday evening, 5 March. Earlier in the evening Compston had attended a preview at the Serpentine Gallery of the Jean-Michel Basquiat exhibition: large-scale work by the New York graffiti artist who also died young, from drug abuse. Compston drank a lot that night, and – it was later recalled – was heard to complain of recent difficulties in sleeping. He looked tired and undernourished, but not unduly so, and nobody could have anticipated the night's tragedy. Whether in a deliberate dice with death or by miscalculation, flat out on his ascetic's bed Compston inhaled liquid ether (halophane) from a scavenged bottle which for some years had stood on the shelves of his washroom cabinet and, in search of rest, slowed the beat of his heart until it stopped. And never restarted. There was a great deal of blood on the rug and pillow on which he lay, haemorrhaged from mouth and nose in violent protest at the physical cessation of young life. He was wearing a rust-coloured T-shirt. On a shelf above his head were ranged, as usual, some of his favourite objects: a bronze lion escutcheon, his Pugin keys (which had featured in 'Es La Manera!'), a Gilbert and George bottle of China 1993 wine, two Damien Hirst dot-painted bottles of Beck's beer, unopened, tied up in a plastic bag, a Gilbert and George biscuit tin, and select samples from his teenage collection of historic cigarette packets.

Compston's coffin was painted in Gary
Hume's studio in Hoxton Square, by him
and Gavin Turk, here photographed with
Turk's son Curtis.

The funeral procession, from left to right: Aurel Scheibler, X, Emily Compston, Ben King, Charlie Varley, Andrew Waugh, Jay Jopling.

OPPOSITE Compston's funeral procession, 22 March 1996, passing down Commercial Street on the way from Charlotte Road to the memorial service at Christchurch, Spitalfields. Left to right: policeman, James Lynch, James Goff, Andrew Waugh, Gordon Faulds, Bob Whittaker, Gary Hume, Gavin Turk, Mark Dowsett, Christopher Compston, Andrew Herman, Max Wigram. The team of pallbearers wore red FN stickers on their lapels.

Newspapers which had failed to review a single FN event feasted on the dramatic death, aged twenty-five, of a man who was – to some – 'a brilliant meteor'[7], to others 'an art-world fixer'[8], 'a unique and highly eccentric figure'[9] 'who made Damien Hirst look tame'[10]. His artist friends declined to share in this construction of a media myth. In counter response to the ghoulish attention of the establishment press to Compston's violent end, Tracey Emin wrote in *The Big Issue* a celebration of his life. 'He went to extremes: of generosity, of bringing people together, and within the vision of art. That's why he was loved so much.'[11] Gary Hume and Gavin Turk paid their respects by together painting Compston's coffin, in turquoise and magenta, borne by them and other friends in a vast street procession from the doors of Factual Nonsense to his funeral service in Christchurch Spitalfields, Nicholas Hawksmoor's mannerist masterpiece. At the wake that night in the Tramshed around the corner from FN, photographs and videos of Compston and his creations were projected on to the walls, the music turned up full volume, J&B whisky dispensed and a parting party was thrown open to all.

Without Compston, Factual Nonsense 'the entity' no longer existed. The archives were boxed up and given to the Tate Gallery, Compston's personal belongings returned to his family and the Factual

no FuN without U

Peter Blake beneath the entrance porch at Hawksmoor's Christchurch, standing next to the photographer Guy Moberly, a close friend of the Compstons, here captured on camera by his brother Giles, also a photographer. Also in the picture is Mona Kher, an FN exhibitor.

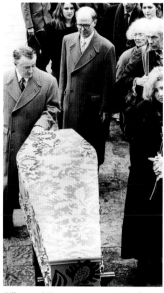

Gilbert and George pass to one side of Joshua Compston's coffin, Albert Irvin to the other.

Nonsense Trust founded to administer the remaining records and remnants of the FN years, for the benefit of artistic enterprise in the Shoreditch area. Measured both in conventional terms and by the standards Compston set himself, Factual Nonsense failed, changed nothing. And yet, as the years since his death multiply, it becomes clear that he did make a difference, that FN does matter.

The art-historical significance of Factual Nonsense lies not in the exhibitions but in the collaborative street events Compston organised from his dynamic, unstaffed office at the back of the gallery space. His key invention was the Fête Worse Than Death, first held in the summer of 1993, at which certain artists explored in public themes normally developed in the privacy of their studios, while others were persuaded into a shift of interests, if only for the fun of a day away from their central creative concerns. It was Compston's gift to generate energy and momentum within the resident community of Shoreditch artists around a unifying idea, of importance to him though often of marginal interest to anybody else. The special nature of FN events, the quality which raised them above any other such happenings, emanated from Compston's person. His passionate need for connectedness obligated artist friends to interact among themselves, and to perform not for him so much as for one another. They were their own audi-

no FuN without U

Encircling the coffin below the steps of Christchurch, Spitalfields, are Eric Franck, Jay Jopling, Gavin Turk, Deborah Curtis, Billy Shoebridge, Sam Crabtree, Rut Blees Luxemburg, Sarah Staton, Simon Bill, Mick Kerr, Cedric Christie, Andrew Herman, Adam MacEwan, Gary Hume, and many other artists and dealers.

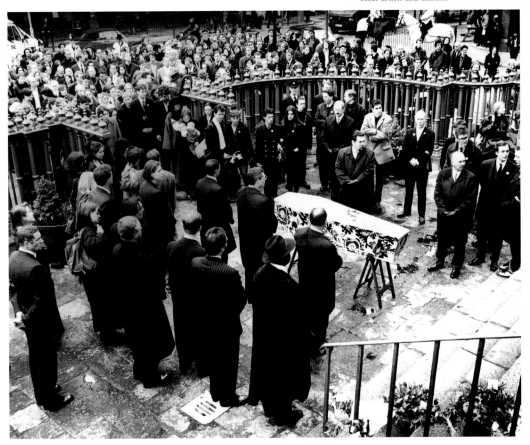

Gilbert and George bottle of China '93 wine and two Damien Hirst bottles of Becks beer, found, unopened, at Compston's bedside after his death.

ence – a vibrant illustration of a phenomenon of the creative unconscious noted by Eric Neumann: 'The rapture of those who give art form, and the rapture of the group celebrating the epiphany constitute an indivisible unit.'[12] It sometimes felt a chore and a bore to be part of the Factual Nonsense scene, but at other times also a privilege and a pleasure. Even the local printers and platemakers in Charlotte Road, initially suspicious of Compston's tortuous flow of impractical instructions, before his death warmed to the tireless enthusiasm with which he pursued his impossible dreams.

Compston succeeded posthumously in bringing the entire neighbourhood out on to the street: the bomb squad were summoned to remove from the premises his unstable sticks of dynamite, discovered by his stepfather in a cupboard. 'What's going on?' a group of grey-suited businessmen asked each other as they waited in the spring sunshine behind hastily erected barricades at the foot of the street, anxious to be allowed back into their offices. 'The IRA?' 'No, no,' the news laughingly circulated, 'it's an *art* bomb scare!' 'What a little drama queen!' a friend commented on Joshua's ghostly presence.

As Tracey Emin noted in her memorial piece in *The Big Issue,* Compston was himself an artist, FN events his principal works of art. Although the theoretical base of his ideas lay in the historical avant-

　　　　　　　　no FuN without U

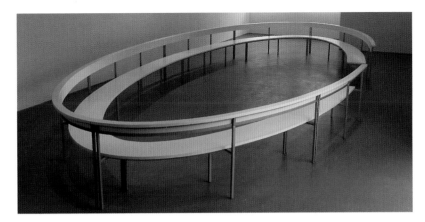

garde, in practice Compston's art was highly contemporary, demanding the active participation of viewers for its existence. As the most thoughtful of British writers on art, David Sylvester, puts it: 'The modern artist creates ... images in which the observer participates, images whose space makes sense only in relation to the position in it occupied by the observer.'[13] Compston constantly concerned himself with the role in the creative act of the widest possible community of participants. One of the projects uncompleted at his death was the CAD/CAM Commissions, sponsored by the Henry Moore Foundation, designed to take a group of artists of his choice into productive partnership with high-tech industrial manufacturers from the trans-Pennine region:

> The project aims to encourage a fulcrum for debate and anvil of change as regards the theories and practices of art, technology and science. For a criminal period there has been too little interest in forming collusions between such fields ... Thus it is anticipated that real progress can be made towards creating a true collaboration between fields hitherto splintered by the vagaries of modern society ... The greatest advertisement for this posited state (that it is inherently necessary/ethically desirable to broker such a marriage) will be its reality, not printed matter or radio programmes. What better way to achieve such objectives than to be able to demonstrate the

One of the numerous projects left unfinished at Compston's death was the Transpennine CAD/CAM Commissions for the Henry Moore Foundation, in which Langlands & Bell were to be exhibited. Though Compston's plans were unrealisable without him, the project went ahead in an altered state, still including Langlands & Bell, with *Eclipse* (1998), a dual-form conference installation here seen at the Henry Moore Institute in Leeds.

Tracey Emin and Sarah Lucas, *U Boat Commander U* (1996), the title a reference to Factual Nonsense's 'First "party" Conference' at which they performed; this commemorative piece made especially for the memorial show at Aurel Scheibler's gallery in Cologne in June 1996.

Gavin Turk, *Syrup* (1996), made for the Cologne show, the black bottle referring to the fact that Compston died inhaling halophane from a scavenged chemist's bottle, exhibited on the Courtauld shelves in 'Es La Manera!' in 1993.

following:
– the virtues of advanced manufacturing and its exciting future within the area.
– the effrontery and 'magic' of an artistic imagination.
– the sheer wealth of material thus engendered as a direct result of the scheme of taking artists right into the dark mills.[14]

On 30 June 1996 Aurel Scheibler opened an exhibition in Cologne as a personal tribute to his friend Compston, including work by many of the artists close to the heart of Factual Nonsense, notably Tracey Emin, Don Brown, Mat Collishaw, Gavin Turk, Langlands & Bell, Sam Crabtree, Sarah Lucas and Angus Fairhurst. Other Men's Flowers was exhibited, and FWTD '94 balloons filled with helium settled among the rafters. A black T-shirt was made for the occasion, printed with the FN logo, in red. On a table Scheibler displayed a host of Joshua-related ephemera, including a letterpress printed paper bag from Pellicci's, his favourite café in Bethnal Green Road, whose home-made pies were regularly served to early-comers at FN previews. Among the framed memorabilia hanging in a quiet corner, with a couple of chairs in which to sit and read FN tracts, was the drawing of a tiger by Eden Box, one of the treasures from Compston's room in Chiswick, an earlier birthday gift to Scheibler. At night there

no FuN without U

was music, and crowds who had until then never heard of Joshua Compston danced in the street, a cut-out image of the man himself floating above them in the gallery's spot-lit window.

The finest demonstration of how much the artists themselves valued the FN legacy came with the invention in August 1997 by Gavin Turk, Deborah Curtis and Mike Walter of a 24-hour street event at the crossing of Charlotte Road and Rivington Street, the precise location of Compston's original Fête Worse Than Death. Under the rubric Live Stock Market – the livestock being the people, the live stock their art of performance, and the market a free street party. Dozens of, by now, well-known artists gathered in the 'pen enclosures'[15] to reinvent the exponential fun of an 'FN Day'[16]. Names listed alphabetically in the official programme include Rut Blees Luxemburg, Don Brown, Jake and Dinos Chapman (Snuff Stall), Adam Chodzko (Blind Date Raffle), Mat Collishaw (Have Another Beer Mat), Peter Doig and Chris Ofili (Cocktail Bar), Tracey Emin, Angus Fairhurst, Anya Gallaccio, Gary Hume and Georgie Hopton (Rabbit Drawings, Fluffy Navels, and Bunny Tails), Elinor Jansz, Abigail Lane, Richard Long (Mud Balls), Sarah Lucas, Leila Sadeghee, Jane Simpson (Mutant Bambis), Sarah Staton (Artist's Holiday), Jessica Voorsanger, Sue Webster and Tim Noble, and Catherine Yass (Por-

Scheibler exhibited in his friend Compston's memory selected work by artists connected to the FN enterprise, including Don Brown, *Emergency Sculpture* (1993) and Mat Collishaw, *Ultraviolet Angels* (1993).

trait Enclosure). With farm gates placed at the end of Charlotte Road to block off the street to motor traffic, Turk decreed that the only currency acceptable at the sixty stalls in the market be the One Bull notes which Tom Shaw designed and printed for the day, exchanged by visitors for sterling at brightly painted kiosks. The official Bull Bank was Factual Nonsense's old premises, where at the end of the event stallholders cashed in their golden notes through the Victorian iron bars – like a cow-town moneylender down Mexico way. Breaking a notorious Factual Nonsense precedent, Live Stock Market managed to turn in a profit of £3000, ready for reinvestment in the next FN Day celebration.

It was certainly a day to cherish, full of laughter, Joshua Compston's name many times remembered. Veterans of the earliest experimental FN events set an example for others to follow. Gary Hume offered all-comers virtual reality helicopter flights: wearing 3-D spectacles, punters were seated in a battered Charles Eames leather chair and twirled round and round till it felt like flight. Gillian Wearing and Michael Landy, barely recognisable in wigs and fancy dress, sweated for hours in the sun making composite Polaroid portraits, chosen by the fairgoers from an expanding portfolio of documented body parts, their own included if they wished. At the next door pitch Georgina Starr and Paul Noble composed sculptural

Gavin Turk's personal celebration of Joshua Compston's life took the form of a street event on Saturday 9 August 1997, designated 'FN Day', for which Turk designed and Tom Shaw printed Bull Notes, the only currency accepted from the six thousand visitors to the fifty artists' stalls at Live Stock Market.

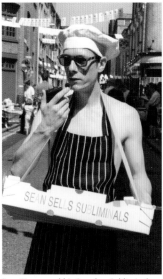

Sean Dower and his Senseless Subliminals.

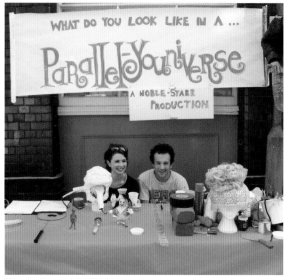

Georgina Starr and Paul Noble's
Parallel Universe.

Jessica Voorsanger's Fan Club Kits.

Gillian Wearing and Michael
Landy preparing their Bits and
Pieces stall at Live Stock Market.

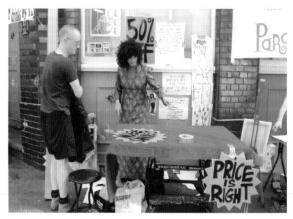

no FuN without U

Abigail Lane, in her Complete Arthole Nosecasters uniform, with tattoo by Sue Webster and Tim Noble.

Mat Collishaw and Tracey Emin display their Webster and Noble Live Stock Market tattoos.

Donald Parsnips (a.k.a. Adam Dant) Love Poems.

Alex Chapel and David C West as the Pantomime Cow.

no FuN without U

images of their equally keen clients from an assortment of domestic material. Jessica Voorsanger's entertaining contribution to the day was the offer for hire of a group of young female art students, armed with autograph books and fake teenage screams, to mob unsuspecting passers-by as named pop or art stars.

Around the corner in Rivington Street, Sarah Staton imported sacks of seaside sand, a paddling pool and colourful sunshades, and made mock palm trees to create her artist's beach on the pavement. Abigail Lane donned a laboratory coat to add clinical conviction to her claim to be a professional modeller of noses: 'LEAD by the NOSE. Your nose cast in lead by experts. Complete Arthole Nosecasters.'[17] In a nearby cul-de-sac Cedric Christie displayed a dark brown cow, calf, goat and a couple of sheep borrowed from Spitalfields City Farm, and asked passers-by to guess on which pavement slab the mother cow would next shit. Meanwhile, Judy Adam gave backstreet massage, Webster and Noble drew tattoos, and Ben Weaver ran a smash-a-plate stall of Habitat china. All day long, from a stage mounted on a lorry drawn up outside the Barley Mow, Mike Walter organised live music, with performances by Die Kunst Reworked, No Money No Detail, Add N to X and numerous other inventive bands.

'An exciting and tumultuous one-day event to be

no FuN without U

held in the open air composed of the multifarious talents and glamorous possibilities created by combining a selection of Britain's hottest visual arts practitioners,'[18] Compston wrote in the press release for Fête Worse Than Death '94.

They are still dancing down his FN streets.

Wearing and Landy's polaroid portraits of Penny Govett and Mick Kerr, incorporating the Bits and Pieces of Kate Bernard, Tracey Emin, Georgina Starr, Max Wigram, and other passers-by.

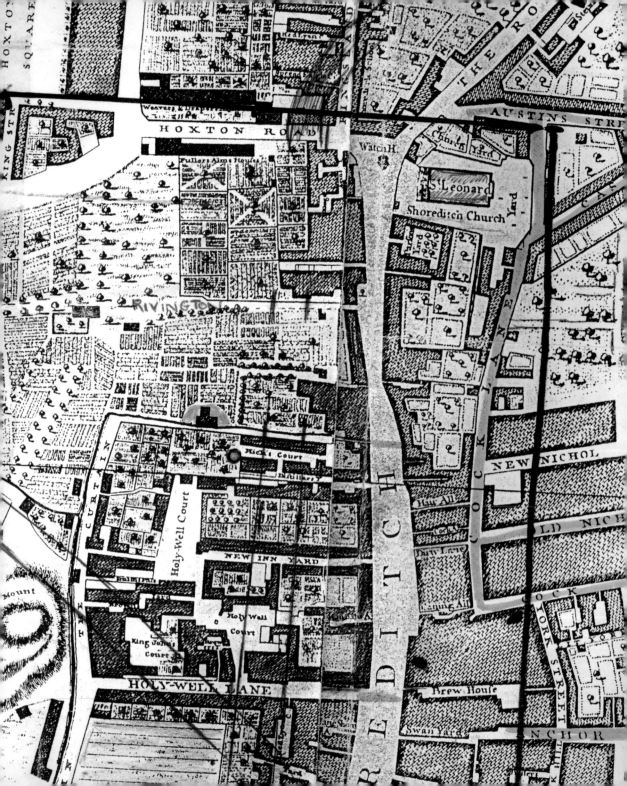

notes

chapter one

1 Joshua Compston, letter 6 February 1989

2 Joshua Compston, letter 20 July 1988

3 Ibid

4 Joshua Compston, press release for exhibition 'SS EXCESS', opening at Factual Nonsense 23 July 1993

5 *The Independent,* 15 March 1996

6 *The Big Issue,* 10 April 1996

7 Interview with Carl Freedman for the exhibition 'Minky Manky', South London Gallery, 12 April to 14 May 1995

8 'SENSATION: Young British Artists from the Saatchi Collection', Royal Academy, London, 18 September to 28 December, 1997

9 'Freeze', easily confused with the art magazine *Frieze,* founded in the summer of 1991, originally edited by Mathew Slotover and Tom Gidley, often featuring articles on this same group of artists

10 'Sarah Lucas', exhibition catalogue, Museum Boymans-van Beuningen, Rotterdam, 1996

11 Bruce Nauman, interview by Tony Oursler, *Paper* Magazine, New York, 1995

12 Interview with Marcello Spinelli, 20 March 1995, for catalogue of the exhibition 'BRILLIANT! New Art from London', Walker Art Centre, Minneapolis, 1995

13 'Modern Medicine', Building One, Southwark, London, 1990

14 'Gambler', Building One, Southwark, London, 1990

15 Quoted by Andrew Graham-Dixon in his catalogue introduction to 'Broken English', Serpentine Gallery, 1 August to 1 September 1991.

16 See note 8

17 Interview with Douglas Fogle, 28 February 1995, for exhibition catalogue 'BRILLIANT!'

18 'The Levellers', catalogue essay in 'BRILLIANT!', 1995

19 'Courtauld Institute Loan Collection: An Introduction', January 1991

20 Ibid

21 Ibid

22 'The Business Plan of Factual Nonsense', drafted in January 1993 in preparation for funding application to the Princes Trust

23 Letter of 23 April 1991

24 'Gilbert and George: Morality and Will', Andrew Wilson in the exhibition catalogue of 'New Democratic Pictures', 1992

25 Letter to Joshua Compston, dated 23 May 1990 (sic)

26 Interview with Andrew Wilson, April 1990

27 See note 6

28 Lecture on the painter Jacques-Louis David, given at the British Academy in 1974

29 Joshua Compston, postcard 12 May 1991

30 Opening paragraph of press release, 'Courtauld Loan Collection Private View', 27 November 1991

31 Joshua Compston, inscribed on 'Courtauld Loan Exhibition' invitation card, No. 27 of the limited edition of 200, November 1991

32 Diary entries for 21 March and 7 May 1991

33 'Damien Hirst: The Butterfly Effect' in Stuart Morgan's selected writings, *What the Butler Saw,* 1996

34 Damien Hirst, *I Want to Spend the Rest of my Life Everywhere, with Everyone, One to One, Always, Forever, Now*, Booth-Clibborn Editions, 1997

35 Ibid

36 Quoted in catalogue of the show *Gavin Turk. Collected Works 1989–1993* at the White Cube, December 1993 to January 1994

37 'Broken English', Serpentine Gallery, 1991

38 Gary Hume, interviewed by Marcelo Spinelli on 30 March 1995, for 'BRILLIANT!'

39 Quoted in Andrew Graham-Dixon's biographical notes on the artists in 'Broken English', 1991. According to the outraged *Daily Star*, the work had been sold before the exhibition for £10,000 to Charles Saatchi

40 Joshua Compston, in an interview with Alison Sarah Jacques in *Flash Art*, November 1993

41 Quoted in *Homage to the Extreme*, Michael Bernstein, 1998.

42 Joshua Compston, in conversation with Richard Gott, for *The Guardian Weekend*, 7 October 1995

43 As quoted in *The Independent*, after the original exhibition of *Ghost* at the Chisenhale Gallery in 1990

44 See note 22

45 Aurel Scheibler Archives

46 *Abstractions from Domestic Suburb Scene (Sin)*, private view broadsheet, 13 August, 1992

47 Ibid

48 Ibid

49 First published in 1995 by Editions Jannick, Paris, in a signed edition of 299 copies

chapter two

1 Jeremy Cooper, 'Gilbert and George "At Home"', *Parkett* 14, November 1987

2 See chapter one, note 46

3 *Magazine Sculpture* commissioned by the *Sunday Times Colour Magazine* in autumn 1970

4 The first Singing Sculpture was performed in the 'Midnight Court' at the Lyceum in the Strand in 1969, and again later that same year at the National Jazz and Blues Festival at Plumpton.

5 'British Rubbish', IAS, 22 June to 3 August 1996

6 Card of 24 September 1992

7 'Dan Asher: Guestarbeiter on the Planet', Aurel Scheibler, Köln, 1993

8 FN Archives

9 'Langlands & Bell', Serpentine Exhibition Catalogue, April/May 1996

10 Card of 3 November 1992

11 Press release, 'Better Than Domestic Shit', December 1992

12 Ibid

13 Press release, 'Sam Crabtree's Utopic Space Manifest', January 1993

14 Sam Crabtree, 1991 (record in Aurel Scheibler Archives)

15 Louise Bourgeois, diary entry, 6 January 1966

16 Undated document in the Aurel Scheibler Archives

17 Factual Nonsense proposal for financial restructuring and development for formation as FN Holdings Ltd, March 1994

18 Joshua Compston, 'Gavin Turk's Studio', written in January 1996 for the launch edition of a magazine called *Code*

19 Quoted by Nicholas Boyle in *Goethe. The Poet and the Age*, Oxford, 1992

20 Ibid

21 Press release for Taborn's 'Wet & Dry' (there was no press release for 'Es La Manera!')

22 Article titled 'Rising Star', *London Evening Standard*, April 1993

chapter three

1 Carl Freedman interviewing himself in catalogue of 'Minky Manky', South London Gallery 1995

2 Sarah Lucas Portikus, Frankfurt 1996

3 'BRILLIANT! New Art from London', Minneapolis 1995

4 Joshua Compston in programme of A Fête Worse Than Death, Saturday 31 July 1993

5 Article in *The Big Issue*, 10 April 1996

6 Quoted in *The Ditch*, spring 1996

7 Quoted in *The Guardian*, 23 March 1996

8 Vladimir Mayakovsky, *Instructions to the Armies of Art*

9 Sue Tilley published an excerpt from her book on Bowery in the art magazine *Abeasea*, spring 1996.

10 Damien Hirst, *I Want To Spend The Rest Of My Life Everywhere, With Everyone, One To One, Always, Forever, Now*

11 See note 5

12 Factual Nonsense and PPQ 'Purveyors of Constant Amazement' present 'A Fete Worse Than Death' Saturday 31 July 1993, 14.00–02.00

no FuN without U

13 Letter of 9 August 1993 to Jacqui Thompson

14 Press release for '33 Rue de La Glacière', 23 September to 15 October 1993

15 Factual Nonsense Archives

16 Ibid

17 Joshua Compston, letter of 20 July 1988

18 Joshua Compston's 'TV Listings Guide' 18 to 22 October 1993

19 Gordon Faulds' slogan for his DJ night, Marquee de Slade, Friday 22 October 1993

20 See note 18

21 Ibid

22 Ibid

23 Aurel Scheibler Archives

24 Private view invitation, 19.00–21.00, 25 November 1993

25 Quoted in an article by Celia Lyttleton, 'Creative Undertaking: Joshua Compston deals in coffins and concepts', *The Independent Magazine*, 27 November 1993

26 Ibid

27 Joshua Compston's journals, diaries and private notebooks are quoted from by courtesy of his mother, Bronwen Lenton

chapter four

1 Quoted by James Park in *Sons, Mothers and other Lovers*, Little, Brown, 1995, in which Joshua Compston is described under the pseudonym 'Roderick'

2 Card dated 5 May 1995, referring to public praise for the print portfolio Other Men's Flowers

3 Card dated 15 September 1994

4 Card dated 13 February 1993

5 Joshua Compston, in 'The Business Plan for Factual Nonsense', January 1993

6 Diary of 1926 produced by the French veterinary pharmaceutical firm Lactéol, makers of 'compressed tablets of latic ferment', adapted by Joshua Compston for his own use. Under 1 June, his date of birth, he has entered: 'another piece of dangerous incandescence born 44 years hence'

7 'Sensible Research Ltd – The Future of FN', October 1994

8 Ibid

9 Letter dated 10 March 1995

10 Letter dated 15 June 1995

11 Proposal for Masthead Sponsorship, prepared by Joshua Compston, Director, FN, June 1995

12 Ibid

13 Conversation with the author

14 Paul Tillich, *The Courage To Be*, Nisbet, 1952

15 See note 5

16 Quoted in 'BRILLIANT! New Art from London', Minneapolis 1995

17 Factual Nonsense Archives

18 'HARDCORE' (the first part), 26 November 1993 to 25 January 1995

19 From the frontispiece of Other Men's Flowers published in 1944

20 Aurel Scheibler Archives

21 Press release for publication and exhibition of Other Men's Flowers, 23 June 1994

22 See note 17

23 Letter dated 15 March 1994

24 See note 21

25 See note 17

chapter five

1 Proposed Financial and Administrative Structure for the Fête Worse Than Death '94

2 Cover of official programme of FWTD '94

3 Chairman's statement in FWTD '94 programme

4 Official FWTD '94 programme

5 Tracey Emin, *Exploration of the Soul*, limited edition of 200, printed 1994

6 Letter of 26 October 1994

7 Joshua Compston in flyer for The Hanging Picnic, 12.00–20.00, 8 July 1995

8 *The Daily Telegraph*, 2 December 1995

9 Joshua Compston, press release for 'Assorted States', 24 March to 15 April 1995

10 Joshua Compston, press release for 'HARDCORE' (Part II), 29 September to 4 November 1995

11 Joshua Compston, 10 November 1995

12 Factual Nonsense Archives

13 Ibid

14 Quoted by Sarah Kent in her essay for the FN show 'Slugs and Snails and Puppy Dogs Tails', private view 23 November 1995

15 B Varga, *Conversations with Iannis Xenakis*, Faber, 1996

16 Typed manuscript (later published in Gavin Turk's catalogue of 'The Stuff Show', South London Gallery, September 1998, different from the shorter version published in *Code*) in the Factual Nonsense Archives, dated January 1996

17 Typed manuscript (unpublished) in

the Factual Nonsense Archives,
dated February 1996

18 Tracey Emin, *Exploration of the
Soul*, limited edition of 200, printed
1994

19 Small notebook pasted into a larger
book of photographs taken by
Joshua Compston between 1985 and
1987, 'to raise affection in the
onlooker for scenes which the
majority despise'

20 See note 15

chapter six

1 Sensible Research Ltd, 'The Future
of FN Holdings Ltd', October 1994

2 *The Daily Telegraph*, 13 March
1996

3 David Cohen in *The Independent*,
15 March 1996

4 A Fête Worse Than Death '94,
official programme

5 Quoted in Ronald Clark's biography
of Bertrand Russell

6 Letter of 20 July 1988

7 *The Independent*, 17 November
1993

8 Quoted in *House*, edited by James
Lingwood, 1995

9 *The Independent*, 11 November
1993

10 'Gavin Turk Collected Works
1989–1993', December 1993 to
January 1994

11 'Gavin Turk's Studio', January 1996,
draft of version later published in
Code

12 See note 10

13 Aurel Scheibler Archives

14 Transcript of trial in Damien Hirst,
*I Want To Spend The Rest Of
My Life Everywhere, With

*Everyone, One To One, Always,
Forever, Now*

15 Ibid

16 'Some Went Mad, Some Ran Away
…', Serpentine Gallery 4 May to 5
June 1995

17 Richard Gott, *The Guardian
Weekend*, 7 October 1995

18 'Minky Manky', South London Art
Gallery, 12 April to 14 May 1995

19 Ibid

20 Ibid

21 David Sylvester, *About Modern Art:
Critical Essays 1948–96*, Chatto and
Windus, 1996

22 'BRILLIANT! New Art from London',
Minneapolis, October 1995

23 Ibid

24 Ibid

25 Ibid

26 Ibid

27 Joshua Compston, FWTD '93

28 Press release for '33 Rue de la
Glacière', September 1993

29 Card dated 7 September 1993

30 Doris Lessing in *Walking in the
Shade*, Harper Collins, 1997

31 Catalogue of 'The British Art Show',
Glasgow Jan/March 1990, Leeds
April/May 1990, Hayward Gallery,
London, 14 June to 12 August 1990

32 Review of 'Piero Manzoni' at the
Serpentine Gallery, *Frieze* Magazine
June 1998

33 The personal invitation to Joshua
Compston is in the Factual Nonsense
Archives, given by the Factual
Nonsense Trust to the Tate Gallery

34 *Detour: The Slightly Listing Cultural
Guide for Hackney*, December 1995

35 Joshua Compston, letter dated 11
January 1994

chapter seven

1 Letter of 20 July 1988

2 Journal, 6 December 1988

3 Journal, 31 December 1988

4 Joshua Compston, undated, c. 1987

5 Ibid

6 *The Guardian*, 12 March 1996

7 *The Independent*, 21 March 1996

8 *The Independent*, 15 March 1996

9 *Daily Mail*, 22 March 1996

10 *The Big Issue*, 10 April 1996

11 Eric Neumann, *Art and the Creative
Unconscious*, Bollinger Foundation,
1954

12 David Sylvester, *About Modern Art:
Critical Essays 1948–96*

13 Joshua Compston in a report
commissioned by Robert Hopper of
the Henry Moore Foundation,
Leeds, delivered on 17 August 1995

14 Official Live Stock Market
programme (designed by Tom
Shaw), Saturday, 9 August 1997,
from 11.00 to 23.00

15 Ibid

16 Advertisement in Live Stock Market
programme

17 Press release for A Fête Worse Than
Death, 30 July 1994

chronology of **Factual Nonsense** exhibitions and events

Courtauld Loan Collection

Private view 27 November 1991.
Courtauld Institute of Art, Somerset
House, Strand, London WC2R 0RN
Rachel Budd, Darren Coffield, Sam
Crabtree, Ian Davenport, Gilbert and
George, Damien Hirst, Howard
Hodgkin, Gary Hume, Albert Irvin,
Langlands & Bell, Olivia Lloyd, Fiona
Rae, Andrew Sabin, David Taborn, Piers
Wardle, Hilary Wilson.
Collection of paintings formed and the
exhibition curated by Joshua Compston.
Two invitations, jointly designed by
Joshua Compston and Darren Coffield,
one as a 'limited edition' using an image
by Darren Coffield, the other
incorporating a William Chambers print
of Somerset House.
Financial assistance from (among
others): Jeremy Fry, Natalia Duchess of
Westminster, Edward Lee, Robert Loder,
Tim Llewellyn for the Friends of the
Courtauld Institute, Martin Owen for
Blackwall Green Ltd, Prudence
Cummings Associates Ltd.
Photographs by Guy Moberly
Physical assistance from (among others):

Susannah Brooke-Webb, Ian Finlator,
Paul Godfrey, Sumaya el Hassan,
Tabitha Potts.

David Taborn – Recent Work

28 February to 4 April 1992. Grob
Gallery, 20 Dering Street, London
W1R 9AA
David Taborn
Paintings
London showing, arranged by Joshua
Compston, of an exhibition organised
by the University of Nottingham Art
Gallery.

**Abstractions from Domestic Suburb
Scene (Sin)**

Private view 13 August 1992. Benjamin
Rhodes Gallery, 4 New Burlington
Place, London W1X 1SB.
Rebecca Bower, Jason Brooks, APC,
Darren Coffield, Michael Kerr, Mary
Nicholson, Michael Robertson, David J
Smith, Joanne Thorpe, Ane Vester,
Hilary Wilson.
Found and made art objects
Curated and designed by Joshua
Compston and Violet Fraser. Invitation

and poster/catalogue designed and
printed by Tom Shaw.

A Guide for the Perplexed

Private view 22 November 1992.
Factual Nonsense, 44a Charlotte Road,
London EC2A 3PD
Daz Coffield, Sam Crabtree, David
Taborn.
Paintings
Invitation designed and letterpress
printed by Tom Shaw, for the opening
show of Factual Nonsense's ground
floor premises, the purple and tangerine
lettering on the fascia board designed
and executed by Zebedee Helm.

Better Than Domestic Shit

Private view 10 December 1992. Factual
Nonsense, 44a Charlotte Road, London
EC2A 3PD
Rebecca Bower, Mick Kerr, David J
Smith
Installations and designs for multiples
Invitation designed by Joshua
Compston, incorporating newspaper
cutting from the *Evening Post*, 17
September 1931.

Sam Crabtree's 'Utopic Space Manifest' (Amber Series)

Private view 21 January 1993, at Factual Nonsense

Sam Crabtree

Paintings

Invitation designed by Joshua Compston, incorporating items from his ephemera collection: photographs of the Silver Bullet (a racing car built by the Sunbeam Motor Car Co. Ltd, Wolverhampton, England), and Heinrich Focko's 'World's Safest Airplane'.

An evening of improvised music

Thursday 18 February 1993, 21.00, at Factual Nonsense

Mike Walter on saxophones, Roger Turner on percussion, and Adam Bowman playing prepared strings and amplified objects, responding in sound to the sight of Sam Crabtree's Amber Series of large canvases.

Es La Manera!

Private view 16 March 1993 (exhibition billed to run from 10 to 30 March) at Factual Nonsense.

A Pugin, Eden Ham, A Aalto, Beat Time, C Voysey, Bad Brum, Asher Pile, W Kandinsky, J Koons, P Wardle, S Karakashian, Waugh's Aunt, A Schroeder

Works new and old belonging to or commissioned by Joshua Compston. Invitation designed by Joshua Compston, printed by Tom Shaw. Assistance with design and mounting of exhibition from (among others): Gavin Turk, Andrew Capstick, Deborah Curtis, Andrew Waugh, Tony Relph.

Taborn's Wet & Dry (paperworks 1991–1993)

Private view 15 April 1993, at Factual Nonsense

David Taborn

Paintings

Invitation designed by Joshua Compston, marked 'Factual Nonsense collector's card No. 5'.

Lady Lazarus. A Celebration of the Poetry of Sylvia Plath (1932–1963)

Wednesday 21 April 1993, 19.45, at Factual Nonsense

Speakers: Al Alvarez and Carol Rumens; readers: Jane Duran, Sue Hubbard and Mimi Khalavi; presented by Blue Nose Poetry in conjunction with Factual Nonsense

Improvised Music at Factual Nonsense

Thursday 22 April 1993, 22.00, at Factual Nonsense

Jim Lebaigue: drums; Alan Tomlinson: trombones; Mike Walter: saxophones.

Dan Asher's Sight Unseen

Private view 20 May 1993, at Factual Nonsense

Dan Asher

Sculpture and drawings

Exhibition mounted with Aurel Scheibler of Cologne, marking his publication of a book on 'Dan Asher Guestarbeiter on the Planet', to which Joshua Compston contributed an essay.

'SS EXCESS' From Mary Magdalen to John the Baptist 1993

Private view 23 June 1993, at Factual Nonsense

Zoe Benbow, Jason Brooks, Mona Kher, Piers Wardle, James Robinson, Olivia Lloyd

Painting and sculpture

Invitation designed by Joshua Compston.

A Fête Worse Than Death 1993

Saturday 31 July 1993, 14.00–02.00, stalls and performances in the streets at the crossing of Charlotte Road and Rivington Street, and also in The Tramshed, Rivington Street.

Artists billed include: Adam Chodzko, Sarah Staton, Damien Hirst, Mick Kerr, Gary Hume, Sarah Lucas, Gillian Wearing, Gavin Turk, Simon Bill, Angus Fairhurst, Andrew Capstick, Tracey Emin, Adam McEwan, John Bischard, Deborah Curtis, Sharon Dowsett, John Lundberg, Piers Wardle, PPQ, Stephen Hughes, Rod Dickinson, Gordon Faulds.

Programme designed by Joshua Compston and Tom Shaw, printed by Charterhouse Graphics, of Charlotte Road.

Flyer donated by Call Print, of Curtain Road.

Supported, financially and otherwise, by: Bipasha Ghosh, Adrian Amos of the London Architecture and Salvage Co., Charterhouse Graphics, James Lynch, The Cabinet Gallery, Rob Dawson Moore, M Bardigger, and The Cooler.

33 Rue de la Glacière

Private view 23 September 1993, at Factual Nonsense

Max Jourdan

Letterpress catalogue and invitation designed and printed by Simon

Reddington, with financial support from AGFA.

Photographs selected by the artist and printed by Rob Dawson Moore, exhibition accompanied by première performance of Molly Nyman's Wind Quintet, costumed by Hannah Greenaway.

Factual Nonsense first 'party' Conference

From 18 to 22 October 1993, at the Barley Mow, Rivington Street Performers and participants billed include: Tracey Emin, Sarah Lucas, Leigh Bowery, Angus Fairhurst, Maureen Paley, Stuart Morgan, Max Wigram, Cerith Wyn Evans, Paul Fisher, Dan Asher, Stuart Brisley, Maya Brisley, Helen Chadwick, PPQ, Albert Irvin, Piers Wardle, Mark Wigan, David Lillington, Tabitha Potts, Molly Nyman, Leila Sadeghee, Miranda Sex Garden, Chloe Ruthven, David Taborn.
Music in the 'Marquee de Slade' on night of 22 October by Gordon Faulds, Joe Hagan and the Extreme Quartet (Lol Coxhill: soprano saxophone; Mike Walter: tenor saxophone; Hugh Metcalfe: guitar; Jim Lebaigue: percussion)
Photograph (of Angus Fairhurst's genitals, painted by Leigh Bowery) used on the poster was taken by Guy Moberly at FWTD '93.

ERRATA

Private view 25 November 1993, at 18 Charlotte Road
Leila Sadeghee
Billed as a 'live and video installation by Sadeghee & Daughters Ltd', devised by

Leila Sadeghee and Joshua Compston.
Invitation designed by Andrew Capstick

HARDCORE (the first part)

26 November 1993 to mid-January 1994, at Factual Nonsense
Gary Hume, Andrew Capstick, Fiona Rae, Piers Wardle, David Taborn, Darren Coffield, Rebecca Bower, Dan Asher, David J Smith
Paintings, photographs and sculpture

seamless cream

Private view 12 May 1994, at Factual Nonsense
David Taborn
Recent paintings
Invitation designed by Tom Shaw, incorporating a sticker of Zebedee Helm's FN monogram (see pair of enamel on steel memorial plaques now mounted on the façade of 44 Charlotte Road, at first-floor level, flanking the place where Joshua Compston stood for an iconic photograph by Anthony Oliver, first published in *The Guardian*).

Other Men's Flowers

Private view 23 June 1994, in a derelict sawmill at 33 Coronet Street, off Hoxton Square, subsequently exhibited at Factual Nonsense
Henry Bond, Stuart Brisley, Don Brown, Helen Chadwick, Mat Collishaw, Itai Doron, Tracey Emin, Angus Fairhurst, Liam Gillick, Andrew Herman, Gary Hume, Sarah Staton, Sam Taylor-Wood, Gavin Turk, Max Wigram.
A text publication curated by Joshua Compston, published by the Paragon Press, all prints measuring 470 mm by 610 mm, screen or letterpress printed by

Tom Shaw and Simon Reddington.
Portfolio edition of 50 copies, with 20 artist proofs, consisting of 15 prints, a title page, an introduction and a colophon page signed by all the artists, presented in a box.
Book edition of 100 copies, with 20 artist proofs
Also exhibited:
In Edinburgh, at the Scottish National Gallery of Modern Art, from 25th February to 30th April 1995, in an exhibition of all the publications of the Paragon Press. The show toured to America, being seen at the Yale Center for British Art in New Haven, and at the McNay Museum of Art in San Antonio, Texas.
In Berlin by Louise Wirz and Astrid Ihle, at Im Pferdestall im Kunsthof, Oranienburgstrasse 27, from 13 to 23 May 1995.
In Athens, at Icebox, 151 Pattission Ave, from 19 October to 18 November 1995.
In Cologne, at Aurel Scheibler's gallery, Maria Hilf Strasse 17, from 30 June to 7 September 1996

A Fête Worse Than Death 1994

Saturday 30 July 1994, 10.00 to 24.00, in Hoxton Square, Circus Space courtyard and adjoining streets.
Artists with stalls/pitches (as listed in the programme): Mat Collishaw, Georgie Hopton and Mariol Scott, Izi Glover, Simon Bill, Rod Dickinson, *Frieze*, Philippe Bradshaw and Andrea Mason, Sean Kimber and Simon Periton, Art in Ruins, Alison Gill with Roz Lowrie and Emma Rushton, Stephen Hughes, Jessica Voorsanger, Bipasha Ghosh, Tracey Emin and Tom Shaw, David

Goldenburg, Peter Newman, John Lundberg, Sue Webster and Tim Noble, Independent Art Space, Renato Niemis, Gordon Faulds, Billy Shoebridge, Link, Jibby Beane, Penny Govett and Mick Kerr, Nic Clear, Dominic Berning Fine Art in association with Nick Silver, John Marchant, Louise Lamburn, Nicholas Morgan, Nicholas Treadwell, Rose Cecil and Sally Howarth, Piers Wardle, Alexander de Cadenet, Emily Grant, Daniel Cigman, 30 Underwood Street and ABC Magazine, Diego Ferrari, Jane Kelly and the Brothers Costin, Henrietta Park, Martina Treacy and Rose Wallin, Curtain Road Arts, Gillian Wearing, Deborah and Curtis Turk, Placebola, Simon Josebury, Stirling Ackroyd.
Music and performance (organised by Adam McEwan), in order of billed appearance on stage: Ken Ardley's Playboys, Armitage Shanks, Gavin Turk's *Killers and Cannibals*, Cerith Wyn Evans' *People Should Beg God to Stop*, Settee (Mike Walter: Saxophone; Adam Bowman: prepared strings and amplified objects; John Russell: guitar; Thomas Lehn: Moog synthesisers), Flying Medallions, Leigh Bowery and Minty, The Raincoats, Mannaseh Sound Systems.
Film and Theatre: London Video Access, showing work by Sadie Benning, George Snow, Alison Walker, and others; London Film Makers Co-operative's *Celestial Bodies* (a performance film installation by Thomas Gray and Rene Eyre, with music by Julian 'bev' Moore); Painted Faces Theatre Company (with Bi Ma Dance Co. and Graeae Theatre Co.) presenting *The Scathach of Skye*; Blast Theory presenting *Invisible Bullets*.

Supported, financially and otherwise, by: Interim Art, Rob Dawson Moore, Dicky Stringer Associates, Derek Hodgson Associates, Dean Watts of FFS Scaffolding, Phil Taylor of Townlink, Charles Holland and Teo Greenstreet of Circus Space, Cockroft Adams Ltd, Gavin Turk, The Arts Council of England, Dalston City Partnership, Glasshouse Investments Ltd, London Film and Video Development Agency, London Borough of Hackney.

Assorted States
Private view 23 March 1995, at Factual Nonsense
William Shoebridge
Photographs
Invitation designed by Joshua Compston and William Shoebridge, 'with thanks to Amanda Kane'.

The Hanging Picnic
Saturday 8 July 1995, in Hoxton Square
Programme and invitation featuring Gary Hume's *Jammy Boots (Version 2)* (photographed by Anthony Oliver).
Exhibiting artists: Art in Ruins, Philippe Bradshaw and Andrea Mason, Philip Brown, Andrew Capstick, Helen Chadwick, Mat Collishaw, Iain Forsyth and Jane Pollard, Jonathan Goslan, Laura Gerahty, Andrew Herman, Gary Hume, Elinor Jansz, Mick Kerr, John Lundberg, Maria Marshall, Elizabeth Manchester, Renato Niemis, Tim Noble, Orphan Drift, Mr & Mrs Quick, William Shoebridge, David J Smith, Sam Taylor-Wood, Jessica Voorsanger, Sebastian Wrong, Piers Wardle, Sue Webster, Max Wigram.
The picnic committee: South London

Art Gallery, Picnic 2000, Bona Colonna Montagu, Philippe Bradshaw and Andrea Mason, Penny Govett, Laura Gerahty, The Gasworks, Linda Karshan, Jane Kelly, M16NIC, Mouse Picnic, Dominic Berning, Clare Manchester, Jibby Beane, Richard Lilley, PPQ.
Supported, financially and otherwise, by: Beck's Beer, J & B Whisky, Bombay Sapphire Gin, Bricklayers Arms, London Apprentice, Rob Dawson Moore, London Weekend Television, Stirling Ackroyd.
Assistants to Joshua Compston: Andrew Capstick, Katherine Tulloh, Ra Zamora.
Filmed by Liz Friend for London Weekend Television for Opening Shots, for first transmission on 3 December 1995 (Compston hosted an FN party at the Tramshed on 30 November 1995 to preview the film, the celebratory event sponsored by J & B Whisky and Bombay Sapphire Gin, the free bar staffed by Factual Nonsense supporters, including Sam Gleisner and Val Fanshaw).

HARDCORE' (part II)
Private view 28 September 1995, at Factual Nonsense
Don Brown, Mat Collishaw, Gilbert and George, Gary Hume, Gavin Turk, Robert Whittaker
Paintings, photographs, sculpture and drawings.
Invitation designed by Joshua Compston, incorporating an untitled photograph of Compston in disguise by Robert Whittaker.
Preview sponsored by J & B Whisky and Bombay Sapphire Gin.

no FuN without U

**Slugs and Snails and Puppy Dogs
Tails**
Private view 23 November 1995, at
Factual Nonsense
Renato Niemis
Sculpture
Invitation card with essay by Sarah Kent
Preview sponsored by J & B Whisky and
Bombay Sapphire Gin.

Gavin Turk, wearing the FWTD '94 T-
shirt which he designed, here signing his
initials on a T-shirt for Live Stock
Market which he organised.

Early on the morning of 'FN Day',
Saturday 9 August 1997, Turk and his
children Francis and Curtis at the
crossing of Rivington Street with
Charlotte Road, precisely where Factual
Nonsense hosted the first Fête Worse
Than Death, on Saturday 31 July 1993.

Joshua Compston was born on 1 June 1970 and died at FN in the early morning hours of 6 March 1996, in his twenty-fifth year, possibly by accident, possibly by intention. His funeral took place on Friday, 22 March 1996, and his coffin, painted by Gavin Turk and Gary Hume after a William Morris design, was carried from Factual Nonsense (44a Charlotte Road, London EC2A 3PD) to Hawksmoor's masterpiece Christchurch Spitalfields for a memorial service at which the address was made by a childhood friend from St Edwards, Oxford, Ben King. Afterwards an all-night wake was held at the Tramshed in Rivington Street, with impromptu addresses and performances, the continuous display of photographs and videos, and drink and dancing. He is buried in Kensal Green Cemetery (ref. 65657/57/PF), beneath a tomb designed and sculpted by another childhood friend, Zebedee Helm. The funeral/wake invitation was designed and printed by Tom Shaw, in black and red, emblazoned with the FN logo by which Joshua Compston lived his vital final years. Two enamel-on-steel memorial plaques bearing the FN logo and Compston's dates have been mounted on the façade of the Charlotte Road building. The Factual Nonsense Archives, preserved in accessible order due to Andrew Capstick's months of dedicated voluntary work at FN, were presented to the Tate Gallery by the Factual Nonsense Trust, a charity formed to administer Joshua Compston's affairs after his death.

OPPOSITE Compston posed naked at the end of a line of human columns at Carlton House Terrace, beside the Institute of Contemporary Art in The Mall

Diego Ferrari, *Key Observers*

acknowledgements

Without financial assistance from the Henry Moore Foundation [£5000], the Elephant Trust [£2000] and Stirling Ackroyd [£1000] this publication would have been impossible. The publishers and author are grateful for this generous support.

The author is also very grateful for the encouragement received for this project from the artists and photographers originally involved with Factual Nonsense, for their kind loan of visual material.

Many people have helped in many different ways. Special thanks to: Judy Adam, Rosa Ainley, Nikki Bell, Simon Bill, Don Brown, Katrin Brügelmann, Charles Booth-Clibborn, Sadie Coles, Emily Compston, Deborah Curtis, Tracey Emin, Angus Fairhurst, Carl Freedman, Gilbert & George, James Goff, Charles Gregson, Gary Hume, Mick Kerr, Ben Langlands, Bronwen Lenton, Tim Llewellyn, Sarah Lucas, Rut Blees Luxemburg, Jonathan Moberly, Guy Moberly, Tom Neville, Renato Niemis, Tim Noble, Maureen Paley, Leila Sadeghee, Nick Serota, Aurel Scheibler, Tom Shaw, Billy Shoebridge, Sarah Staton, David Taborn, Gavin Turk, Charlie Varley, Mike Walter, Akiko Watabe, Gillian Wearing, Sue Webster, John Winter.

no FuN without U

photographic credits

Artangel: pages 169, 170, 171; Iris Athanasoula: page 124 (centre and bottom); Charles Booth-Clibborn (Paragon Press): pages 40, 41; Don Brown: pages 156, 157 (courtesy of Sadie Coles HQ); Sadie Coles HQ: pages 17, 51 (bottom), 76 (top), 77 (right), 178 (bottom); Tracey Emin: pages 75, 76 (bottom), 77 (left and bottom), 180 (top and bottom left); Angus Fairhurst: pages 12 (top), 13 (top), 15 (top), 16, 110, 111; Diego Ferrari: page 226; Carl Freedman: pages 11, 177 (bottom), 178 (top); Gilbert and George: page 27; Gary Hume: pages 30 (bottom), 107, 144, 155, 198; Bid Jones: page 109; Jay Jopling: pages 36, 180 (bottom right); Max Jourdan: pages 84 (left), 85; Mick Kerr: pages 57 (top), 83, 127 (bottom), 184 (bottom), 185, 188, 213; Langlands & Bell: pages 29 (bottom), 53, 54 (centre and bottom), 205; Rut Blees Luxemburg: pages 97, 151; Giles Moberly: pages 7, 200, 201, 202 (bottom); Guy Moberly: pages 10, 31, 63, 64, 80, 81, 131, 132, 133, 172, 190, 204; Renato Niemis: pages 159, 160, 161, 162, 163, 165; Tim Noble and Sue Webster: pages 48, 50, 51 (top and centre), 98, 145, 210, 211; Anthony Oliver: pages 141, 143, 147, 148, 149, 150, 192, 203; Maureen Paley (Interim Art): page 52; Aurel Scheibler: pages 28, 43, 55 (top and centre), 64 (bottom), 95, 114 (bottom), 123, 206, 207; William Shoebridge: pages 115 (bottom) (photograph by George Selwyn), 152 (photographs by Helen Marsden); South London Art Gallery: pages 177 (bottom), 181 (top); Sarah Staton: pages 35, 82, 126, 188, 189, 190, 191; Gavin Turk: pages 33, 61, 99, 100, 101, 174; Charlie Varley: pages 8, 9 (left), 136, 193, 194, 199; Waddington Galleries: page 30 (top); Walker Art Centre, Minneapolis: pages 179, 182, 183, 184 (top); Mike Walter: page 124 (top); Steven White: page 170 (bottom) (courtesy of Rachel Whiteread, Artangel and Anthony D'Offay Gallery); Edward Woodman: pages 12 (bottom), 13 (bottom) (both courtesy of Jay Jopling), 14 (courtesy of Carl

Freedman), 15 (bottom) (courtesy of Laure Genillard Gallery), 18, 19, 20, 21 (all courtesy of Carl Freedman), 32 (courtesy of Jay Jopling), 172 (top), 173 (both courtesy of Rachel Whiteread, Artangel and Anthony D'Offay). Other photographs have been loaned from the Factual Nonsense Archives at the Tate Gallery, from Bronwen Lenton, from the Factual Nonsense Trust, and from the author's private collection of Factual Nonsense documents.

no FuN without U

index

no FuN without U

no FuN without U

no FuN without U